RYAN
KORBAN

RYAN KORBAN

LUXURY REDEFINED

RYAN KORBAN

with Karin Nelson

HARPER
DESIGN

An Imprint of HarperCollins Publishers

FOR ANTOINE AND CAROL

CONTENTS

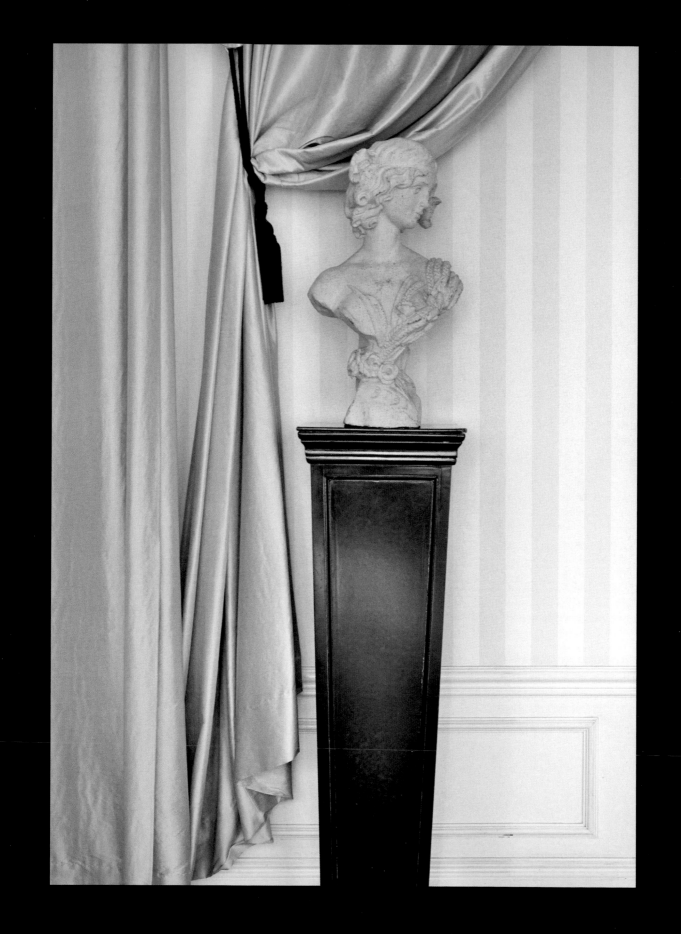

FOREWORD

From the moment I met Ryan Korban, when we were both studying at university, I was struck by his expressive personality as well as his innate creativity. We instantly bonded over our mutual love of fashion and design, and we became frequent collaborators and devoted friends.

Ryan's sense of design has always been inspired by fashion and his knowledge of art history. He can just as easily identify a piece of clothing or a shoe by both designer and season as he can a rare antique or a painting by artist and year. His interests are deep and varied, and his work is the ultimate reflection of this. In any one of his rooms one can find references that run the gamut from the Italian Renaissance to the mod styles of the 1960s. His playfulness is always counterbalanced with definite sophistication and elegance.

Ryan has become known for interiors that incorporate classic luxury with a modern feeling. He reinterprets his love of old-world elegance and style in a new and fresh way using the exotic skins, textural fabrics, sleek surfaces, and shiny metals that have become his signature. Mixing old and new, high and low, Ryan has an uncanny ability to both elevate a space and infuse it with a youthful sense of ease. Clients come to Ryan for his fabulous taste and walk away with an expertly designed space.

Although his career is in its early stages, Ryan has already managed to accomplish an incredible amount. His spaces are not only extraordinarily striking but also truly inspiring.

—Victoria Traina

INTRODUCTION

I didn't set out to be an interior designer—at least not at first. From the age of four, I thought I wanted to be an actor. I spent a lot of time at the theater, fascinated by period pieces from Shakespeare's plays to *The Phantom of the Opera*. Later on, I studied acting in college at The New School in New York City, where I realized it wasn't just performing that intrigued me but the costumes and set design as well. I went on to take a lot of art classes and to study European history; at the same time, I pursued an underlying love of fashion by interning for a designer. Ultimately, all those interests—art, fashion, history, and theater—came together in a way that drew me toward interior design and creating residential and commercial environments with a luxurious sensibility.

While I was still in school, my friend Davinia Wang and I started discussing an idea for a store. She had a passion for shoes; I had a growing interest in interior design; and we shared a similar aesthetic taste. We came up with the concept of a small neighborhood boutique that would carry an array of luxury brand accessories—something we felt was lacking in New York City. We went to look at spaces and found one we loved tucked away in Tribeca. Taking a leap of faith, we went for it, naming the shop Edon Manor after a house in the English countryside.

Inspired by the look and feel of an English library, I went to work on the design for the shop, conceiving a space with antique chandeliers, hooded Louis XV chairs, silk curtains, and tufted ottomans. The idea was to integrate the accessories with the décor:

shoes would be displayed on a silver tray or teeter atop a pile of books. We had a watercolor rendering done of the store, and we packaged it with marketing materials, tied them with a beautiful ribbon, and sent it all off to brands like Azzedine Alaïa, Givenchy, and Nina Ricci, which we hoped to carry. We were thrilled that they not only liked our vision but also wanted to be a part of it. In 2007, just about a year and a half after our initial conversation, we opened for business.

We conceived Edon Manor to be a commercial space that didn't look like one. Walking past the boutique, you might think it's a gallery, a salon of some sort, even a living room. It's only when you get closer to the windows and can see the products inside that it becomes evident that Edon Manor is an accessories shop. We've had customers come in wanting to buy the couch. People have commented on how much they love the bookshelves, which are filled with art and fashion volumes that I've collected specifically for display. Some have even said they wanted their house to look like the shop—which is not a usual reaction when you enter a store. Hearing comments like this made me confident that people liked my aesthetic. It wasn't long before I started helping friends decorate their apartments and, through word of mouth, began receiving design jobs for a range of projects, including other stores, showrooms, and event spaces. That's how my career as an interior designer began.

When I am asked to describe my style, I often say that it has three critical elements: sex, romance, and fantasy. When I say sex, I'm talking about allure, seduction, and mystery. My father, who is Lebanese, owned a hair salon outside Philadelphia. As I look back, he was

like a Middle Eastern version of the sexy Beverly Hills hairdresser played by Warren Beatty in *Shampoo*, driving a sports car with his shirt buttoned low. My mother, who was twenty years his junior, was tall and thin, had long red nails, and wore lots of makeup. There was a definite sexual charge between them, and they were always getting dressed up and going out somewhere. I'd be asleep on the couch by the time they came home, and my mother would cover me in her fur coat. Because of them, I'm very comfortable with overt sexuality and have always been drawn to it. It's what feeds my need for design elements with a harder, more animalistic edge, like zebra skins, leather chairs, crystal ashtrays, and brass lamps.

That said, I'm also inclined toward the romantic—flowers, classic figurative sculpture, and weathered antiques. I think my love of romance can also be traced back to my parents and the décor of their house, which was awash in pastels. Our living room had Louis XIV chairs done up in pale pink silk taffeta and matching love seats in seafoam green. As I think of it now, it was kind of horrible—in an amazing way—but back then I thought it was beautiful, and I always wanted to sit in there. My mother, however, never allowed that— except on special occasions—and she always knew when I'd snuck in, from my footprints in the white pile carpet. Later on, my fascination with romance was fueled by an art history course on the Elizabethan era and another on classical artists and composers—worlds that enthralled me with their pageantry and flourish. When I started designing, I realized that a magical thing happens when you bring together objects that convey sex and romance, such as a sleek brass art deco coffee table with an antique marble bust on it. You create a sensory impression that is at once hard and soft, masculine and feminine, and there is something very alluring about that juxtaposition.

The third element is what I refer to as fantasy. I like there to be a sense of imagination or a bit of daring in a room—a quality you don't see very much in design magazines. I like an exotic, unusual statement on a grand scale, such as a large white taxidermy peacock on a small console table or a living room covered with a panoramic mural. From my early career on, the spaces I've loved the most have been those that incorporated all three of these elements into their design, and this has inspired me to do the same in my own work.

Of course, there is a positive and a negative side to not having been schooled in interior design. In the beginning, my lack of formal training really freed me. I thought about designing spaces without constraint. As a result, though, I also made many mistakes. But I have learned something from every project I've done and have drawn inspiration from the world around me. In choosing fabrics, I've referenced fashion collections as well as art photography. I've called on striking bouquets for color ideas. In the beginning, I struggled a lot when it came to metals, thinking they had to be consistent throughout a whole room. And then I saw a vintage Jaeger-LeCoultre watch with a silver-and-gold band—I've been mixing chrome with brass ever since.

Design ideas can be found in the most unexpected places. Because I've been fortunate enough to be surrounded by creative people and beautiful things on a regular basis, I never fall short of inspiration. This book serves as a catalog of those wide-ranging influences. It is not a how-to guide; rather, it is a curated reference. Each thematic chapter presents a vital element of my approach, displaying rooms I've designed along with fashion, art, and interior design images that both capture and inform my aesthetic. I became a designer by schooling myself, by being in tune with what my eye is drawn to and figuring out why. I hope this book encourages you to do the same.

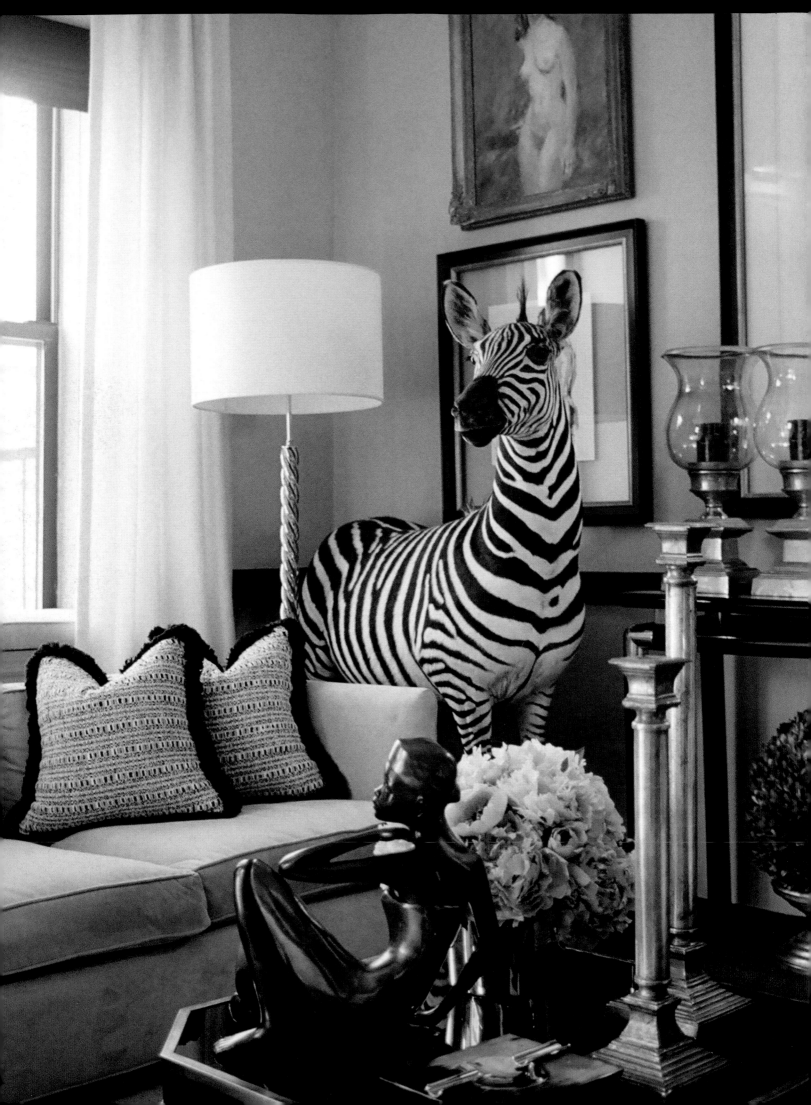

1

ANIMAL INSTINCT

ANIMAL SKINS CONSTITUTE A BIG PART OF MY DESIGN LANGUAGE.

And sex has a lot to do with it: using hide, fur, and taxidermy conveys a sense of allure, seduction, and romance—an overall feeling that I try to bring to every room I do. Filling a space with hides—a zebra skin on the floor, a coyote fur slung across the sofa, a set of stingray chairs around the dining table—creates a palpable sensuality that people enjoy. They feel sexy when they're in a sexy setting.

A room with animal skins always makes me think of the famous Helmut Newton photograph *Charlotte Rampling as Venus in Furs*. In it, Rampling is seated on a daybed, swathed in fur, her long legs defiantly set apart. She's so glamorous, but there's a bit of misbehaving going on. That's the vibe I'm after.

My affinity for animal skins goes beyond their primal appeal, though. I often use them to add texture or to layer a space. I don't use patterns that often; you won't find a lot of toile or Greek keys in my interiors. Using animal skins is how I do prints in a space. Leopard, ostrich, crocodile—they all have an individual, graphic look that lends richness and excitement to a room. But my favorite animal skin is zebra, for its bold geometric stripes.

Animal skins have inspired my color choices, too. I've never really been big on using color. For the most part, I prefer subtle shades, and it's from animal skins—in fact, from the natural world, really—that I learned the nuances of combining colors successfully. Coyote showed me

how great certain shades of camel, black, and brown look together, while the gray, black, and white found in the feathers of the Japanese crane is often the go-to palette for my spaces.

Fur and hides also help set a mood. You can create a sense of calm, warmth, or even seduction by using them. Perhaps because it comes from the skin of deep underwater species, shagreen conveys a quiet coolness. Similarly, bleached parchment can be very peaceful and calming. Boiled wool can create the same comfort and coziness associated with a fuzzy lamb, while tiger stripes add an immediate sense of sex and intrigue to a space.

I love to experiment with materials, and I often look to fashion for inspiration. With new collections every season, luxury fashion houses always seem to be looking forward, searching for innovative ways to use and transform materials. That level of ingenuity inspires me. Consequently, every time I upholster a piece of furniture, I think about what I'm doing probably in the way a luxury fashion designer thinks about a piece in a forthcoming collection. Should I do it in pony skin? How about perforated suede? It's exciting for me to experiment with fabrics in that way. I love the sense of newness that a pair of chairs upholstered in goat hair conveys. Or a hammock in fox fur—which is not a very complicated concept, but it is unexpected and luxurious. I also love covering things in shagreen. When the French interior designer Jean-Michel Frank used it to wrap large pieces of furniture in the 1930s, he made doing so feel fresh, because shagreen had traditionally been used for accessories. The same is true again today: covering chairs with materials used more commonly for a clutch or a pair of shoes feels new and exciting.

I admit I often go overboard when it comes to using animal skins—so much so that the *Wall Street Journal* once described my old apartment as an "animal rights activist's nightmare." But, of course, that's not true. I respect animal life and rights enormously. When it comes to taxidermy, there are strict laws in place that I fully support and abide by. For one, dealers must wait for the animals to pass away in zoos or wildlife sanctuaries before buying or selling their skins. It's illegal to kill the animals, which means that acquiring a certain specimen can take months, even years.

An amazing piece of taxidermy really brings life to a space—as well as a sense of wonder and fantasy. The fact that it's one-of-a-kind enables you to create an environment that is not only unique, but unforgettably your own.

The whole reason I extract from the animal kingdom is to create a visceral reaction. For me, that depth of feeling is the definition of animal instinct.

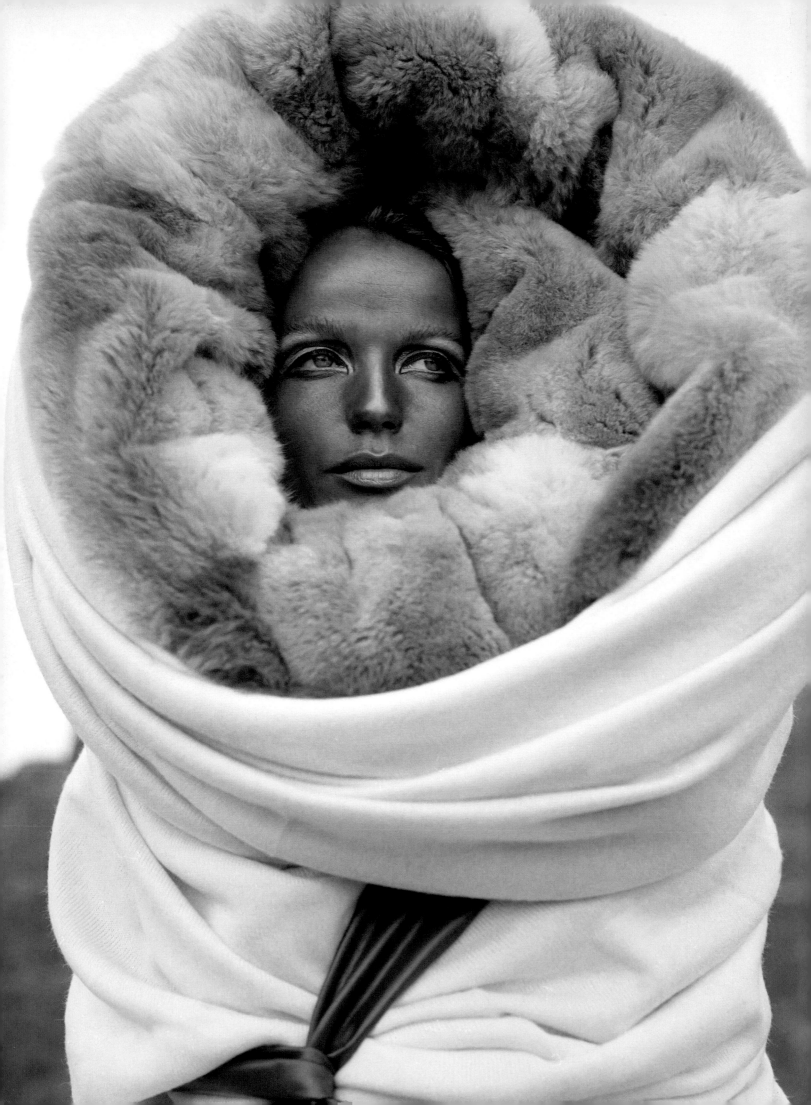

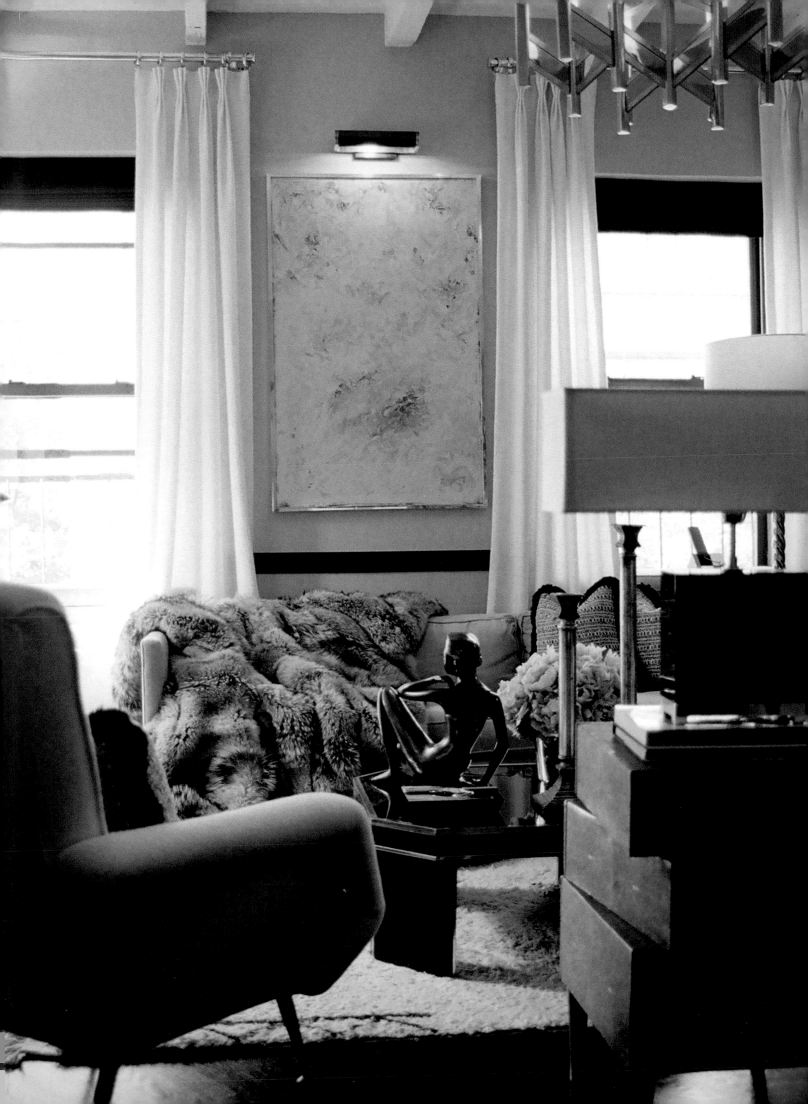

WITH HER LONG LIMBS AND FELINE LOOKS, 1960S SUPERMODEL

PAGE 18:
Franco Rubartelli
The Magnificent Mirage
Vogue, July 1968
featuring Veruschka

PAGE 24:
Inez van Lamsweerde and
Vinoodh Matadin
Kate, *Vogue Paris*
October 2009

V

eruschka was as animalistic as they come. Even the way she posed had a feral quality: bending and arching, tossing her hair, and stretching her body, she carried herself like a jungle cat, completely seducing the lens. I think a lot about Veruschka when I design, and how she transformed when she moved. How do you design a room that would make you feel that way, act that way? A room that makes you want a drink? A room that makes you want to have sex? You take a cue from the animal world.

Inspired by the soft, plush look and feel of lamb's wool, I did the drapes in the dining room of this SoHo apartment on page 25 in boiled wool. I had looked at a few bouclé samples, but they felt too traditional. I came across the wool at a fabric store that sells leftover material from fashion designers—and it had a sheer, slinky quality that I found both beautiful and exciting.

I have a thing for cats—they're the sexiest of all animals. Part of the reason I was drawn to the painting on page 27 was that it looked as if it had been clawed by a cat. The piece worked well with the fox-fur throw and gave the bedroom a feline allure.

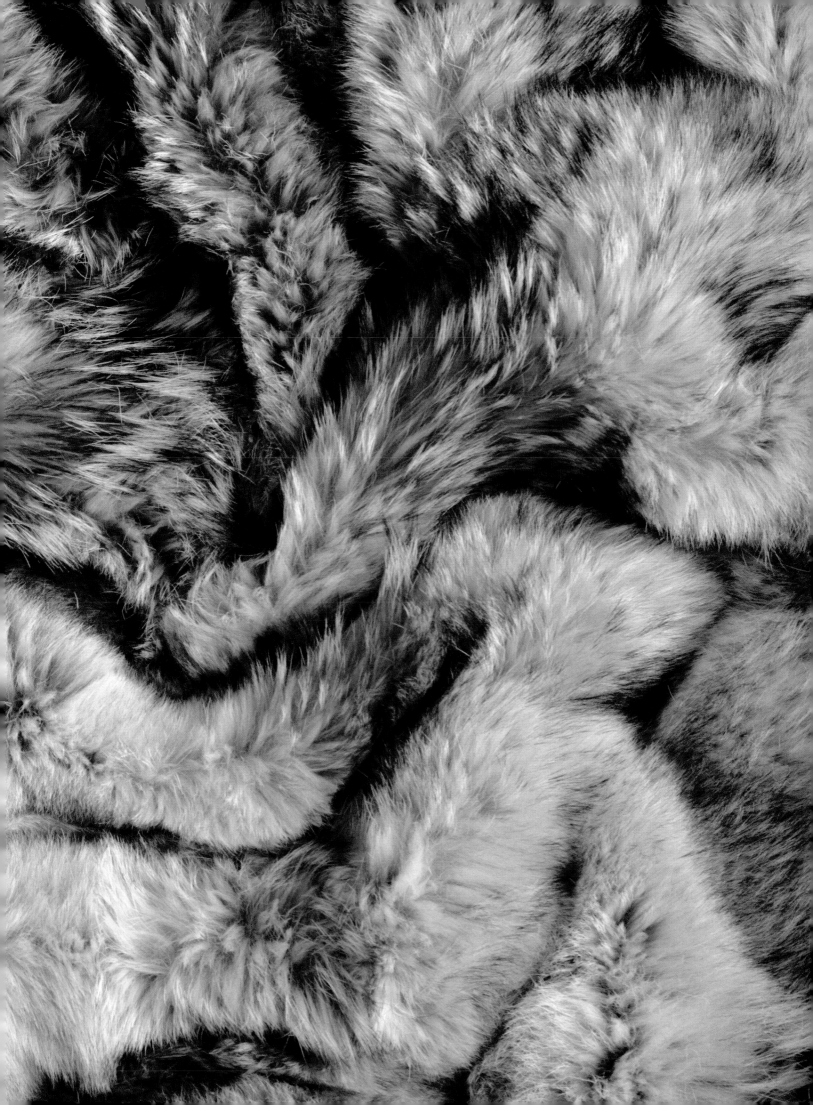

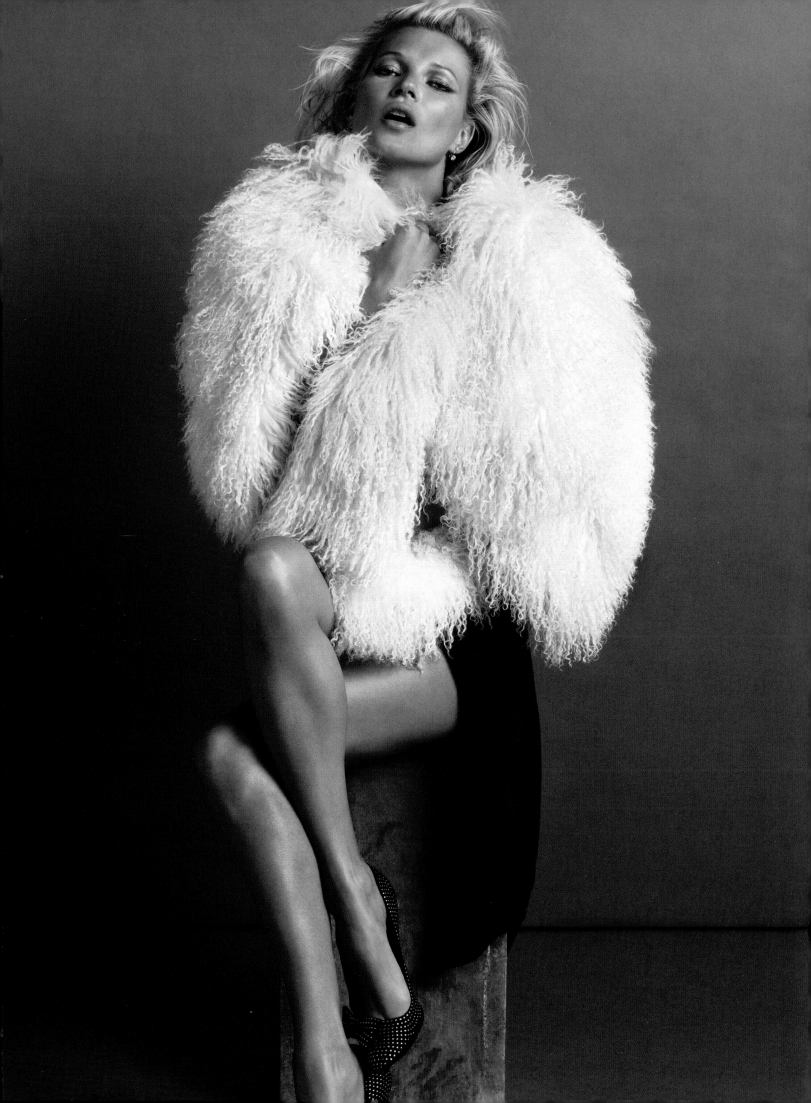

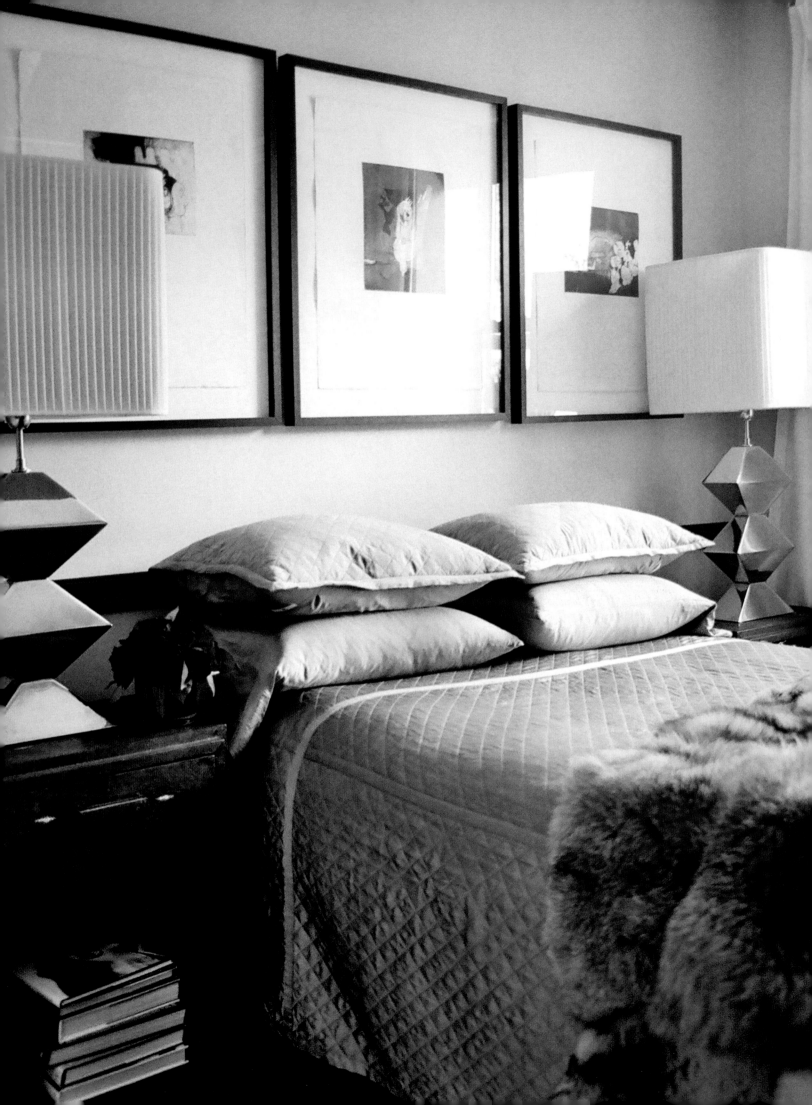

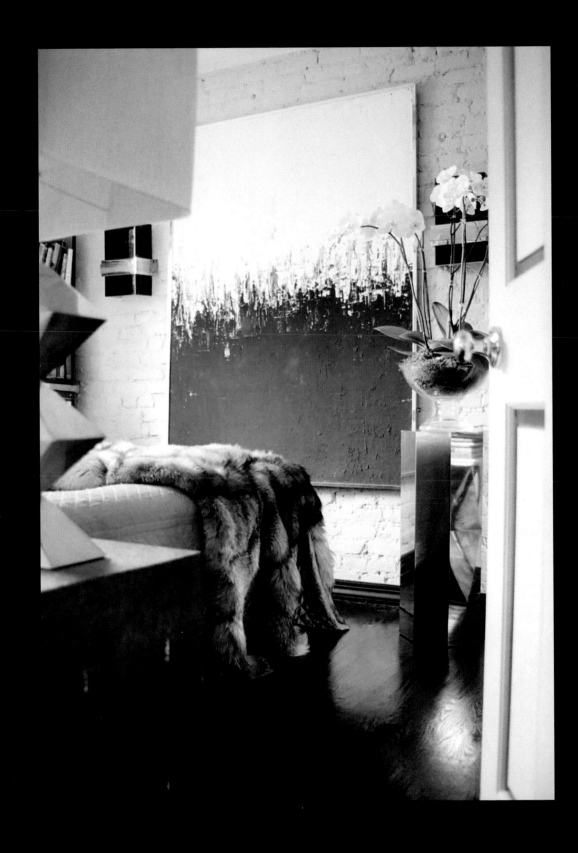

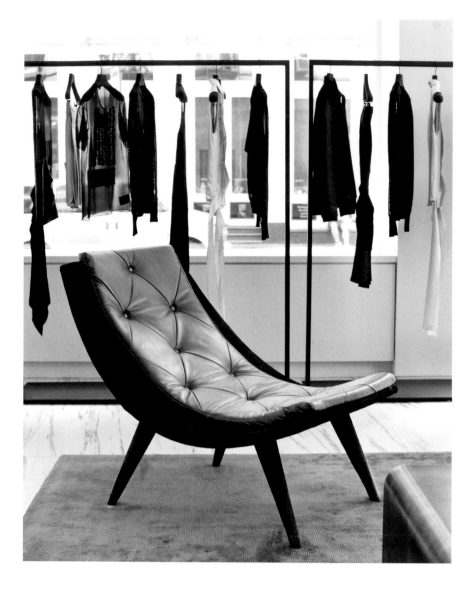

When I designed Alexander Wang's flagship

boutique in New York City (pages 28–35), the décor needed to be polished yet have a youthful, energetic spirit. We wanted the space to be elegant yet not take itself too seriously.

When I'm designing a store for a fashion brand, I think in fashion terms and experiment with materials. I love fur, but I wanted to do something new and unconventional with it. I wanted a statement piece: hence the black fox hammock (pages 32–33).

Initially, the idea behind the cage (pages 34–35) was to bring a bit of street and subversion into the space. Then I realized it was a good solution for covering the unattractive set of stairs at the entrance to the store. It also became a great merchandising tool, serving as an installation piece. For the store opening, floral stylist Jeff Leatham covered it completely in baby's breath.

PAGES 30–31: Mikael Jansson, *Alexander Wang Gang, Interview*, March 2010

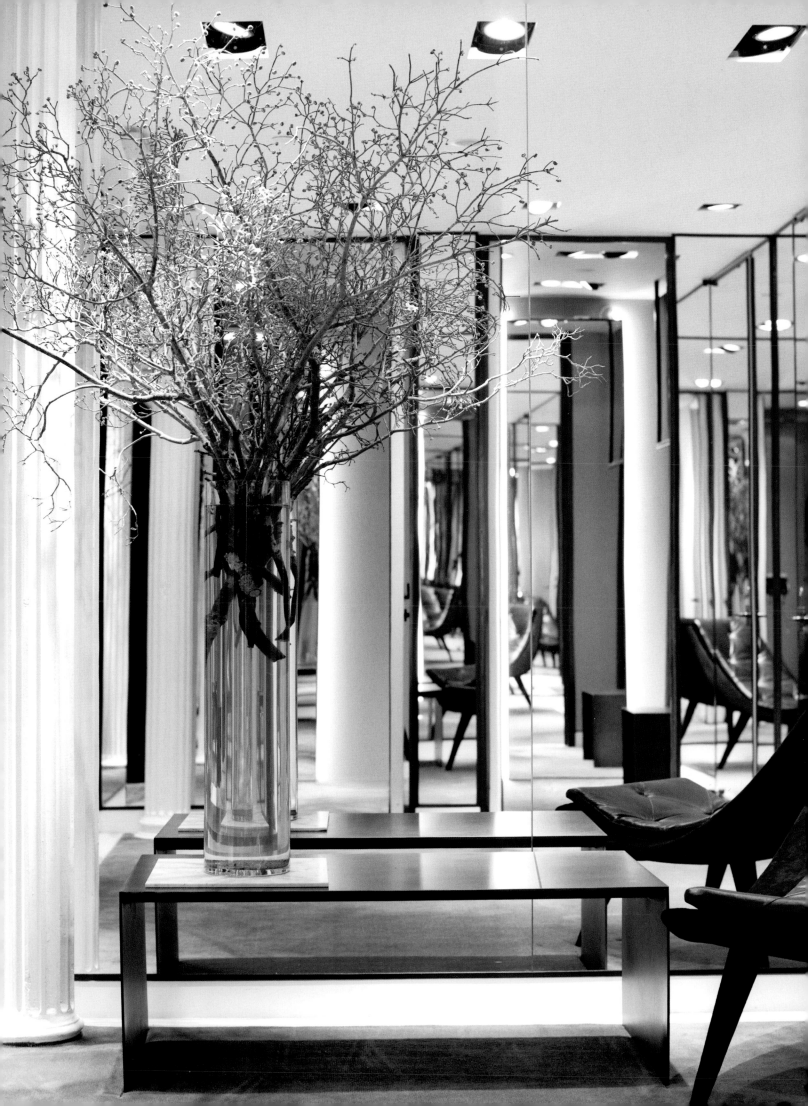

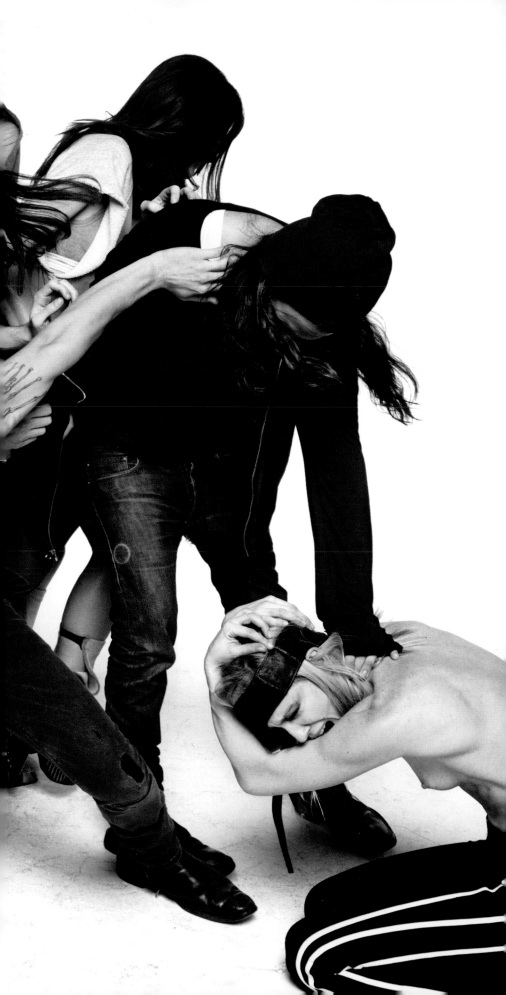

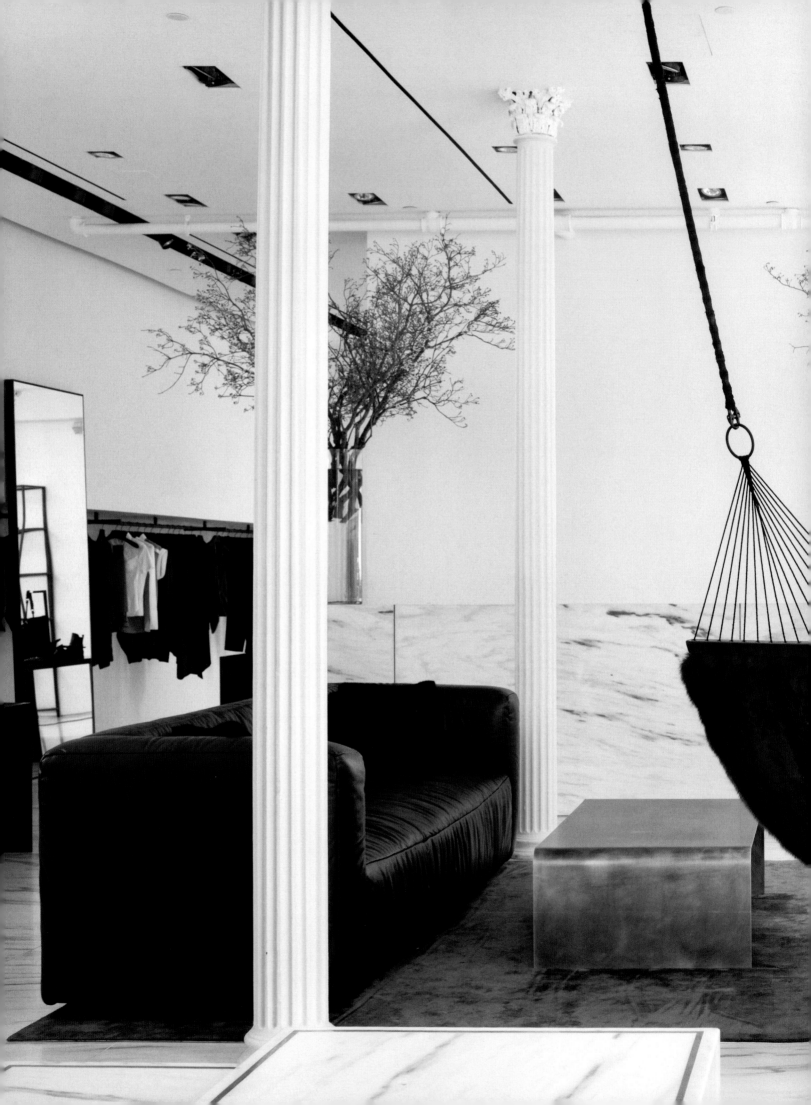

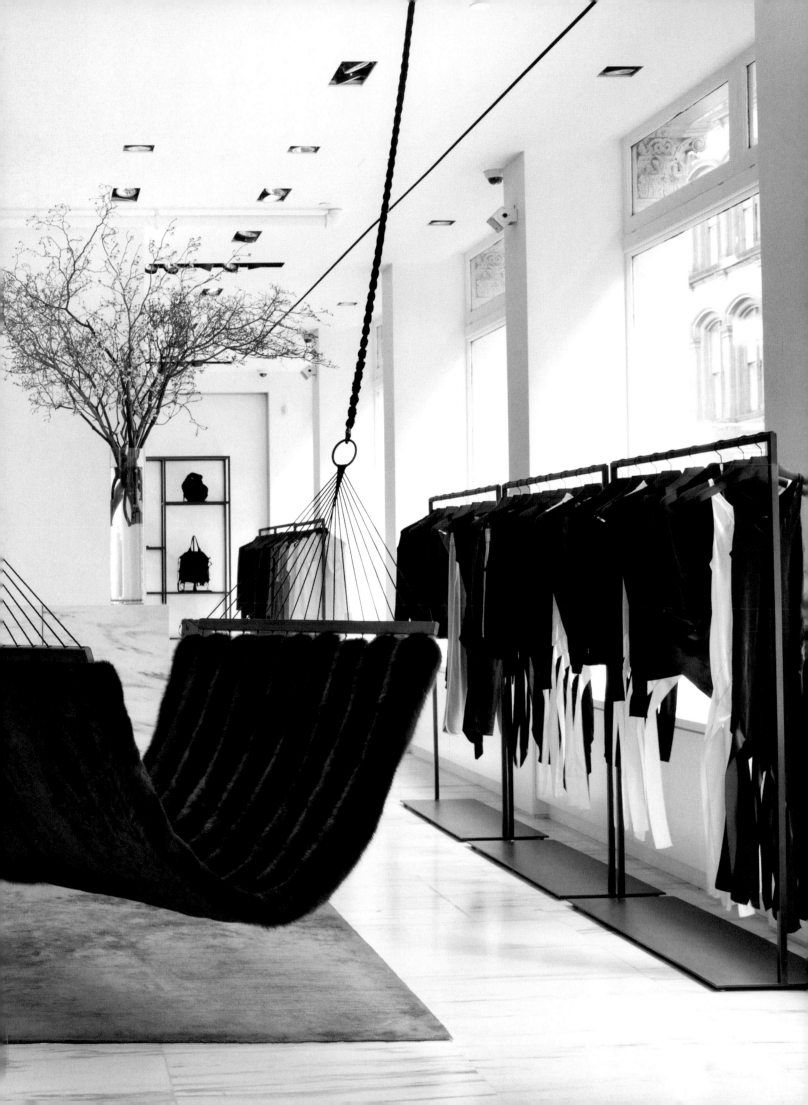

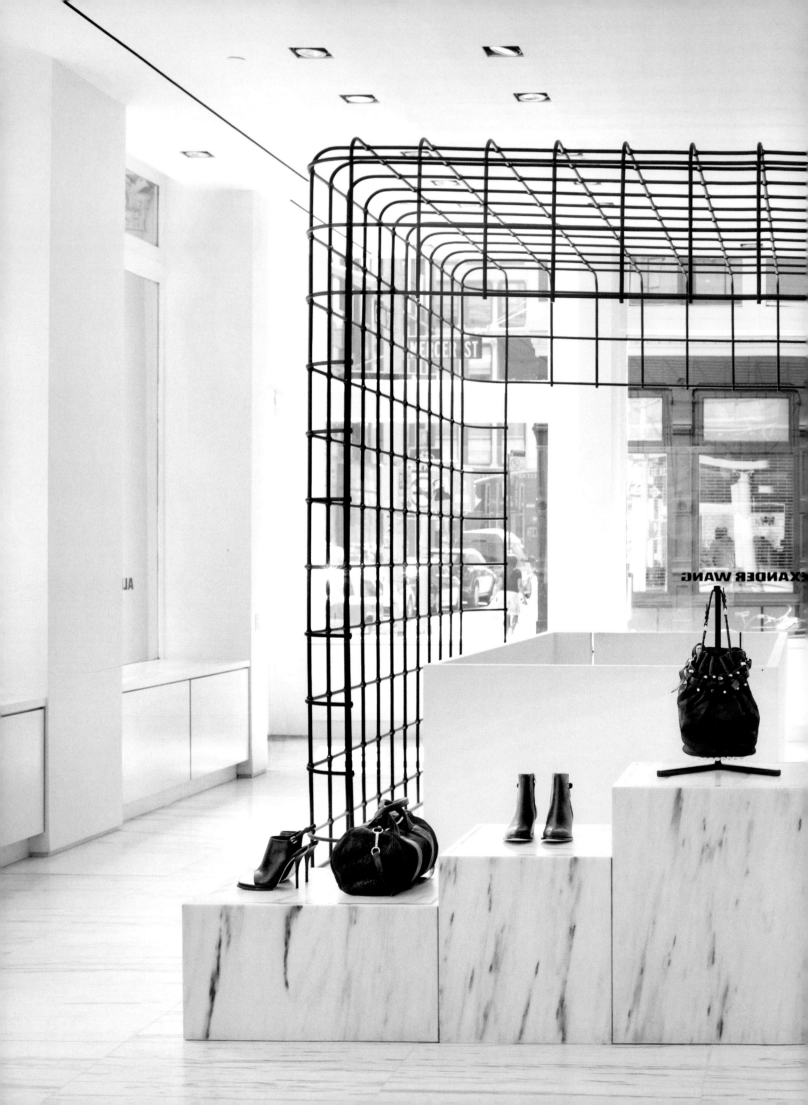

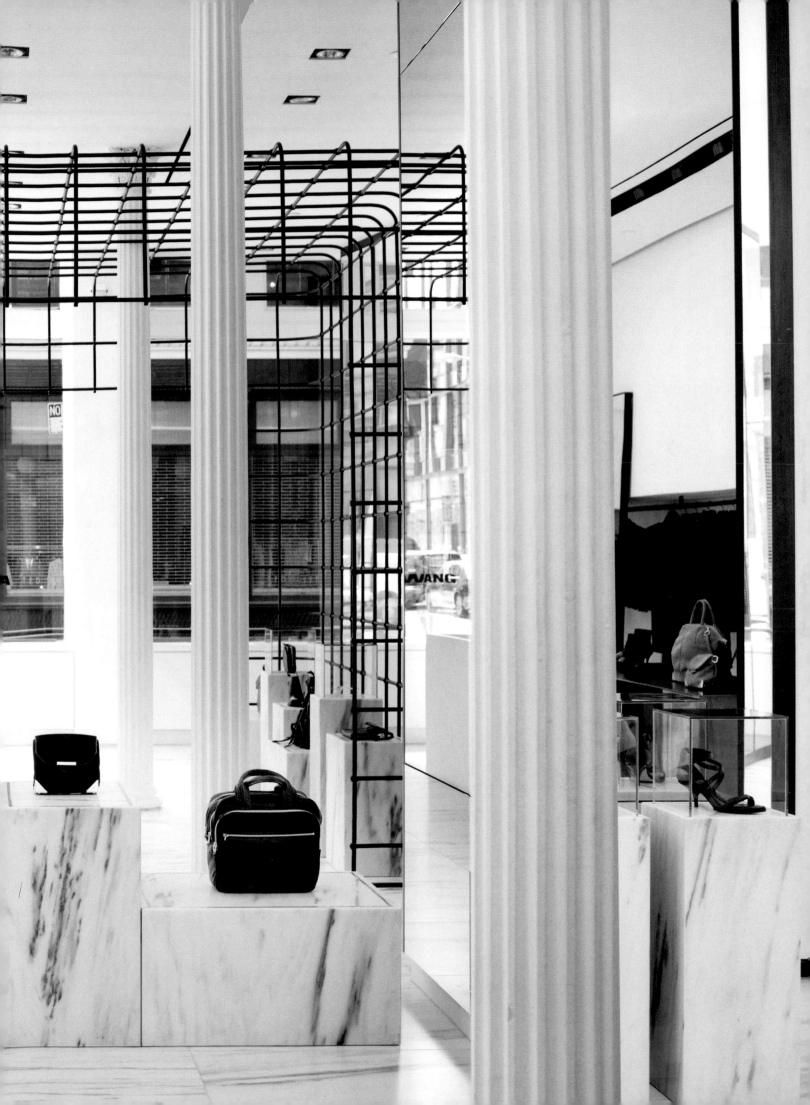

K

BY PLACING BOTH LIVING AND TAXIDERMIED ANIMALS IN OPULENT INTERIORS, ARTIST

aren Knorr creates photographs that blur the boundaries of fantasy and reality. In her Fables series, she playfully recasts Aesop and La Fontaine tales in residences across France using animals borrowed from the Parisian taxidermist Deyrolle. Rabbits and foxes roam freely among the art and furniture of eighteenth-century period rooms, while in the photograph on the opposite page a flock of birds explores the modernist architecture of Corbusier's Villa Savoye.

The clean lines and spare color palette of Knorr's photograph were the starting point for the Tribeca apartment on pages 38–43.

I love the color black, as does this particular client—and his living room (pages 40–42) became a study in it. Mixing textures helps create an all-black room that doesn't feel flat or too dark. I started with black goat-hair chairs and then added black lizard end tables, a black crocodile coffee table, a black suede sofa, and a black leather bench—all set atop a black-and-white zebra-skin rug.

I wanted the black palette of the living room to extend into the dining room (page 43). Nobody likes eating in a black room, though, so I lightened the space a bit with a glass-and-chrome table and a chocolate-brown silk rug. I had the pair of "Beetlejuice" chairs, as I call them, custom-made by R&Y Augousti in a hammered black shell.

OPPOSITE:
Karen Knorr
The Stair
Villa Savoye, Poissy
2008

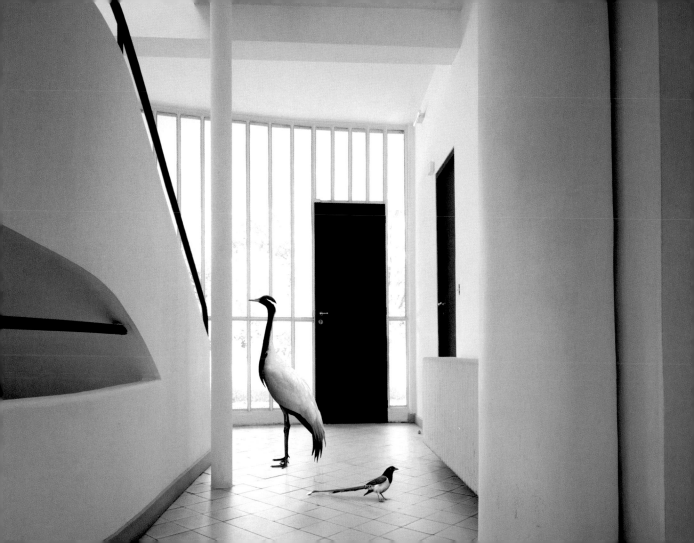

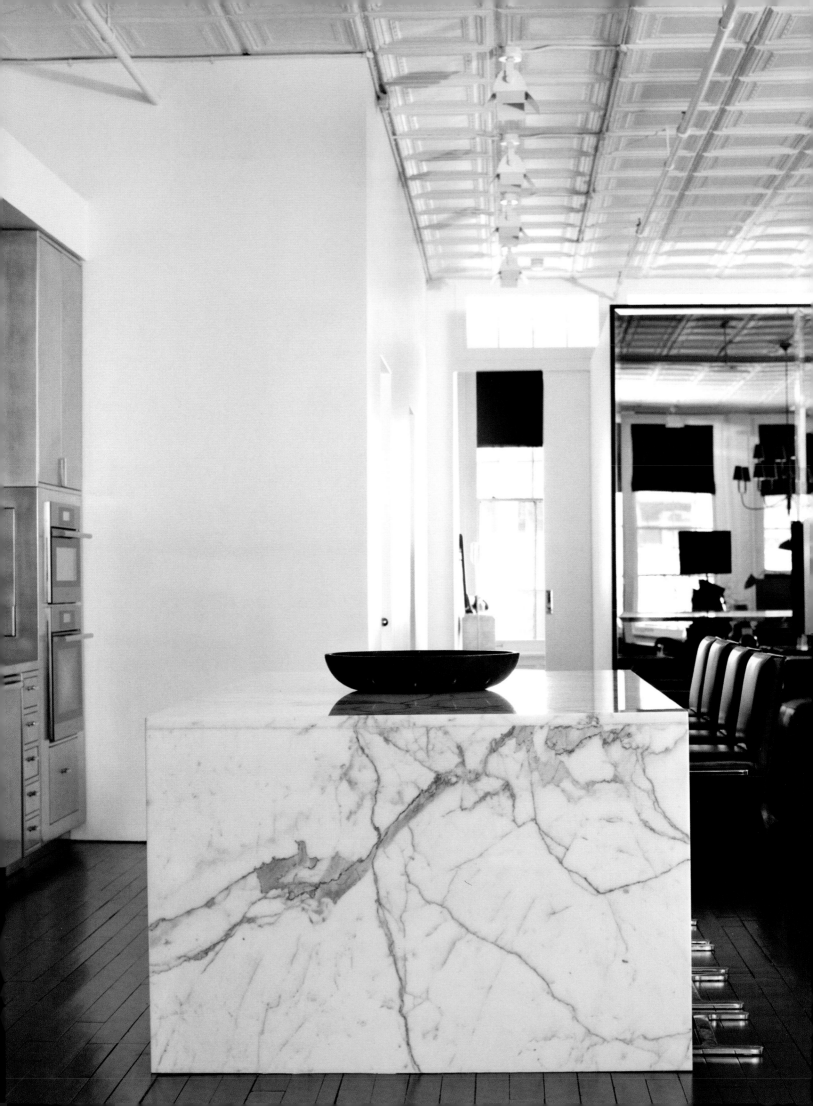

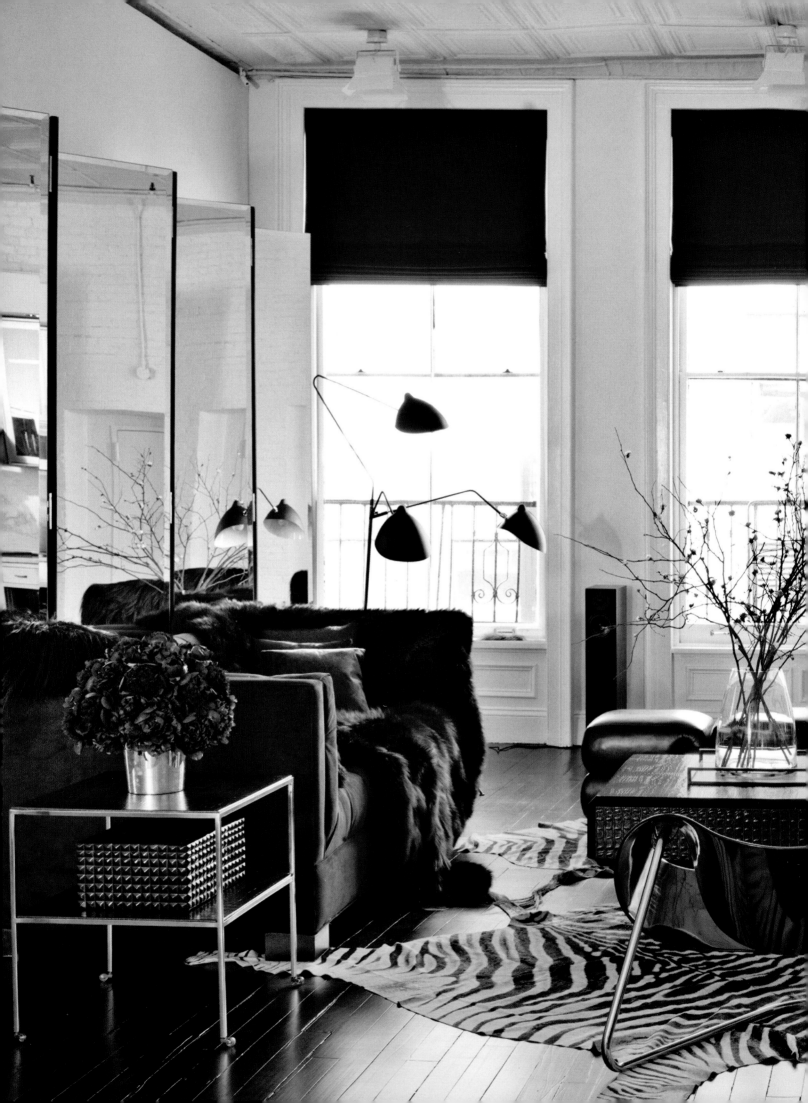

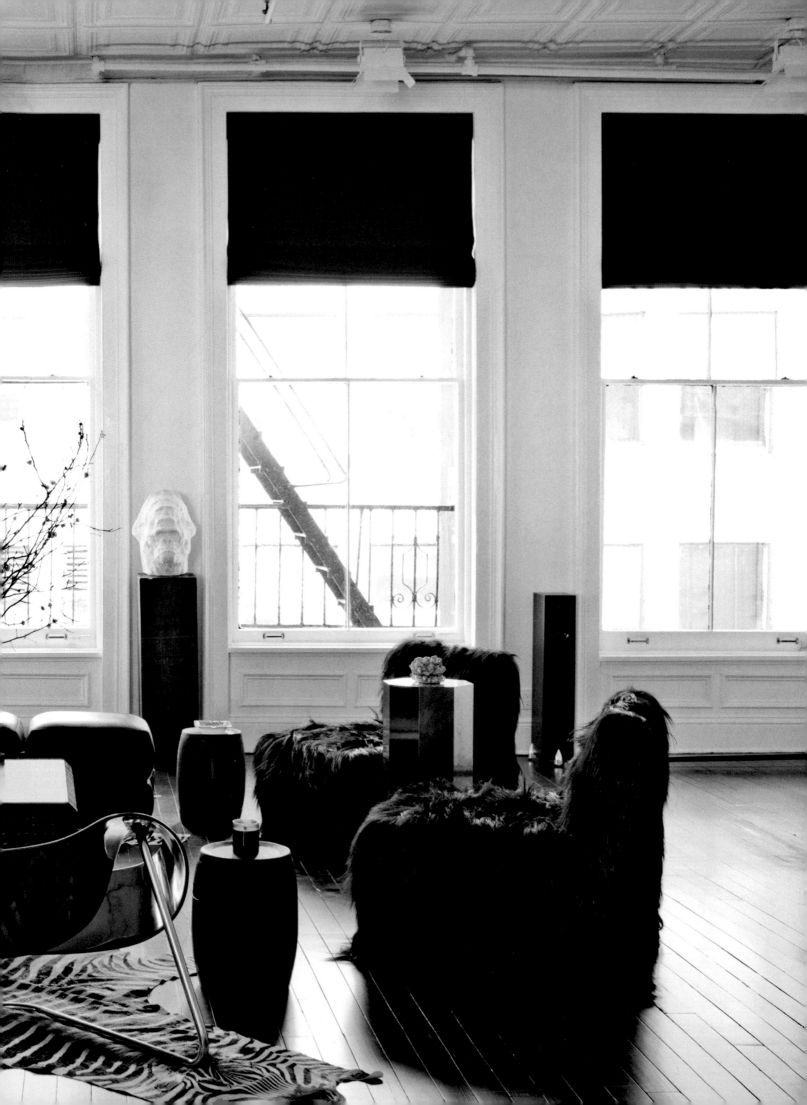

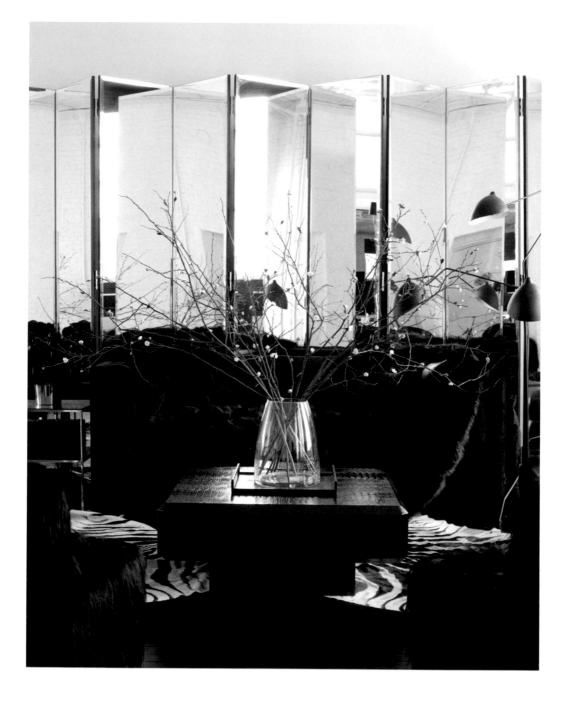

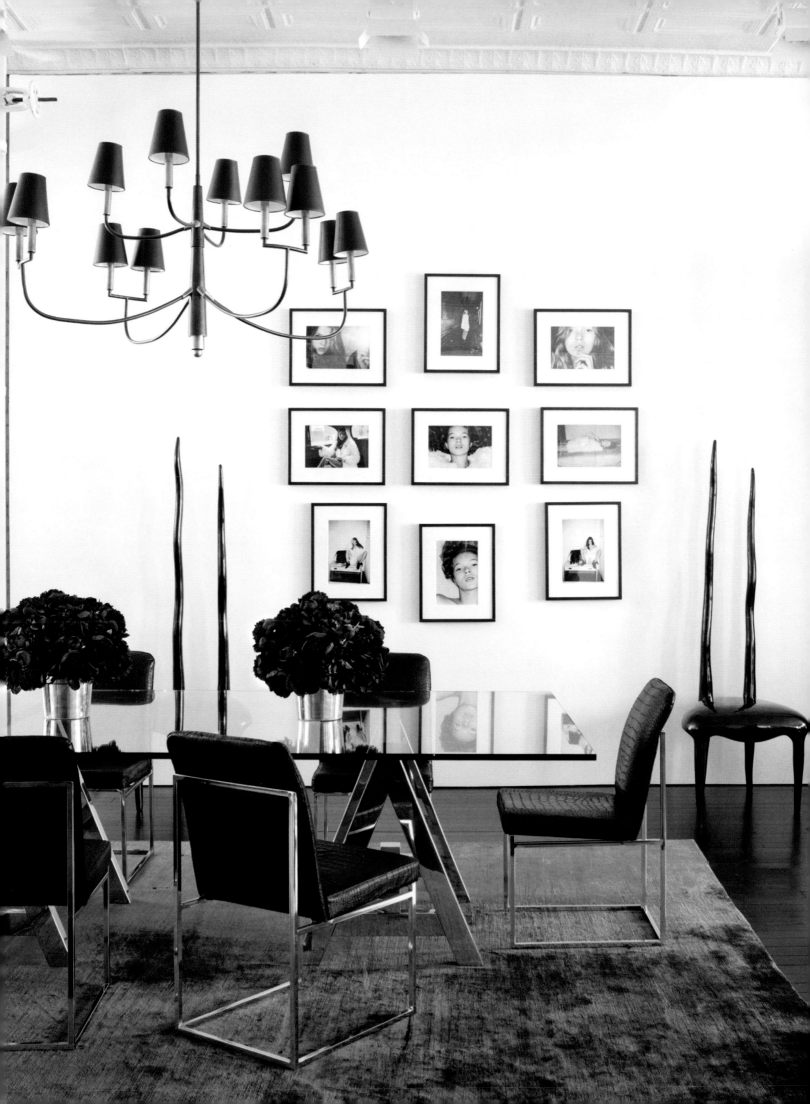

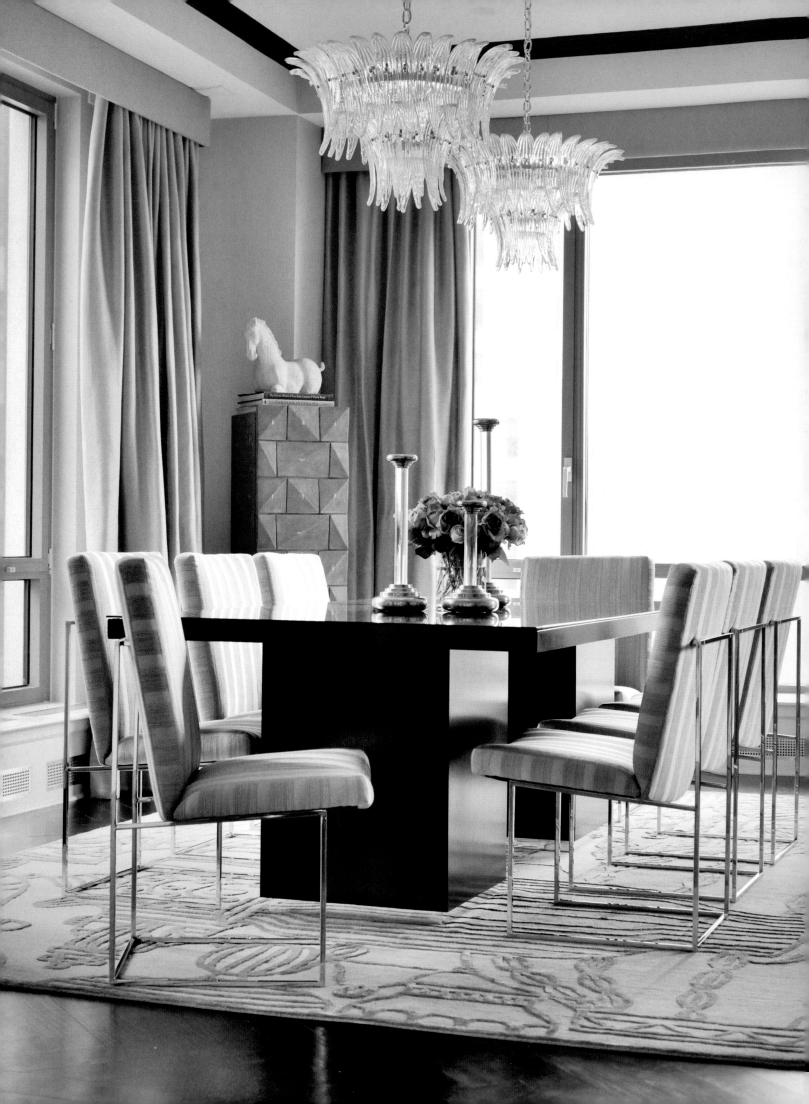

LUXURY REDEFINED

FOR MOST PEOPLE, THE CONCEPT OF INTERIOR DESIGN CONJURES UP AN IMAGE OF THE CLASSIC LIVING ROOM—

the one with perfectly fluffed pillows that no one ever sits in except on special occasions. Interior design is a very traditional industry, one in which change happens slowly. And there isn't a lot of sex appeal, either, which has always puzzled me, since a home should be an alluring place.

Which brings me back to fashion. About a decade ago, there came a turning point in fashion—a shift in people's attitudes toward luxury. Hermès Birkin bags suddenly came off the glass shelf and onto the floor. You would see a woman standing on the street, talking on her phone, with a very expensive bag splayed out on the sidewalk at her feet. People started wearing incredible furs over old T-shirts, or a pair of designer heels with well-worn blue jeans. That attitude—that change in style—just looked and felt right. Suddenly the most glamorous thing in the world was not only to use luxury clothing and accessories in everyday life, combining the high with the low, but also to treat them more casually. In fact, it became cool to even beat up luxury items a bit. Part of the reason was that luxury had simply become more

attainable to more people, and the use of luxury materials less rarified. But the other part was that by using these exquisite fabrics and objects in different ways, they became exciting again. The new notion of luxury incorporates the use of luxury.

That may not be the prevalent attitude in the interior design industry yet, but it's one I try to bring to each of my spaces. Younger people want to live the way they dress; not everything needs to be polished and precise. And that notion translates very easily to interiors—because there's something so sexy about fur on the floor, something so desirable about an eighteenth-century daybed done in a torn-up muslin.

Achieving a sense of casual luxury in the home can be as easy as not having a formal floor plan. I came to that realization early in my career, when I spent a lot of time looking at interior design books, particularly European ones. They were filled with gorgeous homes that gave you the impression that they weren't done by a decorator but by people with a good eye who had accumulated beautiful furniture and objects over the years—rugs from Morocco, chairs from a Paris antique shop, and piles of art books that spoke to their passions—and put them together in an interesting way. The informality of the arrangement felt fresh because it was personal and seemingly unstudied.

Another way of achieving the look is by mixing luxury items with less costly ones. One of the most alluring bedrooms I've seen was virtually unfurnished, except for a mattress—with a fur blanket slung across it—on the floor. The focus on the impractical item rather than the practical, expected piece of furniture is what made the space sexy. I believe in a great couch, but I also believe that if you're on a limited budget you should buy an inexpensive one in a simple shape and neutral color and put your money toward a fantastic fur throw or a stunning pair of silk pillows. So many people spend a fortune on furniture, then look around and wonder why their space doesn't look finished. I can tell you: it's because they didn't invest in those things that add glamour and a personal touch.

The photograph of Faye Dunaway on page 49 epitomizes taste, combining a sense of elegance with ease, even nonchalance. Here she is, a famous movie star with the ultimate award, at the height of her career, yet the glamour she conveys appears so effortless. I'm always after that effect when I decorate a room.

"I WAS IN HOLLYWOOD FOR THE (1976) OSCARS AND I'D ALWAYS FELT BORED BY THE USUAL IMAGE OF A STAR HOLDING UP THE AWARDS.

It always happened on the stage behind a microphone or on the red carpet at the after-party. I wanted to capture that pure moment of 'the morning after' when it occurs to them that the world will never be the same.

"I asked Faye [Dunaway] if she could be poolside at dawn. I explained why. Clarity was what I wanted—the purity and clarity of the light and also the natural vulnerability: how a beautiful woman feels before she's had time to wake up and put on her face for the world. It couldn't happen today. No star would feel so confident and trusting to be photographed in such a candid, natural state.

"She'd been up most of the night celebrating, but as promised, she turned up on the terrace in her dressing gown, all early-morning natural allure. I'd ordered the coffee and the papers. After fifteen minutes she went back to bed and I had the shot of a lifetime."

—TERRY O'NEILL, 2012

OPPOSITE:
Terry O'Neill
Oscar Ennui
1976

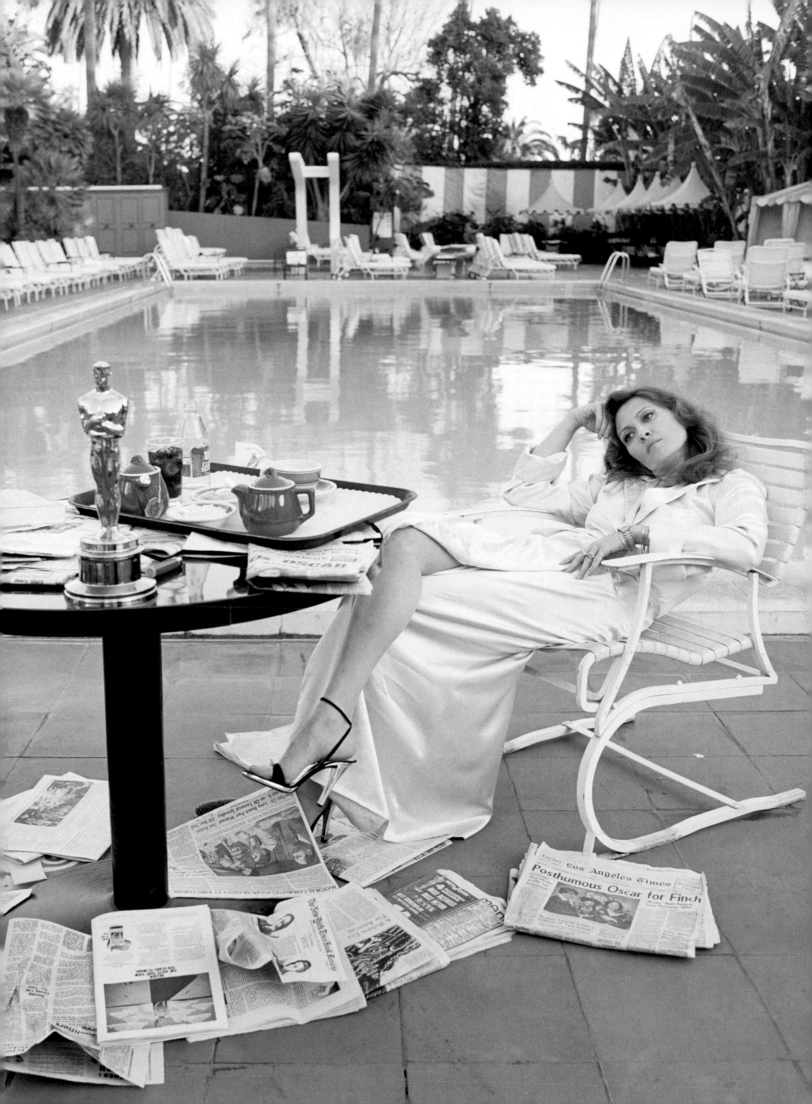

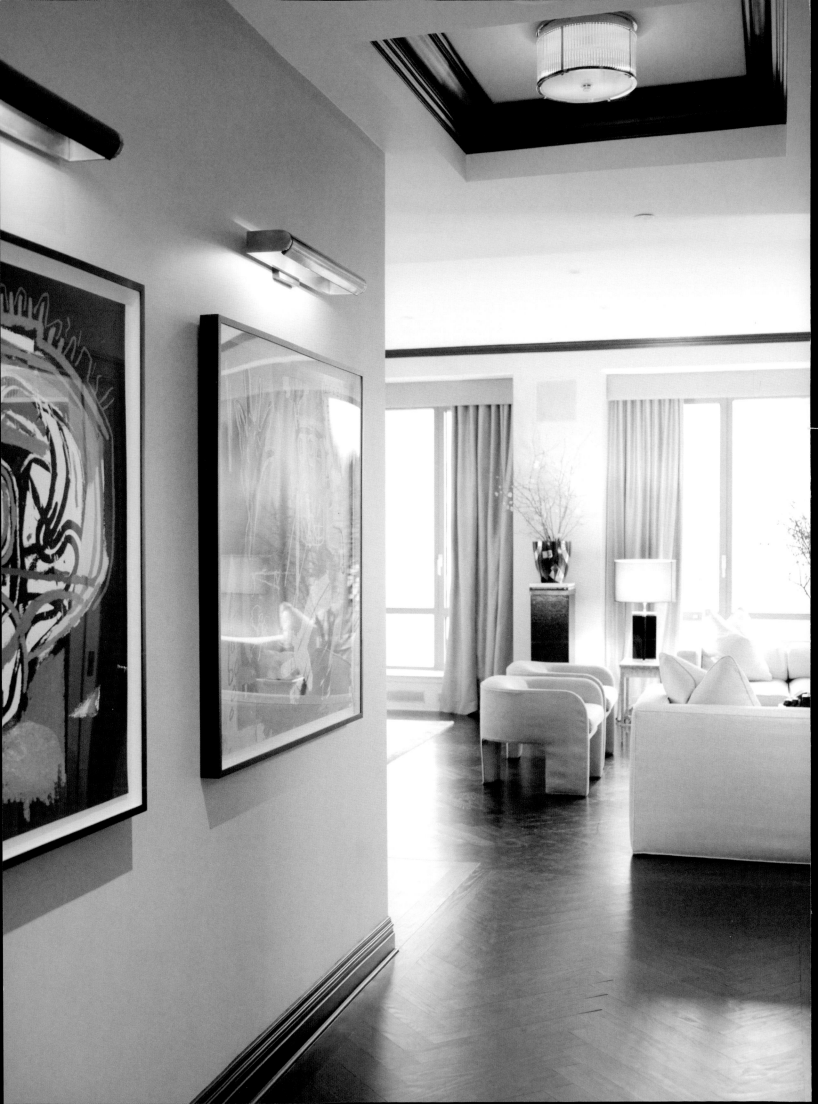

t
his private residence in New York City's Flatiron district reflects the attitude of luxury redefined. Here, I wanted to create a formal entryway to the apartment, but one with some punch to it. I put in a black lacquered bar with an eighteenth-century gold-leaf mirror and a chinoiserie lamp (page 53) and a striking pair of graphic Jean-Michel Basquiat prints (opposite). It's an unusual mix of things, and it makes for a strong impact when you first walk in.

This apartment has beautiful moldings and classic herringbone wood floors. The idea was to bring attention to these traditional elements in a new way, so I painted all the casings and trimmings black and the walls a pale gray. Very often, a luxurious home by today's standards has a neutral color palette of cream, ivory, and beige, mixed with rich walnut browns. For me, the palette is gray—the most stunning neutral, in my opinion—and a glossy black.

Because this is a corner apartment with big rectangular windows, it has a very linear feel. I wanted to counterbalance that with something sexy, so I added a pair of round-back modernist chairs (opposite and page 52) done in a silver raw silk.

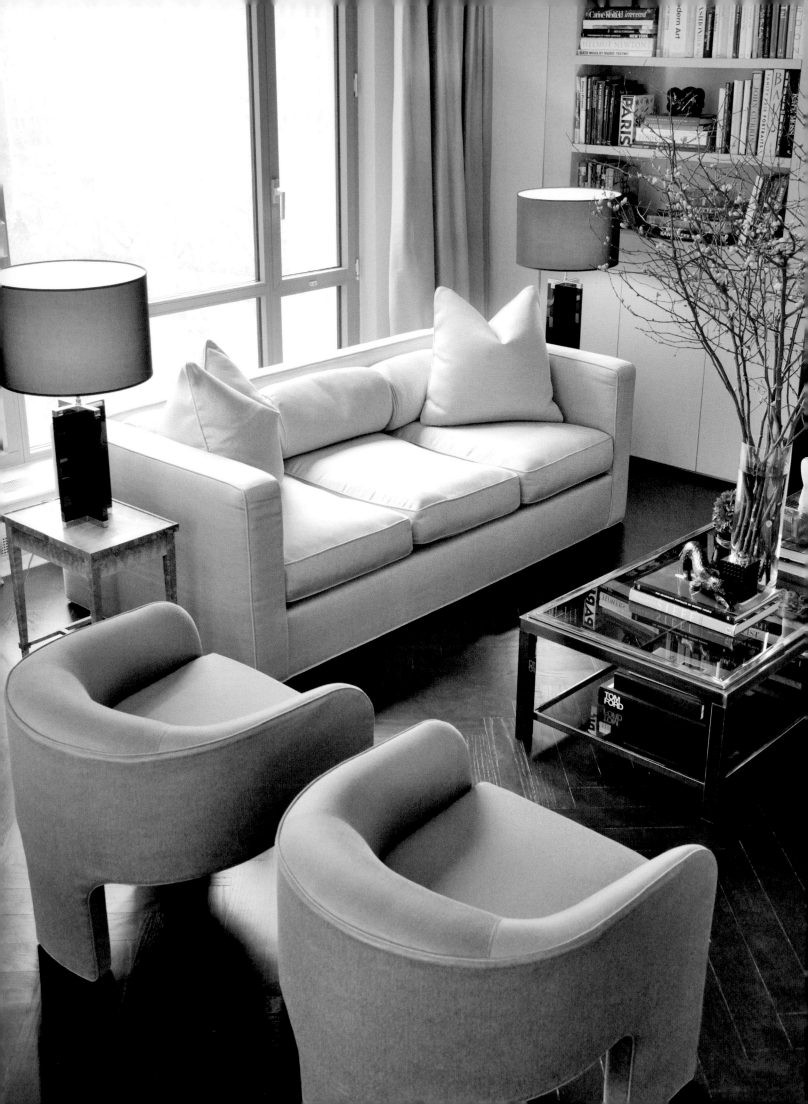

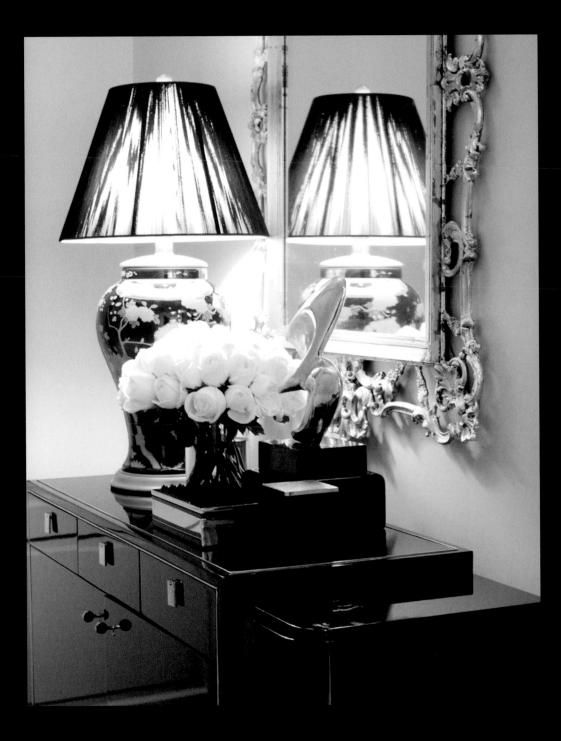

I HAVE ALWAYS HAD A CERTAIN FONDNESS FOR DECADENCE.

These days the term *flashy* has negative connotations, but back then it suggested glamour and was associated with Halston and Bianca Jagger. The decade was all about sex and sheen, and interior design reflected that. There's just something about the work of Karl Springer and Milo Baughman (who, in the 1970s, designed the dining-room chairs pictured on pages 56–57) that's clubby in the right way—the low height and sharp lines, the mix of metals and exotic materials.

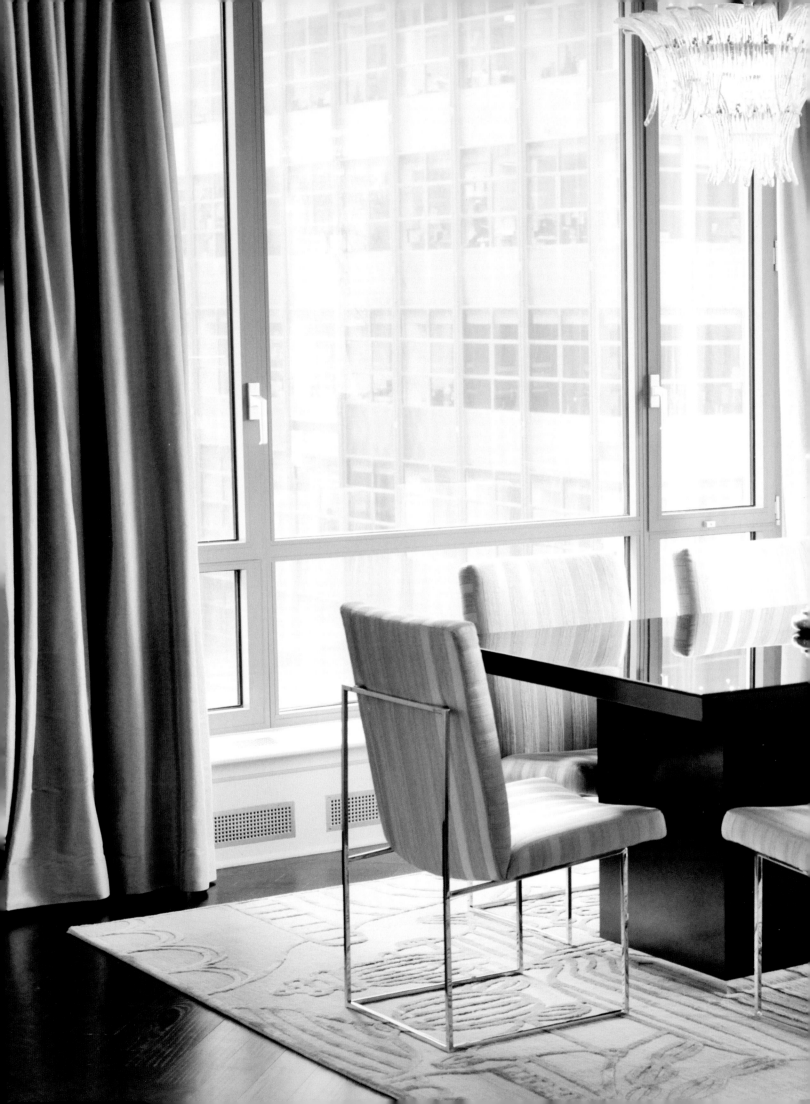

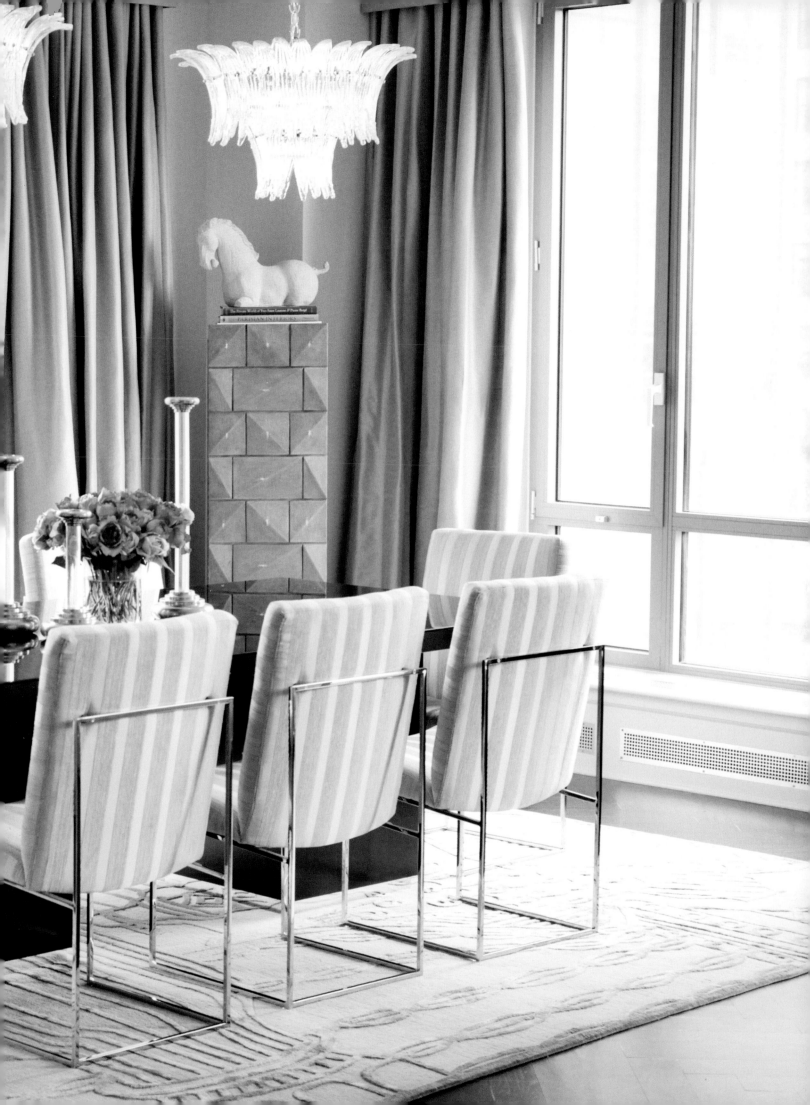

A white marble counter and polished nickel-and-glass cabinets add glamour and sheen to an otherwise traditional kitchen (opposite). In the bedroom (page 60), the owner of this apartment wanted a canopy, but rather than go for the traditional, somewhat frou-frou approach, I created a cleaner, more modern version, stripping the concept down to four hanging panels and a valance—all in a cool gray cotton viscose. I combined a nickel mirror, white marble lamps, and a crystal vase to create a soft "hers" feel in one side of the space (page 61), and I used a shagreen nightstand with a travertine lamp and lacquered boxes to create a rich and brassy more "his" side of the room (pages 64–65).

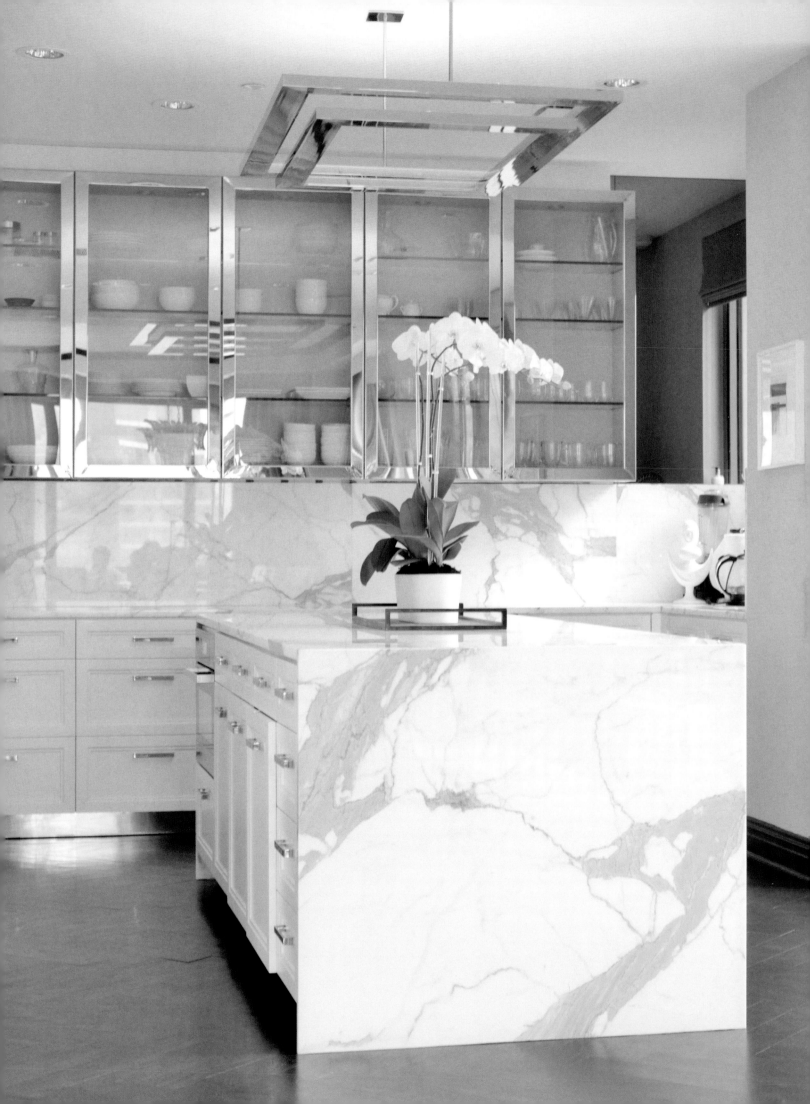

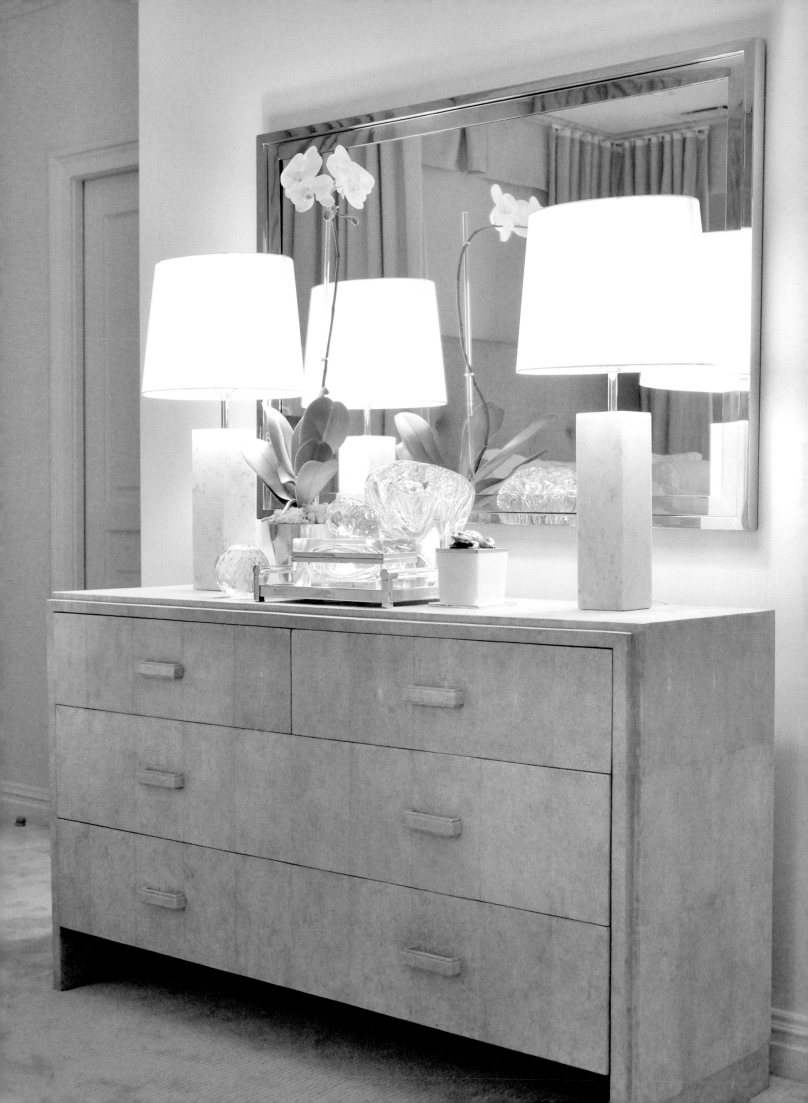

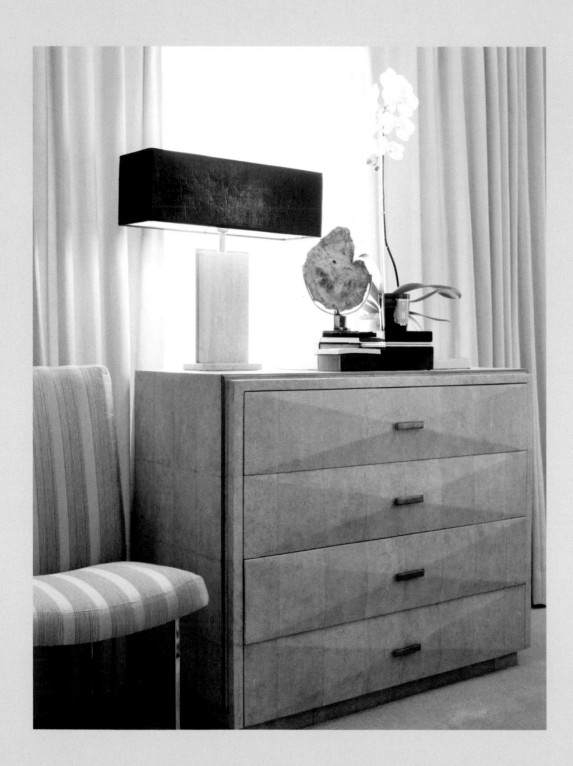

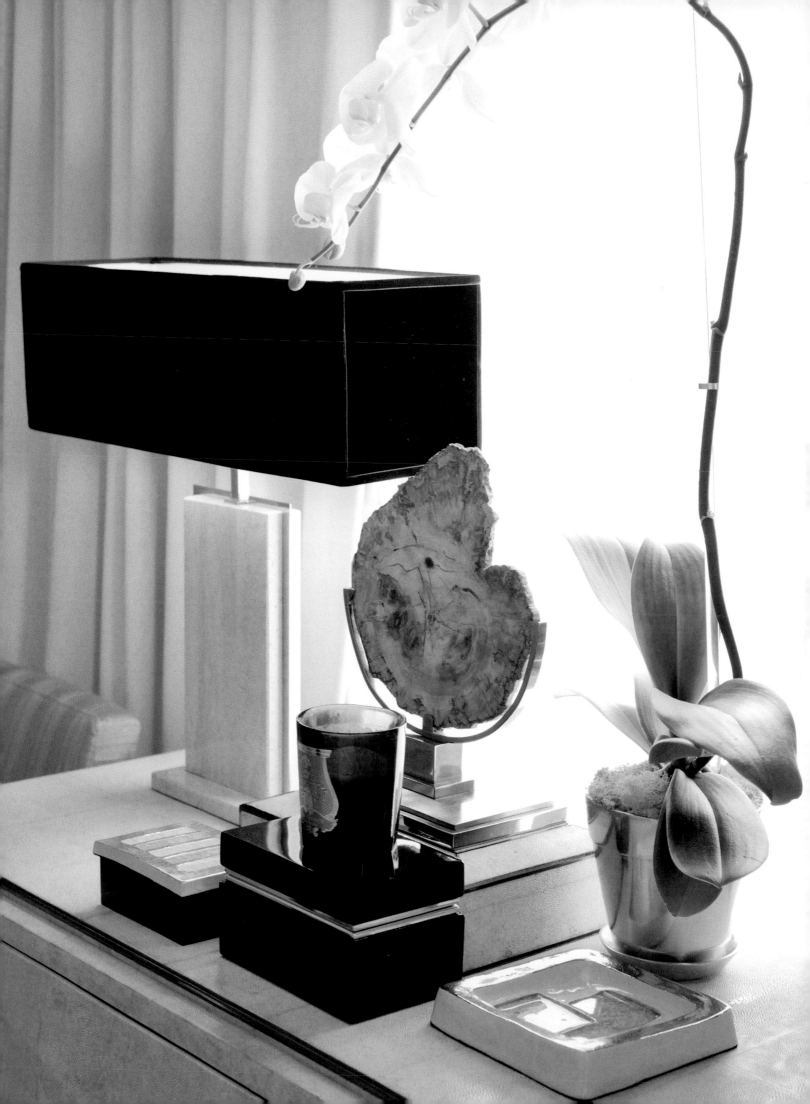

Because a new mother spends so much time in the baby's room,

I WANTED THIS SPACE TO BE PLAYFUL YET SOPHISTICATED.

I chose a gingham wallpaper in pale gray and added a fluted chandelier with lampshades done in the same soft print.

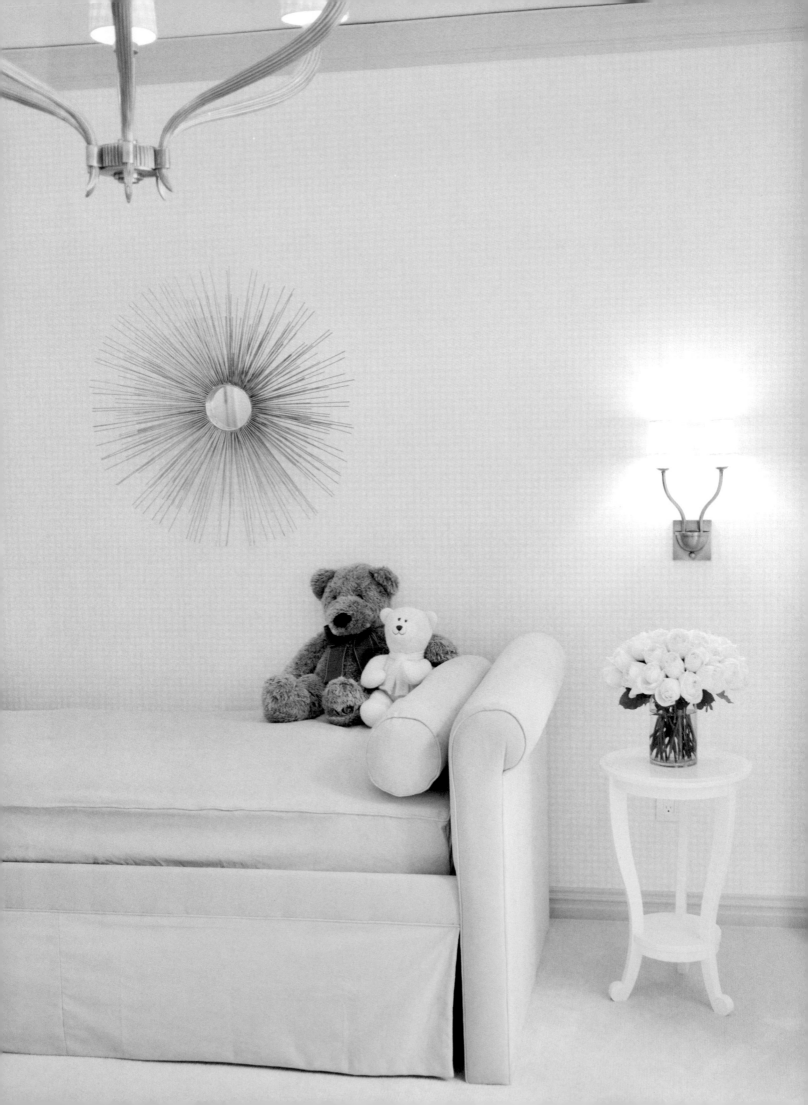

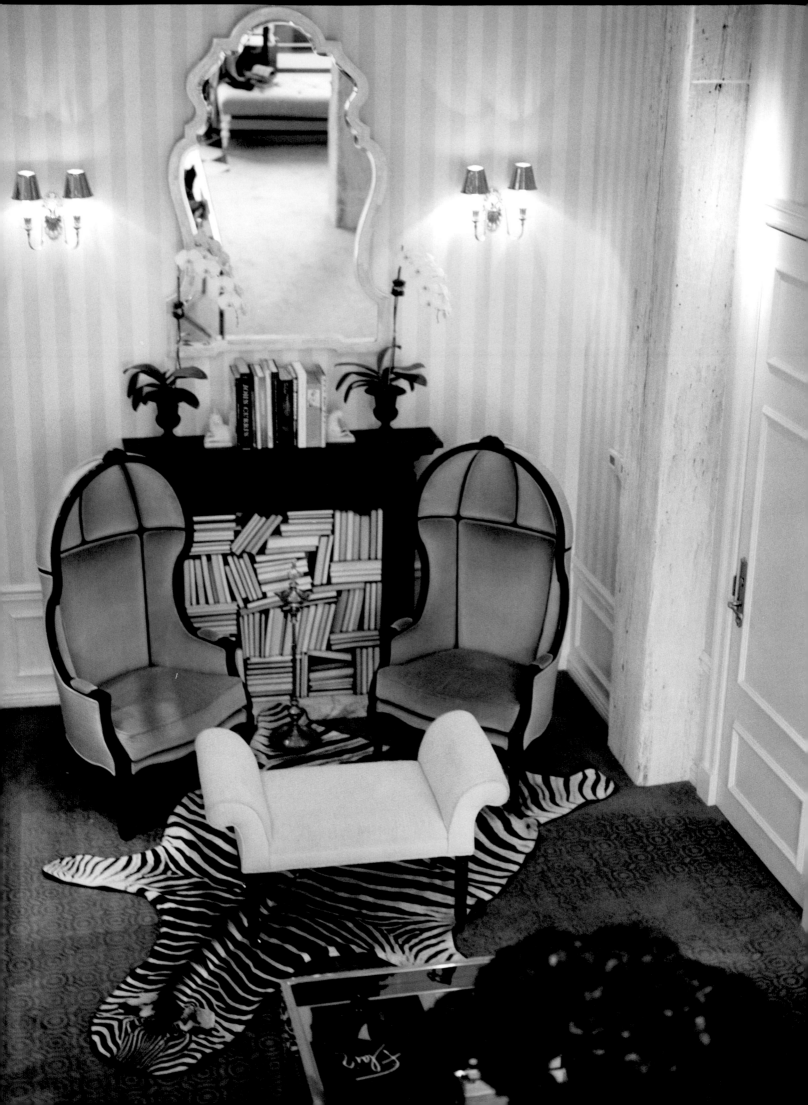

3

BELLES FLEURS

WHEN IT COMES TO COLOR, I'M INSTINCTIVELY DRAWN TO MORE SUBTLE TONES.

Shades of gray and often black have long been the foundation of my palette. I don't easily connect to colors brighter than that. At the beginning of my career, I had a hard time understanding how to use them.

A bouquet of pink peonies arranged in a simple vase on top of a red ottoman changed that. Suddenly, I saw how stunning pink and red were in combination. In fact, it was through using flowers in the spaces I decorated that I started to see which colors play well off one another. Soon enough, dusty pink, lavender, and green began to play into my interiors. My eye started picking up on the mix of colors in all sorts of floral arrangements—from a Balenciaga collection to a Monet painting.

Experimenting with flowers as a way to test color combinations has become my common practice. If I have a desire to use a new color, I order a large bouquet, as opposed to getting a fabric swatch or painting a section of a wall, and live with it for a few days to see if its color has a look and conveys an emotion that I'm after. For the most part, the only colors I consider for more vibrant schemes are natural ones, those found in floral arrangements.

I don't have favorite flowers as much as I favor certain types of arrangements. I veer toward a simple, dramatic statement using a single type of flower. There is nothing more stunning than a heap of white roses with all the leaves intact. Bud vases with a single calla lily are perfect for a small surface, and garden roses tied as a bouquet and arranged in an antique vase add a certain charm to any room.

I prefer fresh flowers, but I'm not opposed to using fake ones. The general thinking is that fake flowers are tacky, but I've been to luxurious European hotels and homes that have

beautiful faux arrangements. A huge bouquet of silk hydrangeas or quince branches can be dramatic and elegant—which often surprises my clients—and they are far more practical than fresh flowers.

When I entertain, flowers are an important part of the ambience, and finding unconventional ways to use them is always my main goal. The frivolousness of over-the-top florals for one evening imbues the space with a sense of elegance and luxury. I like to play with scale, creating large arrangements, especially in small rooms. A tall arrangement draws the eye upward and consequently makes the space seem less confined. In fact, I have always been attracted to an arrangement that is so oversize it needs to stand on the floor rather than on a table. But the ultimate in floral luxury is covering a surface in its entirety (pages 84–85), as if it were made of flowers. Aside from creating an incredible sense of romance, the smell is intoxicating.

<p style="text-align:center">* * *</p>

I strongly believe that scent is the most important aspect of a room's ambience. It's the first thing I notice when I walk in. If a space smells good, I know that someone special is running the joint. When I design a room, I want to create an environment that impacts all the senses, but I always begin with scent, and I always consider two key points: the mood I want to create in the space and what I actually want the room to smell like.

The great thing about a beautifully scented room is that it's easy and inexpensive to achieve. Regardless of how much money you have to decorate, you can always have a candle going, and it immediately elevates the space.

When you choose a fragrance for entertaining, keep in mind the occasion, the crowd, and the vibe of the party. If you're having a spring cocktail party and you want to create a feminine and floral mood, you might light rose candles, so the room smells fresh and romantic. If you are entertaining at night and want the mood to be seductive, you could go with an amber candle, which smells warm and rich. If you want something clean, maybe for the bathroom, you might go with a lily or fig candle, or something grassy.

Diptyque has great basic scents, such as Roses, which is always burning in my home. Otherwise, I love By Kilian candles, created by the French perfumer Kilian Hennessy. I worked with Kilian to produce my own candle. Creating the fragrance took a lot of experimenting, but I knew I wanted the scent to be rich yet feminine. I wanted amber and rose, both of which sprang from childhood memories. Together, they smell wonderful, and they represent the two sides of me: dark and romantic. I'm not the clean type. When I walk into a space, I want to smell something sexy.

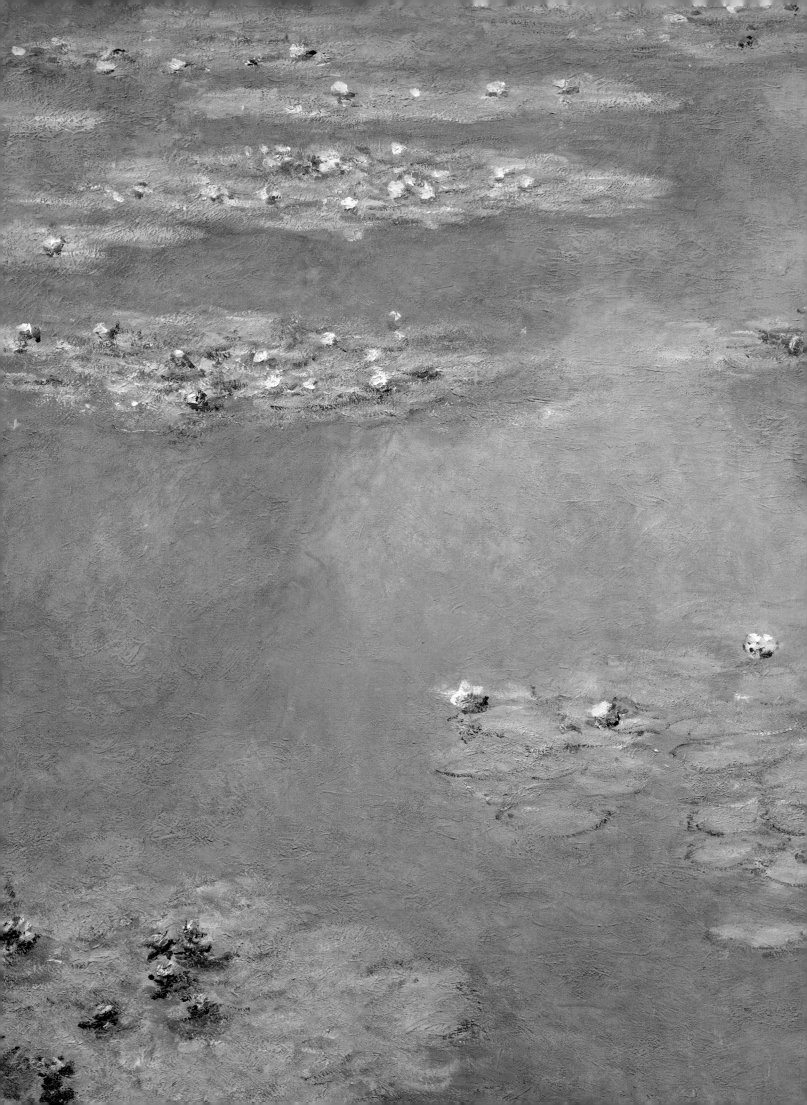

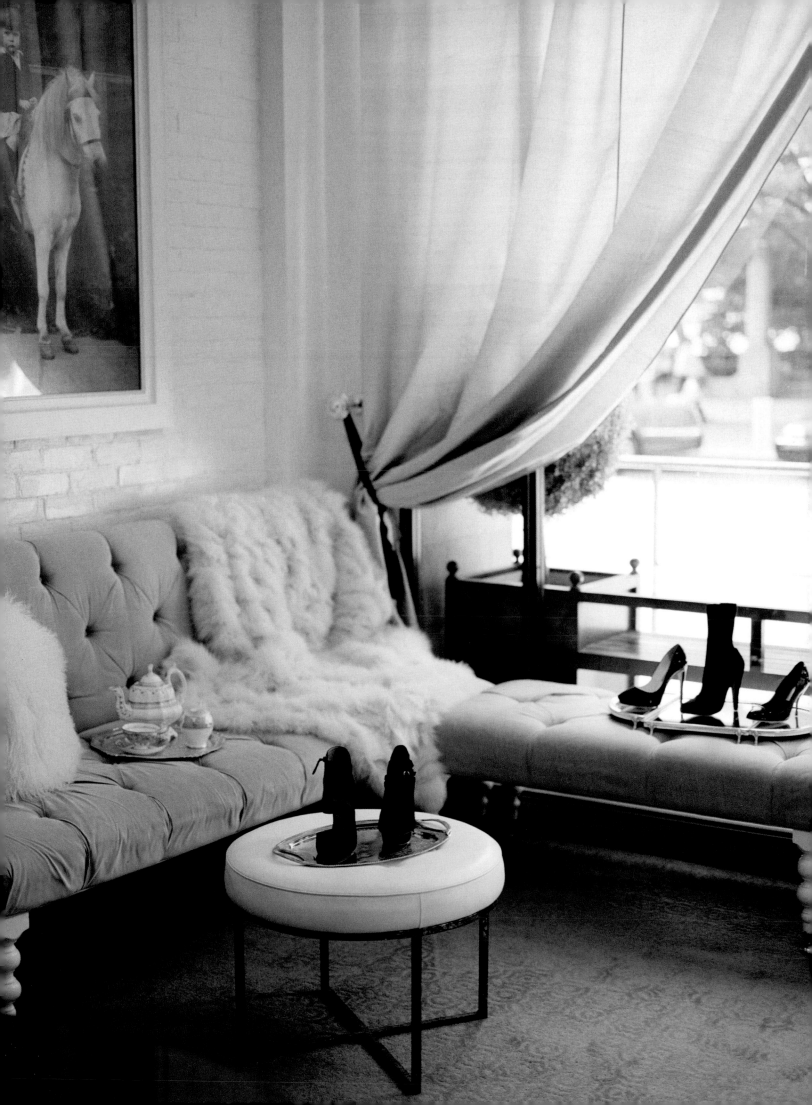

THE PALETTE FOR MY BOUTIQUE

E

don Manor was inspired by the wash of colors in Monet's painting *Water Lilies* (page 72). I used the seafoam green of the water lilies for the hooded chairs and curtains and the lavender of the water for the rug and tufted ottoman, and I echoed the pops of pink flowers with hydrangea bouquets (pages 68, 75).

Sheila Metzner's photograph *Joko, Passion* (pages 76–77) was also an inspiration. The image epitomizes the glamorous marriage of fashion and interiors. Adding dimension to that glamour was the aim for the shop.

PAGE 72:
Claude Monet,
Water Lilies (detail)
1907

PAGES 76–77:
Sheila Metzner
Joko, Passion
1987

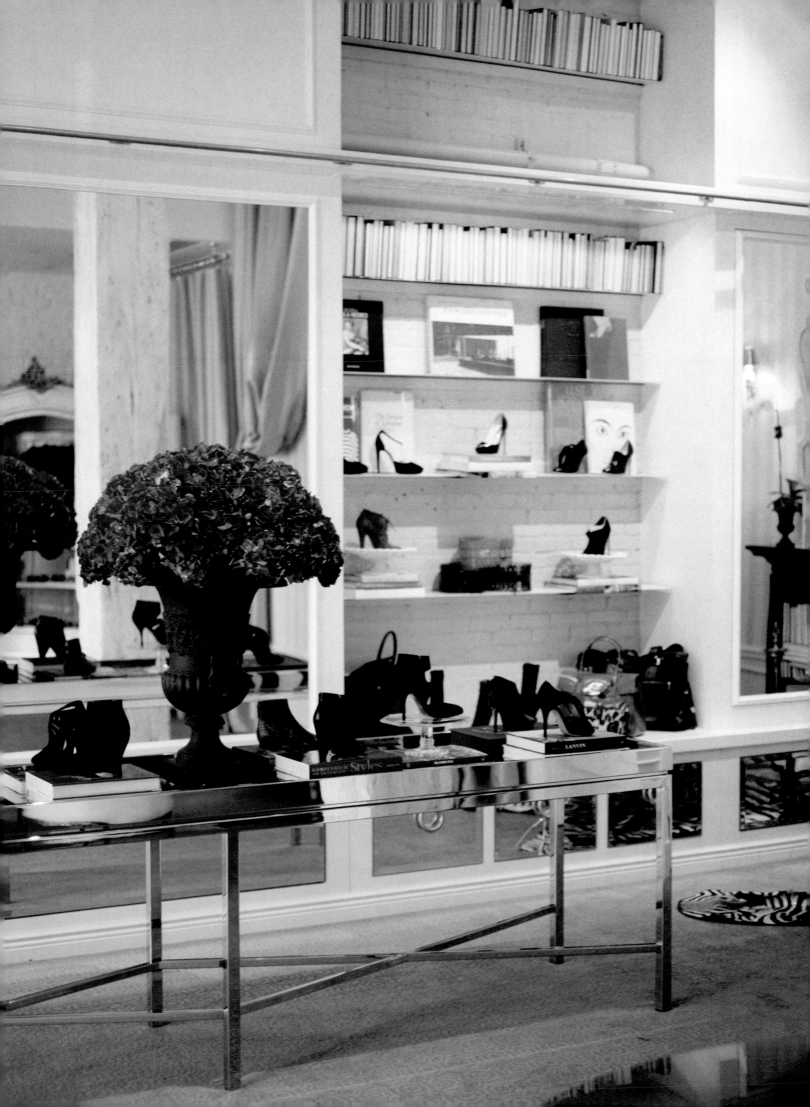

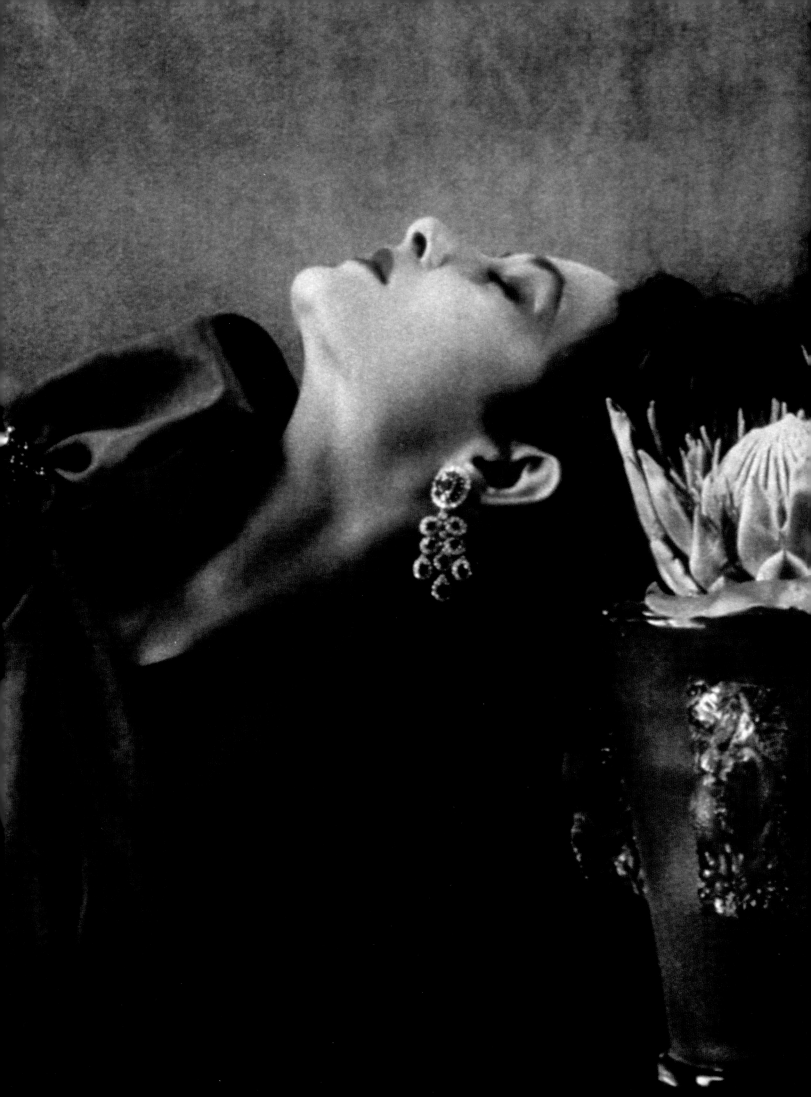

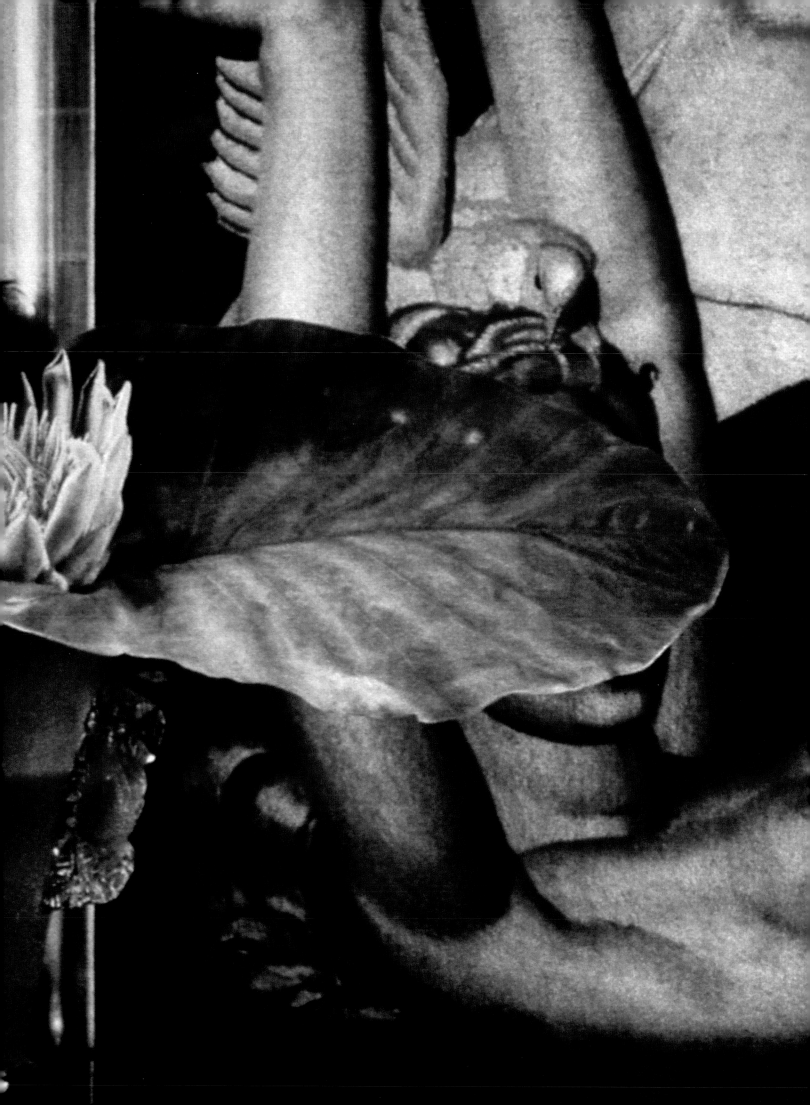

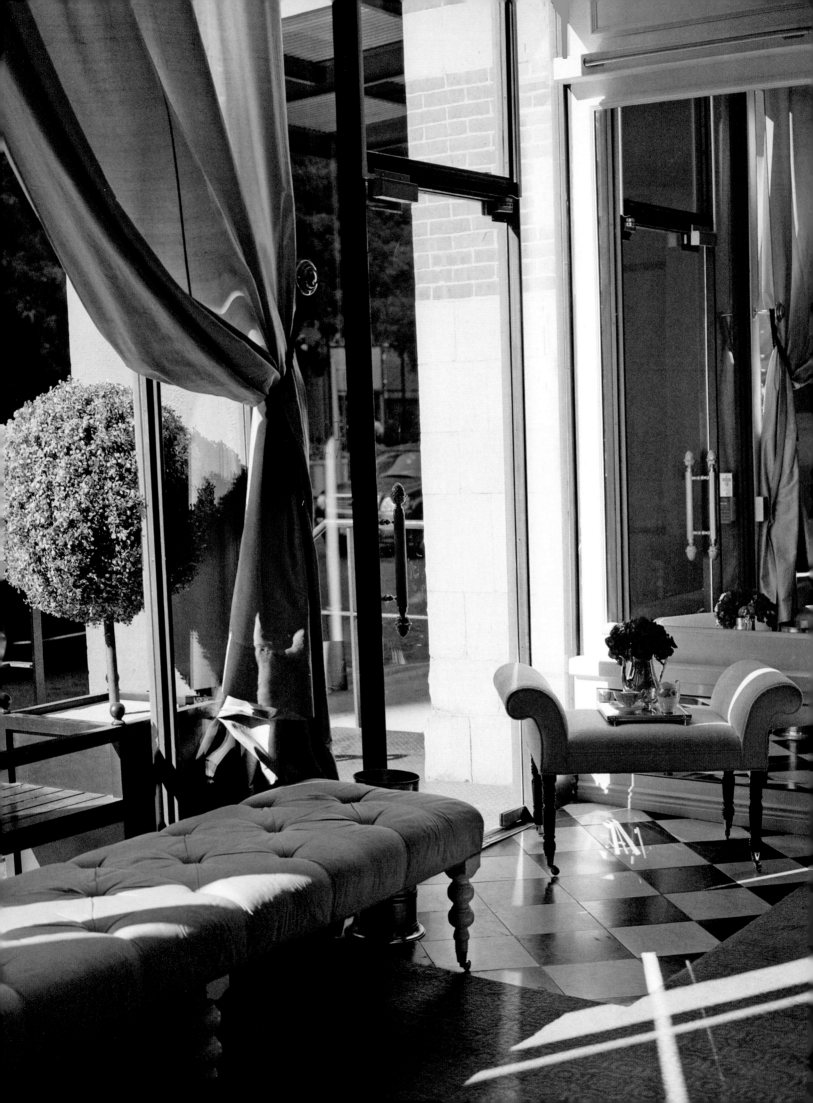

g reenery—particularly garden hedges and mazes—adds a lush and organic architectural element to an area. One of my favorite landscapes appears in *Last Year at Marienbad* (pages 80–81)— a manicured lawn with geometric shrubbery that is as austere and elegant as the film itself. On a smaller scale, box hedges and topiaries create the same effect.

For interiors, I'm drawn to spaces that play with the notion of the outside coming in, such as conservatories or glassed-in rooms that get tons of light and can support a lot of plants. I love putting tall olive or lemon trees inside a spacious, light-filled kitchen or, in this case (opposite), a large topiary just outside the window.

PAGES 80–81:
Film still from
Last Year at Marienbad,
1961

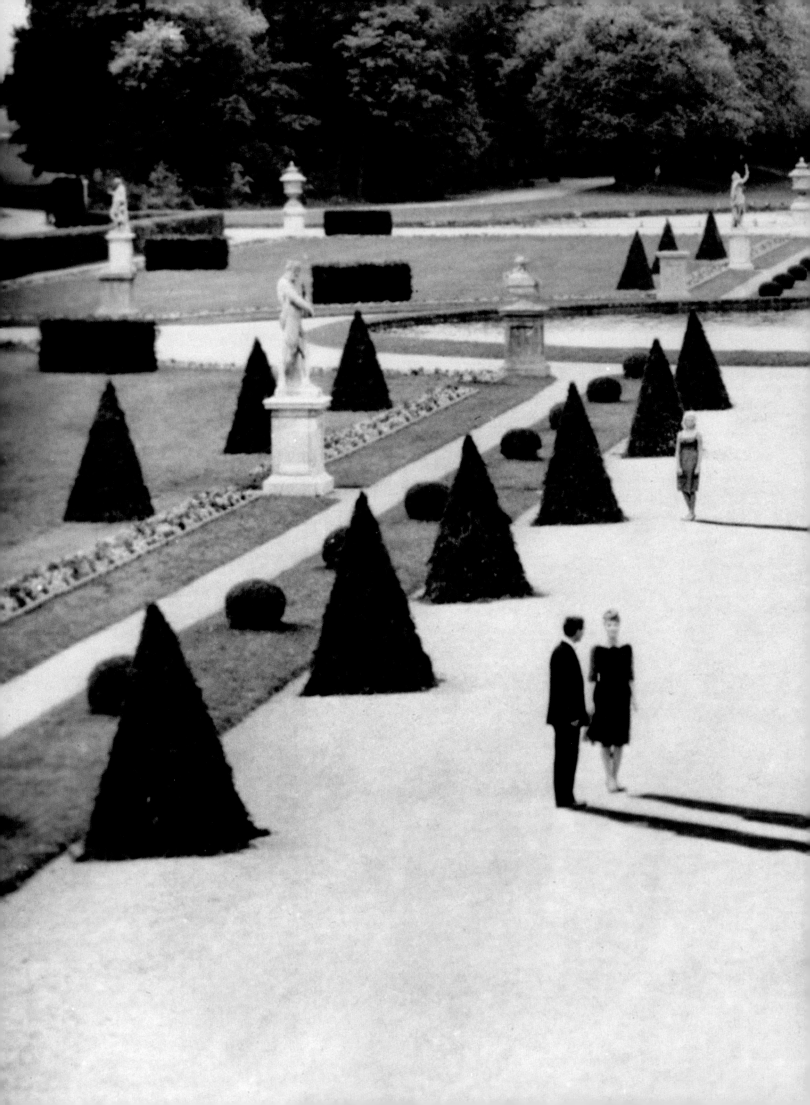

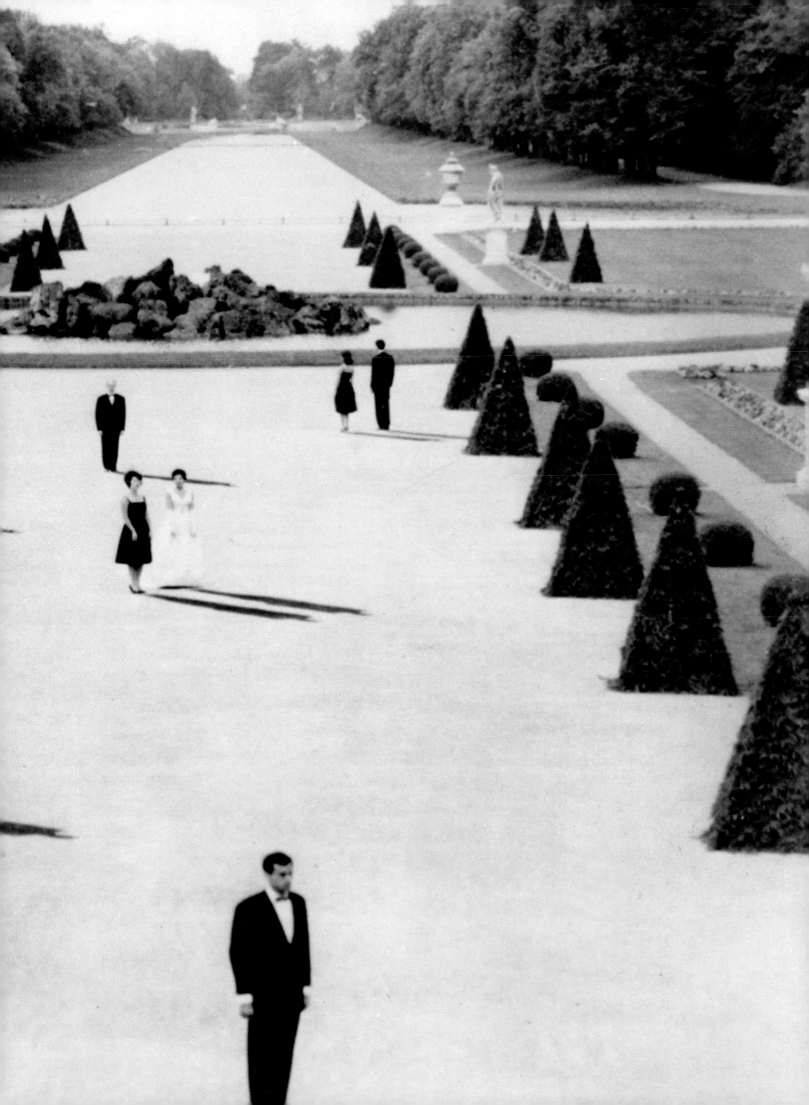

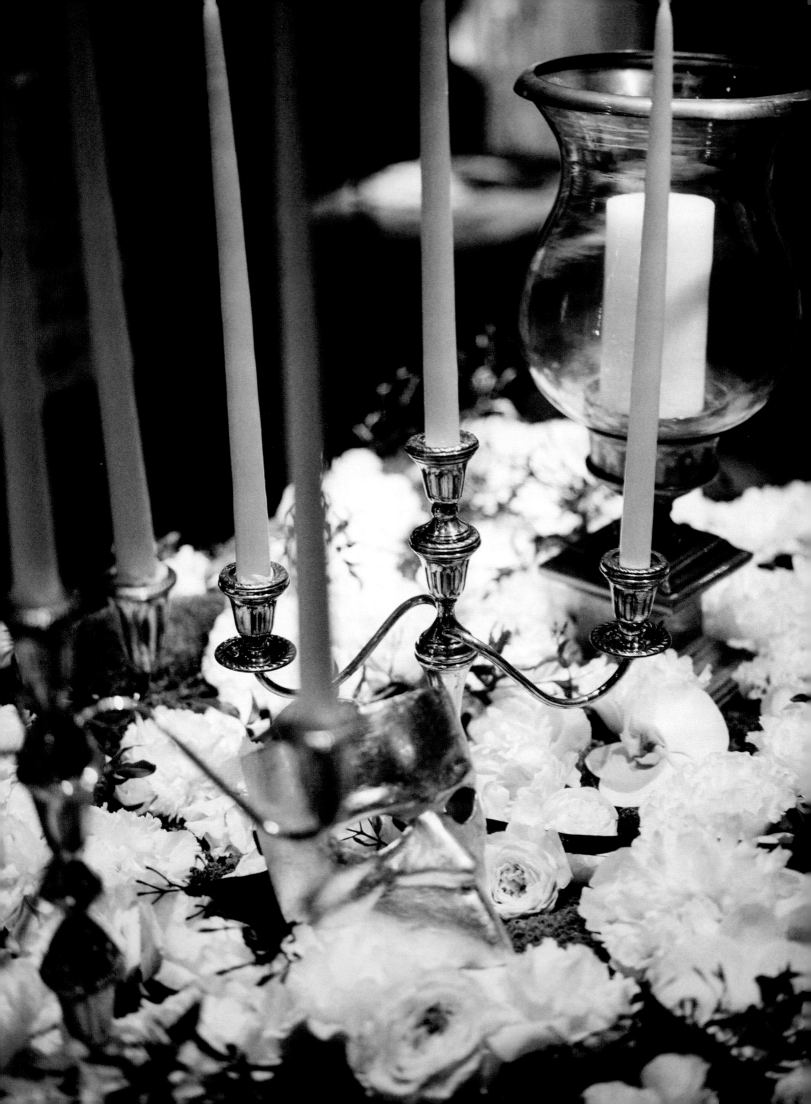

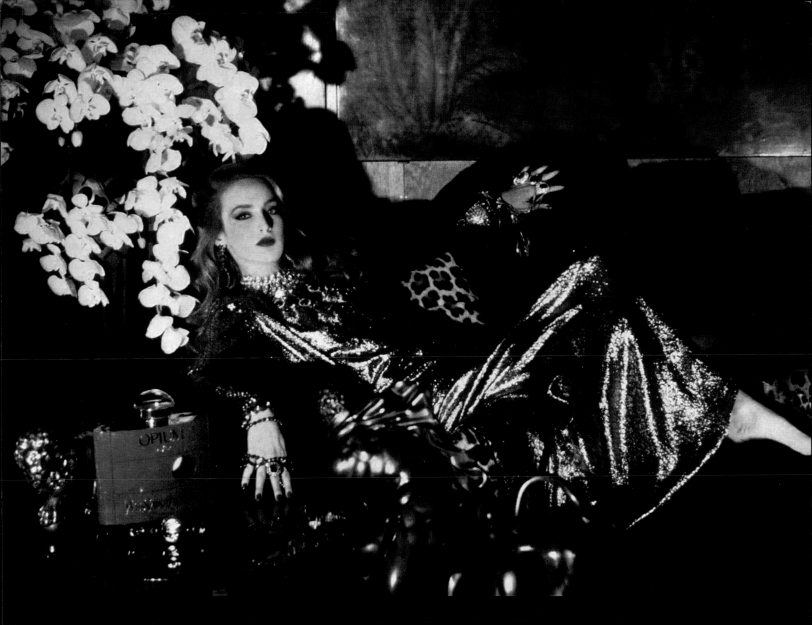

OPIUM.

Pour celles qui s'adonnent à Yves Saint Laurent.

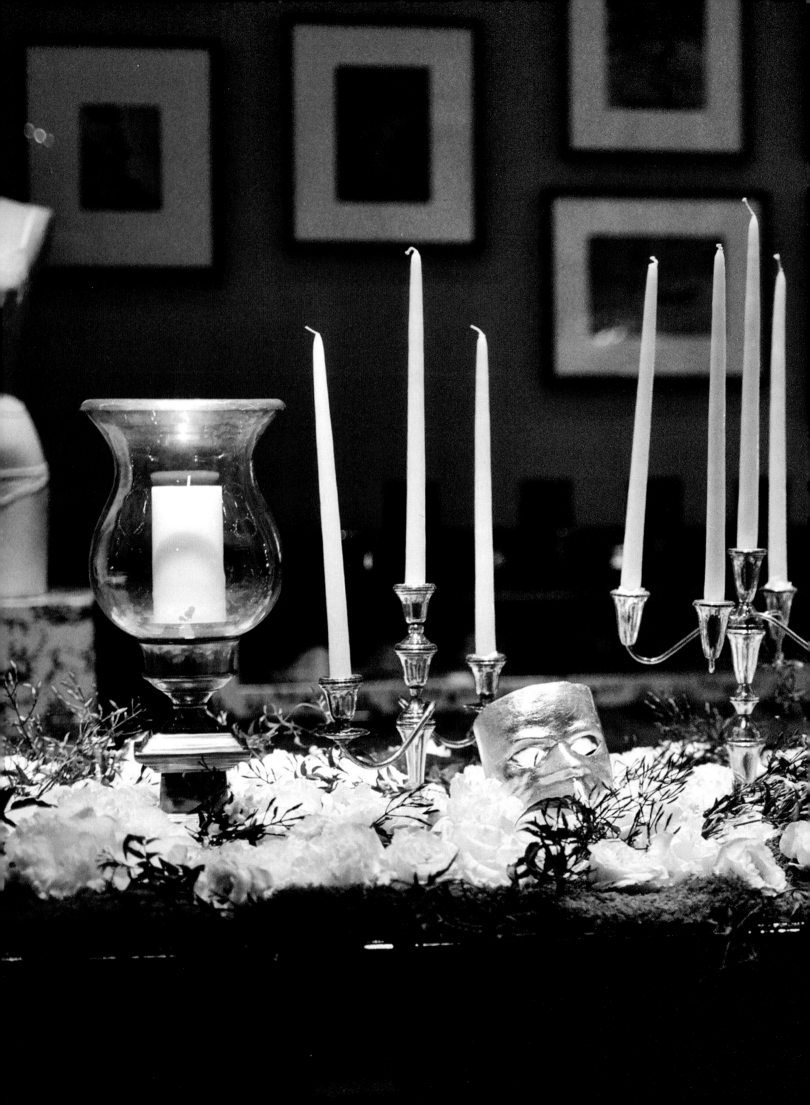

"THE PERFUME WAS A BRILLIANT EVOCATION OF THE LATE 1970S IN PARIS: OPULENT, HEADY, WITH A STRIDENT ARTIFICE THAT YOU COULD LITERALLY TASTE IN YOUR MOUTH.

Then came the advertising image, which was as highly charged and controversial as the name of the scent. Helmut Newton shot the photograph in the musky and mirrored Buddha room of Yves' apartment on the rue de Babylone, while Yves stood around and arranged model Jerry Hall's bangles. In a rapture of lamé and white orchids tumbling from a bronze urn, Jerry sat, back towards the onlooker, face turned with a look of wanton seduction. The image was one of darkness and iridescence, Jerry smoldering on command, her mass of curls hair-sprayed into a river of static, while before her on the low table and in the foreground of the picture was an oversized bottle of Opium."

—Alicia Drake, *The Beautiful Fall*, 2006

The Opium advertisement on page 83 reveals the potential power of scent—naughty, even dangerous. It pushed boundaries of acceptability at the time but was glamorous all the same. I'm drawn to the whole mood of this image—not to mention the black-and-gold color palette and the spill of white orchids. I aimed to re-create its seductive quality in this interior (opposite), with a brass-and-lacquered console table, bouquet of white roses, and albino peacock taxidermy.

PAGE 83: Yves Saint Laurent, Opium advertisement, photographed by Helmut Newton, 1978, featuring Jerry Hall

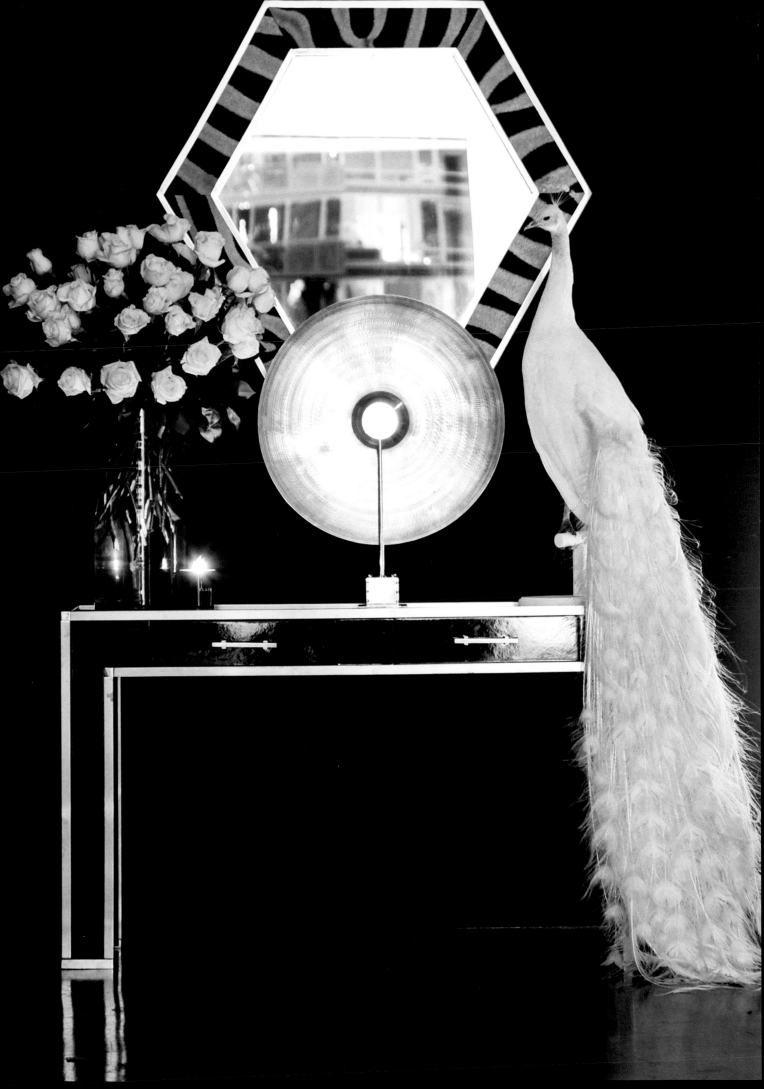

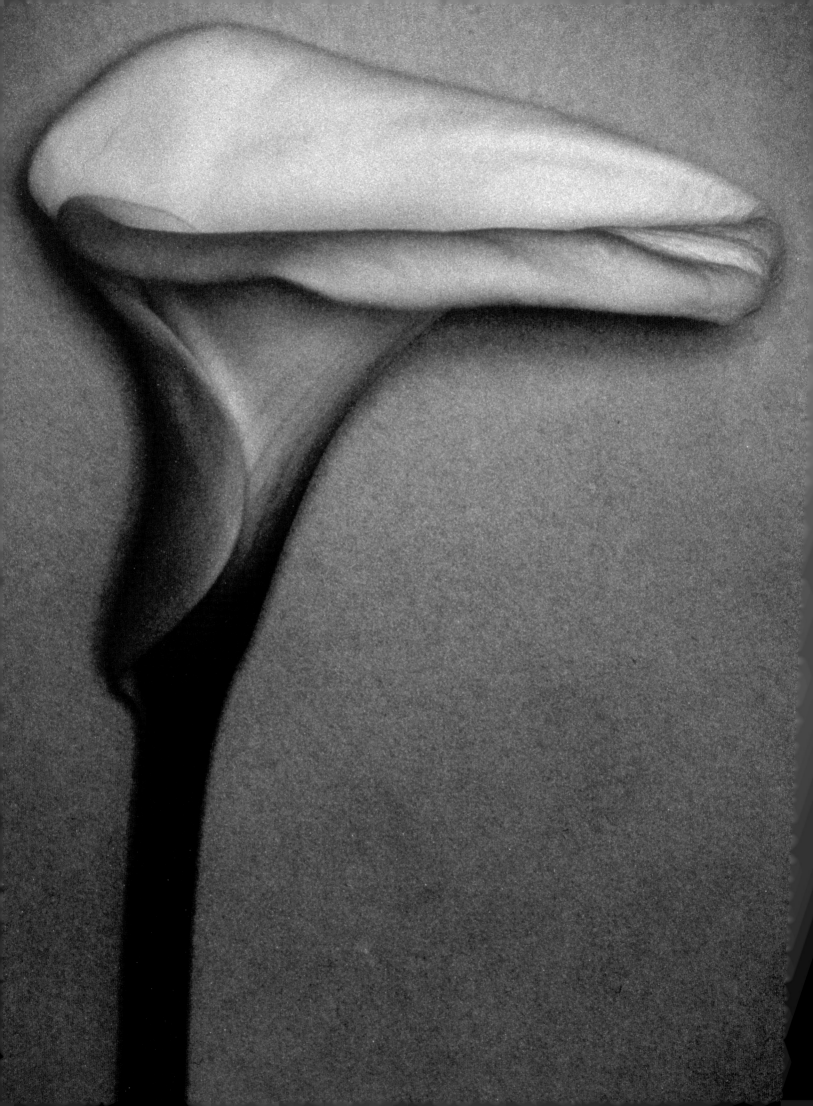

THIS SHEILA METZNER PHOTOGRAPH IS VERY CLEAN AND MINIMALISTIC,

but the sepia tone evokes a sense of romance and nostalgia. I took the same approach with the showroom on the following pages to combine a look that is contemporary yet suggests a certain softness.

The idea for the showroom was to marry a European sensibility with a bit of California cool. To that end, I mixed modern French doors with traditional marble flooring and hand-painted murals with a Lucite coffee table. The glass walls that enclose the seating area are softly draped in silk.

In a city apartment, fireplaces are often just ornamental, but that doesn't mean they should be ignored. I try to find clever ways to fill them. At Edon Manor, I stacked books inside. For this showroom, I used orchids; instead of flames, the fireplace is bursting with white flowers (pages 95–97).

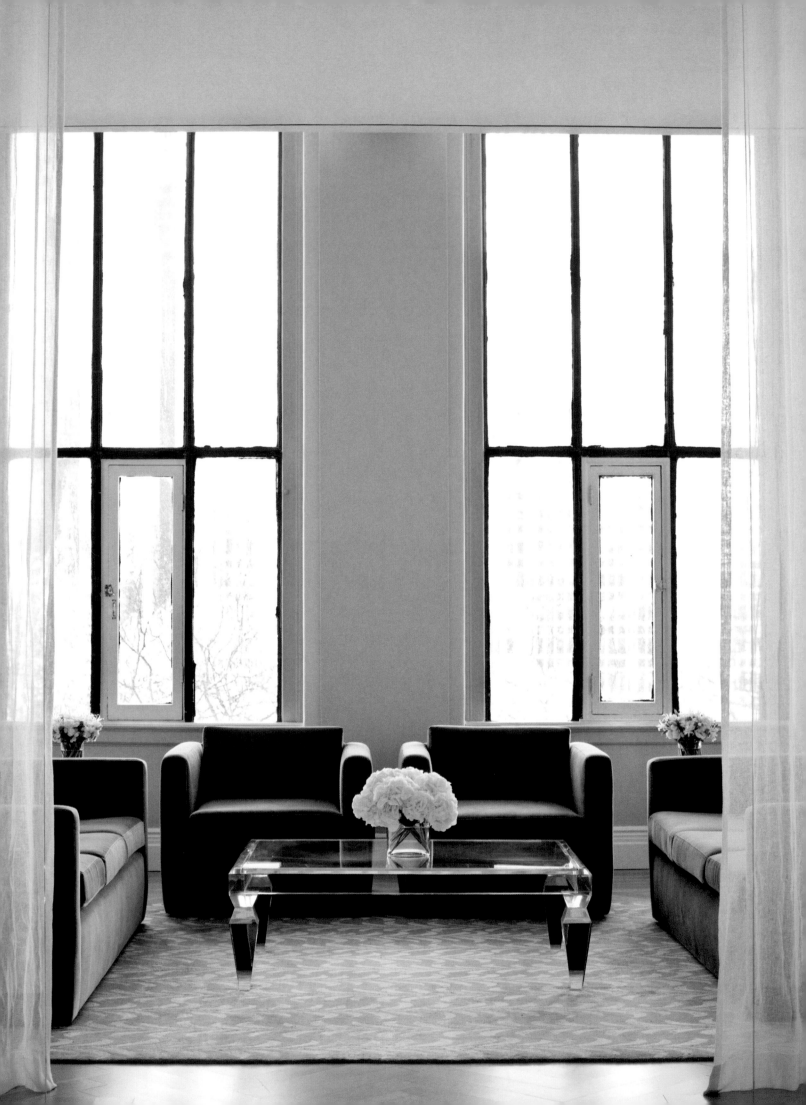

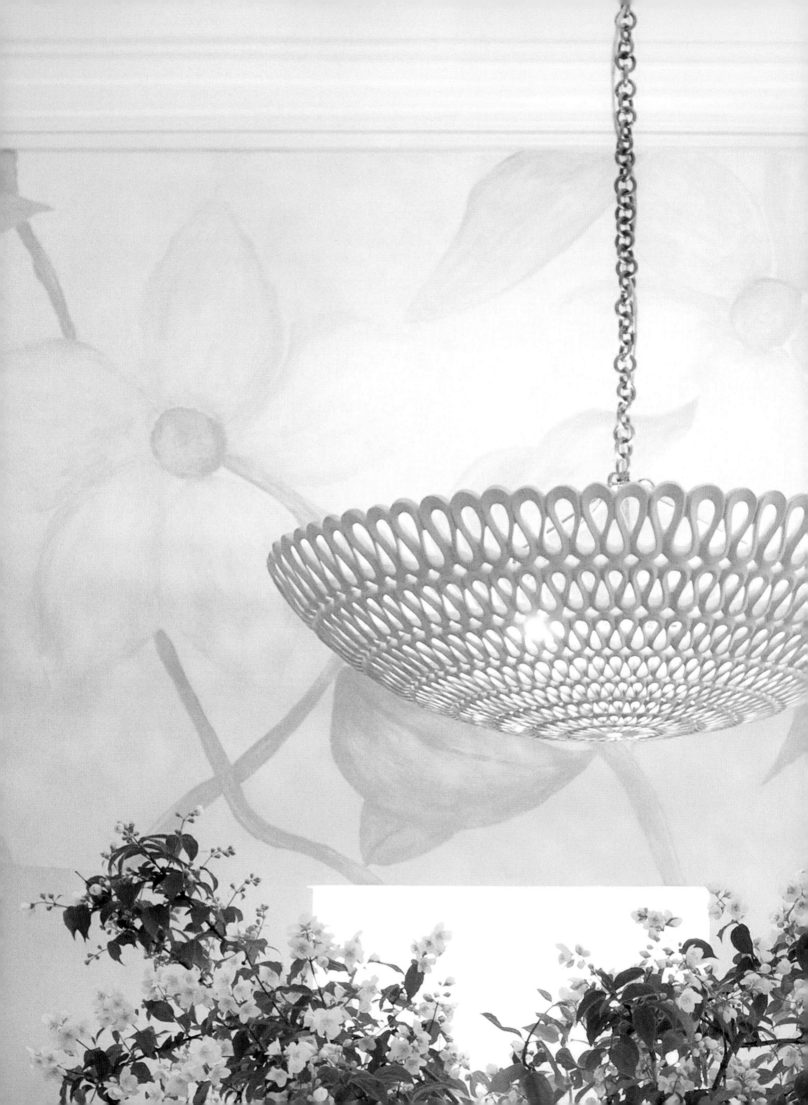

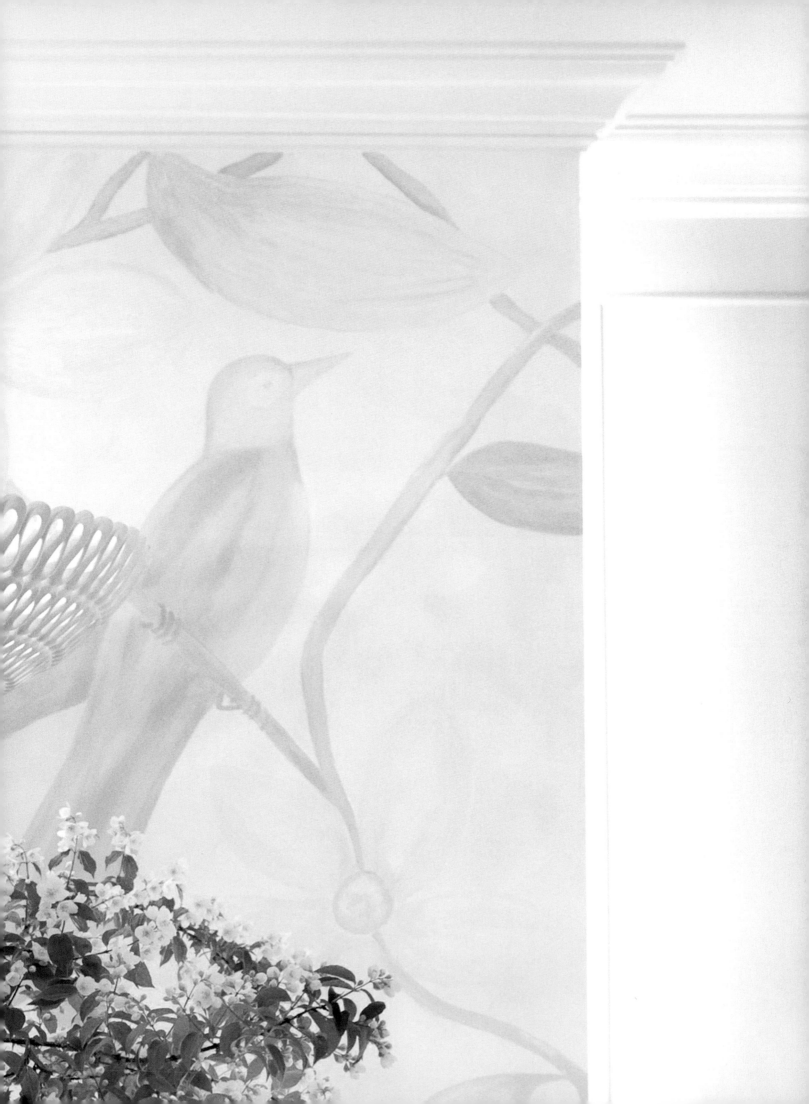

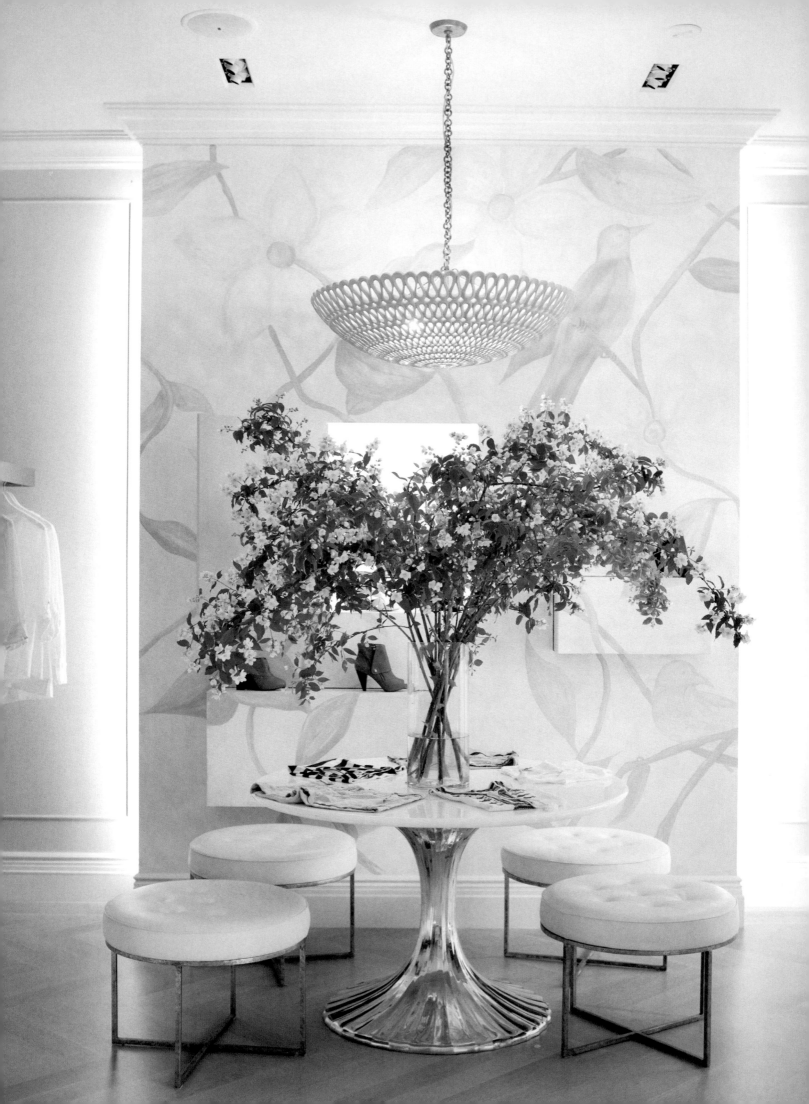

THE SHEER HEIGHT OF BRANCHES IN AN ARRANGEMENT—

whether cherry blossoms, dogwood, or quince—brings an inherent sense of drama to a space.

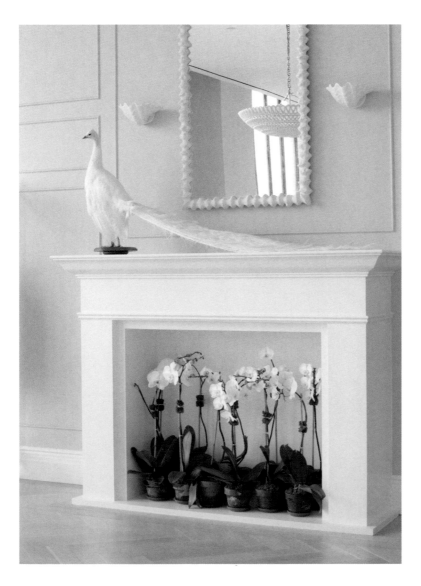

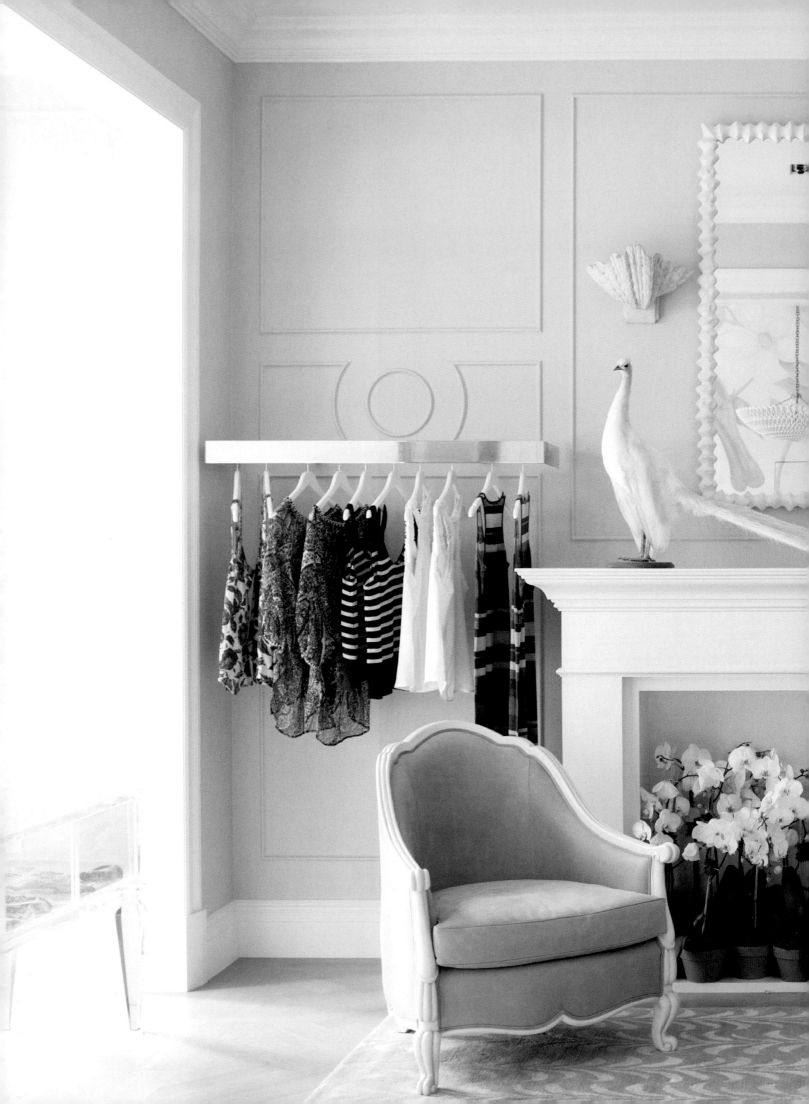

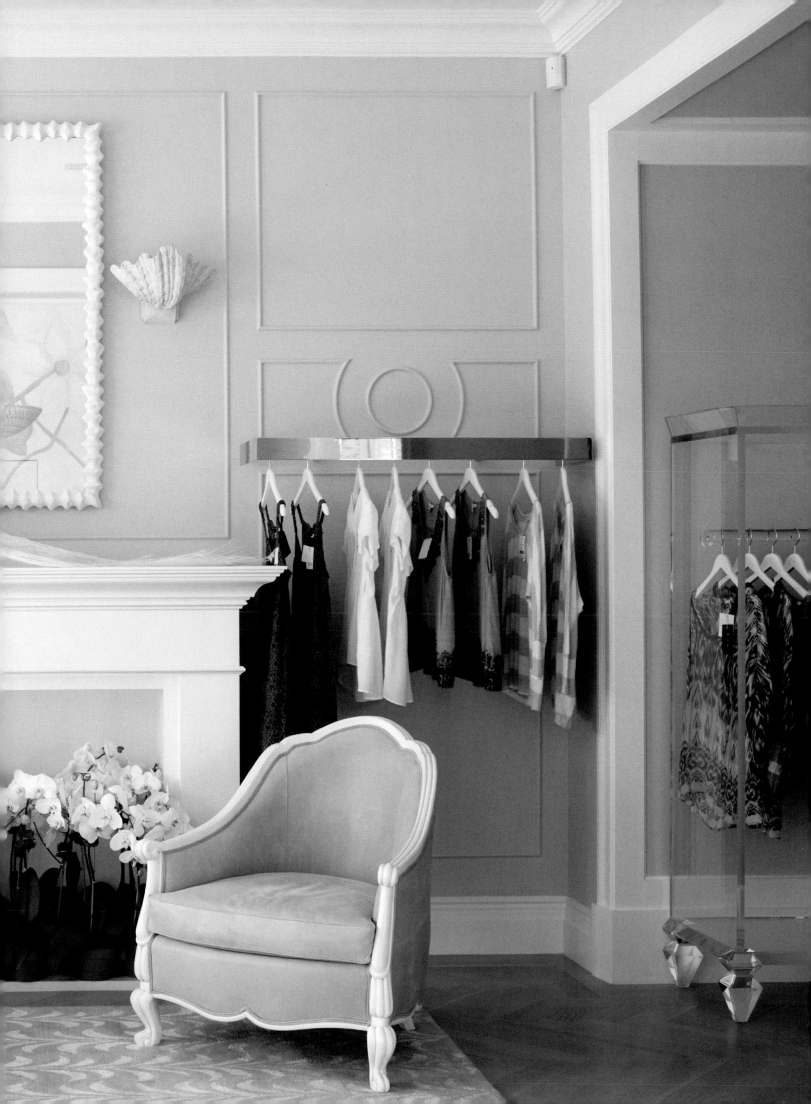

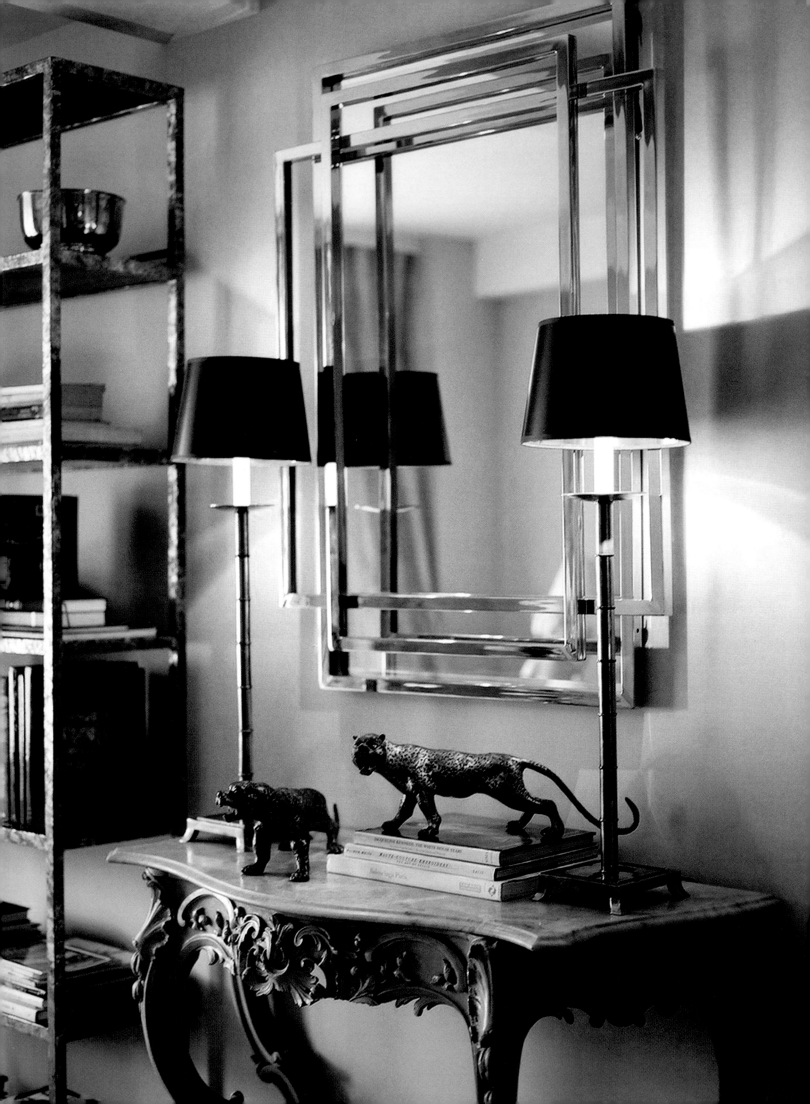

THE SUITE LIFE

A HOTEL IS THE ULTIMATE IN A "LIVING" ENVIRONMENT,

as it's a space that needs constant care. A hotel must always smell good, look good, and feel good. Yes, there's the beautiful décor, but then there are also the flowers, the scent, the bedding, and the restaurant. When you walk through the doors of a world-class hotel, you're transported to a different place. There's a lot of fantasy in that.

My fascination with hotels began during my college days in New York City. Back then, I was always trying to find a place to kill an hour between classes or to meet with a friend, and, as odd as it may seem, I would often do that at a hotel. Now, as a professional, I do the same thing—hotel bars and cafés are great places to pass time between appointments or to schedule a meeting. Lunch, tea, dinner, drinks—there's something there for everyone, and the environment is always comfortable and inviting.

The Carlyle in New York is one of my favorite hotels. It's a very sexy hotel, full of shine and swagger. It has a lot of art deco references that I find inspiring, like the lobby, which has graphic marble floors and bright orange sofas. I love the exterior, too—especially the black-and-gold awning. When I was growing up, my father owned a hair salon called Papillon that had a black awning with the name of the shop spelled out in fancy gold lettering. He always said that nothing looked better than black and gold together. I agree: that's part of the reason that the Carlyle has always remained memorable. Black and gold is a color combination that is both versatile and universal—depending on the context, it can feel regal or sexy, classic or flashy, and I often use it my interiors. The Dorchester in London is another favorite hotel of mine, perhaps because it's just so decadent. The flower arrangements there are outrageous: twelve feet high, six feet wide, and fresh all the time! But the best thing about the hotel is the proper and very popular English high tea served every afternoon in the Promenade room. The George V in Paris is another fantastic hotel. It has a very grand lobby, decorated with marble

columns and mosaic floors, and the most stunning inner courtyard filled with cast-iron furniture, crisp white linens, and orchids suspended from the ceiling.

Whether from sitting in a courtyard, bar, or restaurant; walking through the lobby; or staying in a suite in these legendary hotels, I've picked up a lot about interior design and elegant living, down to the smallest details. Great hotels have inspired me to incorporate a sense of natural abundance and gentility into the spaces I design so that there's a feeling of comfort and extravagance. Hotels have to get the design of their rooms just right in order to make small spaces alluring to guests, which is why a well-designed hotel room can be a good model for people who live in small spaces.

When it comes to interior design, most people, designers and urban dwellers alike, are obsessed with size: a bigger space is a better space. But luxury hotels have taught me that it doesn't matter if you have only four hundred square feet. Their design mentality is: What can we do in this small space to make it look so spectacular that people want to stay—and return? It's a unique way of thinking and a great way to learn how to create an effective floor plan that can fit a bed, dresser, desk, and sitting area when space is at a premium.

So here's my confession. After I graduated from college and got my first design job, I was confident that I had good taste, but I wasn't really sure what I was doing as far as design principles went. I looked to hotels. I went to the websites of some of my favorite luxury hotels for inspiration and got more than what I had hoped for in most cases—actual floor plans. From those plans, I picked up some invaluable tricks that I still use today. Here are a few: putting the short end of a desk against the wall allows it to double as a dining table; placing a love seat at the foot of the bed is a nice way to separate a sitting area from a sleeping area; and arranging upholstered love seats, instead of dining chairs, around a table is an effective way to bring dining and sitting areas together.

Hotel rooms also demonstrate how to create height—and thus the illusion of spaciousness—in a small area. It's somewhat like the theory behind dressing a petite woman so she appears taller: create a long silhouette from head to toe with monochromatic color and an uninterrupted line—and a high heel. Hotels often use long drapes to create that same feeling of height in a small room, going as close to the ceiling as possible with the drapery. By doing this and setting the furniture low to the floor, you can optically stretch out a room. Every luxury hotel I've been to—whether it was ornate like the George V or sleek and minimalist like the Mandarin Oriental—has done something with the window treatments to enlarge the space and impart a sense of grandeur, drama, and allure. These same principles can easily add a little majesty to your small space, too.

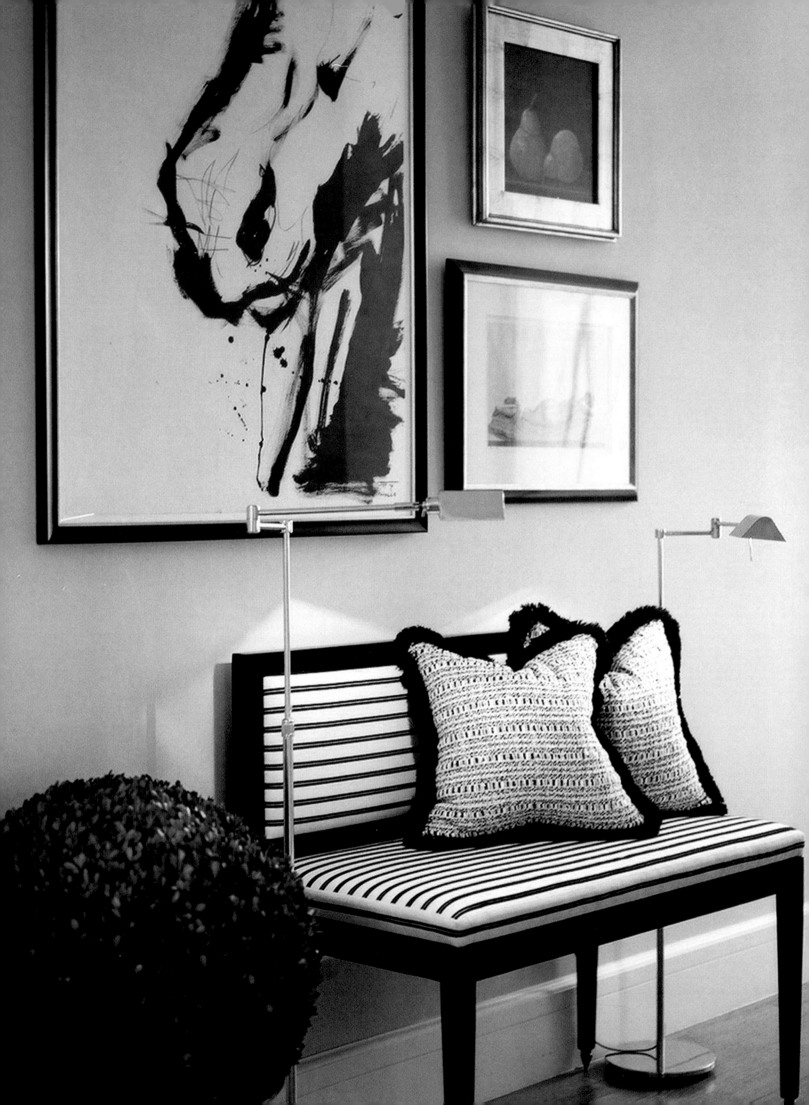

n these pages is a two-bedroom apartment I designed in a building on New York's Upper West Side that was a hotel in the 1970s. My goal was to create a space that didn't necessarily feel like home so much as a sanctuary that transported my client out of her busy life to a place of luxury and respite. I wanted to bring into the design some of the romance and extravagance of a grand hotel but on a more casual scale that was in sync with the architecture and proportions of the space. Elegant hotels never leave any space—no matter how little or seemingly unimportant—undecorated. Whether it's a hallway, a powder room, or a seating area, it's always done. Paying attention to the small details goes far toward making a place special. I wanted to do the same in this entryway (opposite), to create a strong, formal space to offset the femininity of the rest of the apartment.

Because imparting a feeling of comfort was so important in this apartment, I wanted everything touched, sat in, or stepped on to have a warm, cozy feel. In the living room (pages 104–105), I used tactile fabrics throughout: a silk rug, a silk velvet couch, low bucket chairs upholstered in bouclé, and silk drapes with tiebacks. On one side of the room I added a high side table, topped with a pair of busts and an art deco lamp; on the other, a marble console with traditional library lamps and leopard figurines (page 98). Both are purely decorative areas that add a bit of charm to the room overall.

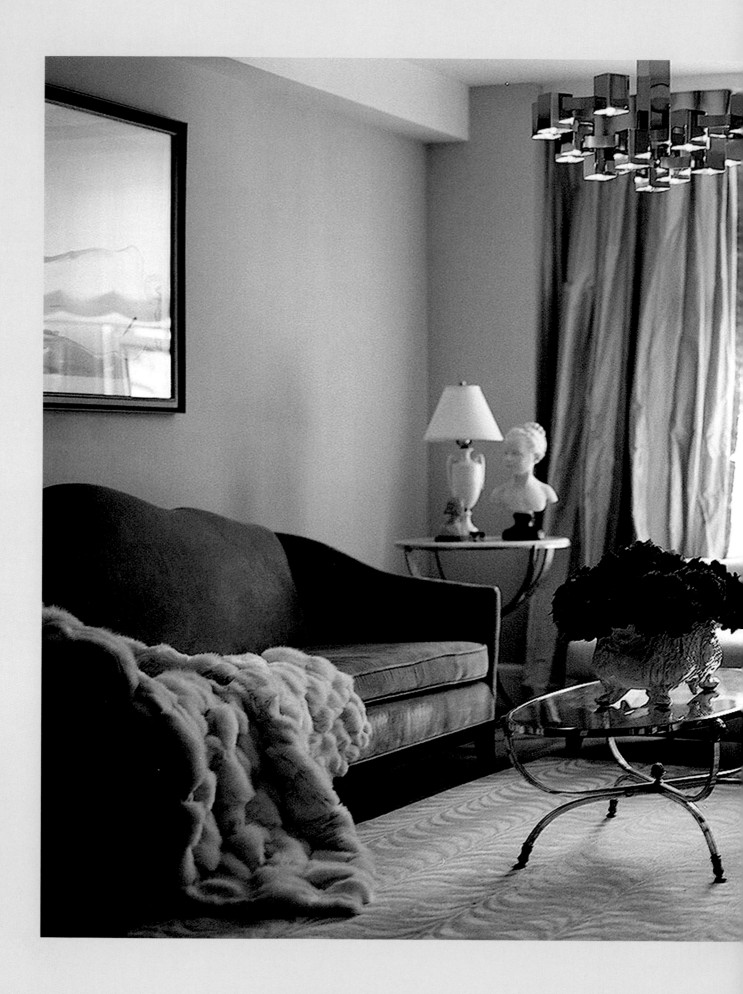

I LOVE THE SOFT COLOR PALETTE AND THE MOVEMENT OF THE SILK

in this romantic Donna Karan advertisement. I wanted the canopy in the master bedroom (pages 108–111) to hang off the frame in the same sculptural way that these clothes hang off the body, so I did it in a gunmetal gray taffeta—with drapes to match. My first stay at the Plaza Athénée lent some inspiration as well. My room was tiny, but there was an enormous canopy over the bed that made the space feel almost palatial, and I wanted to re-create that regal effect in this apartment.

A seating area (pages 110–111) makes this space feel more like a suite than an ordinary bedroom.

RIGHT:
Donna Karan
spring 1999
advertising campaign,
photographed by
Peter Lindbergh

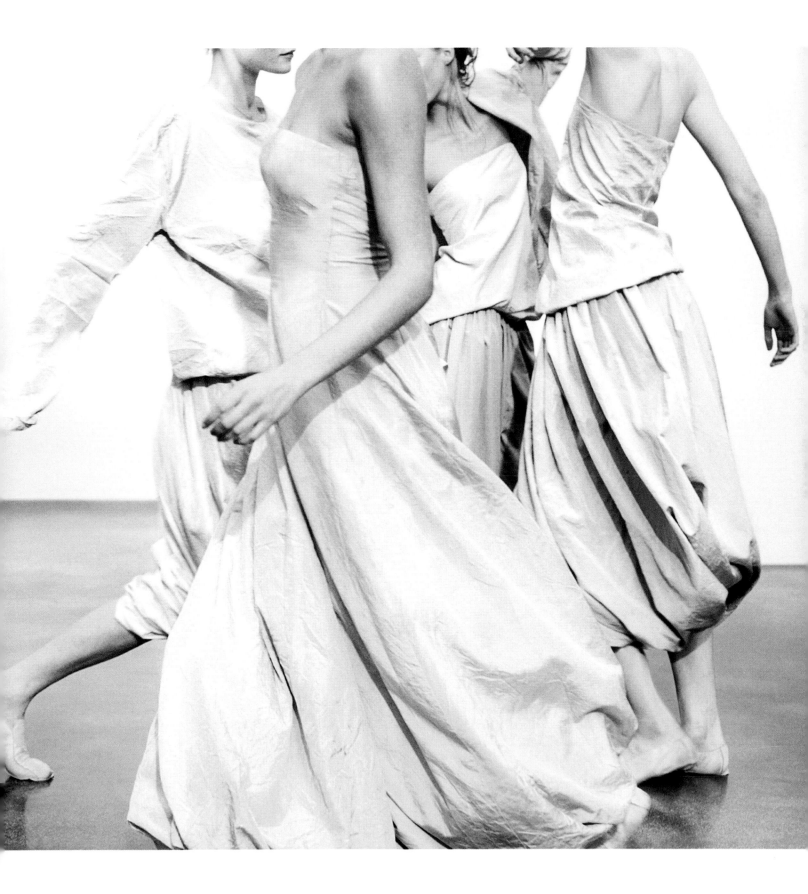

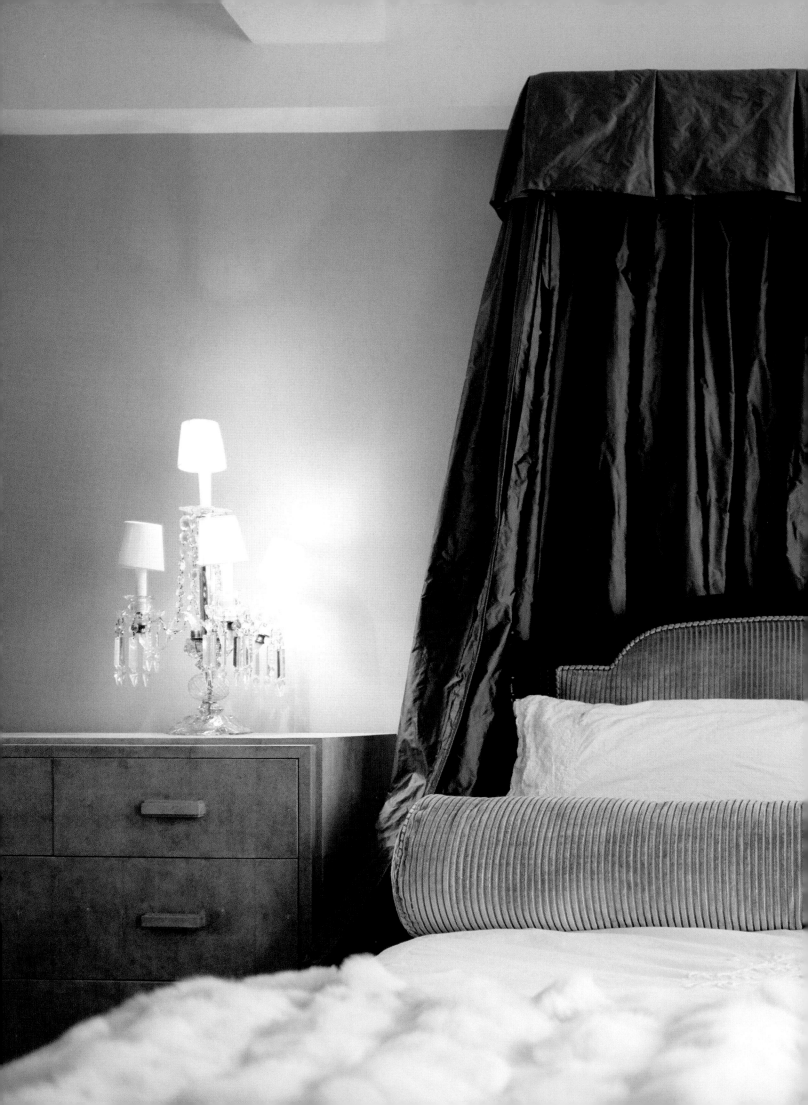

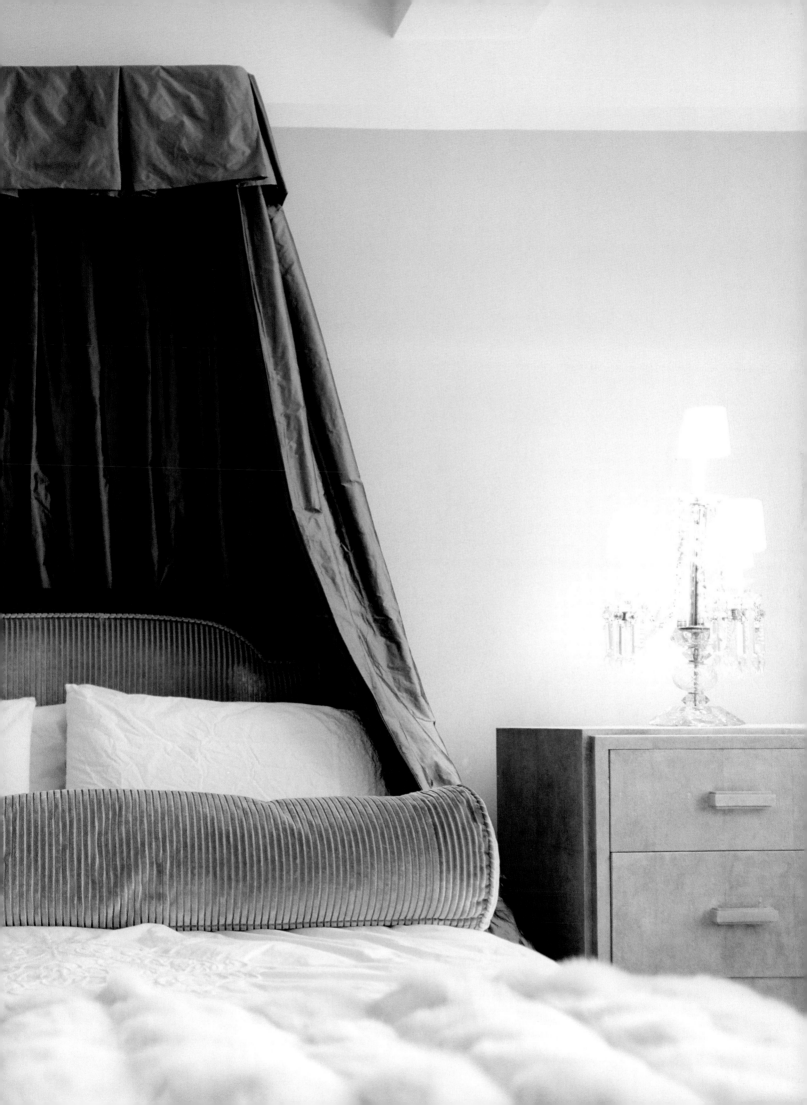

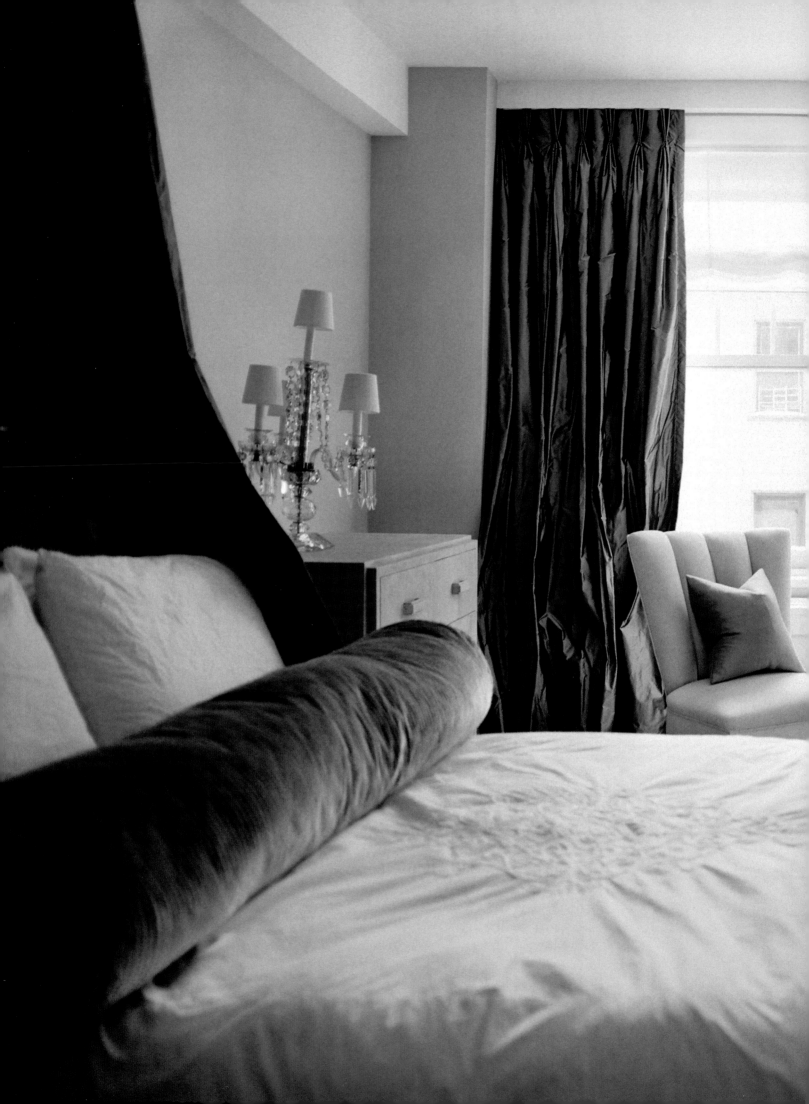

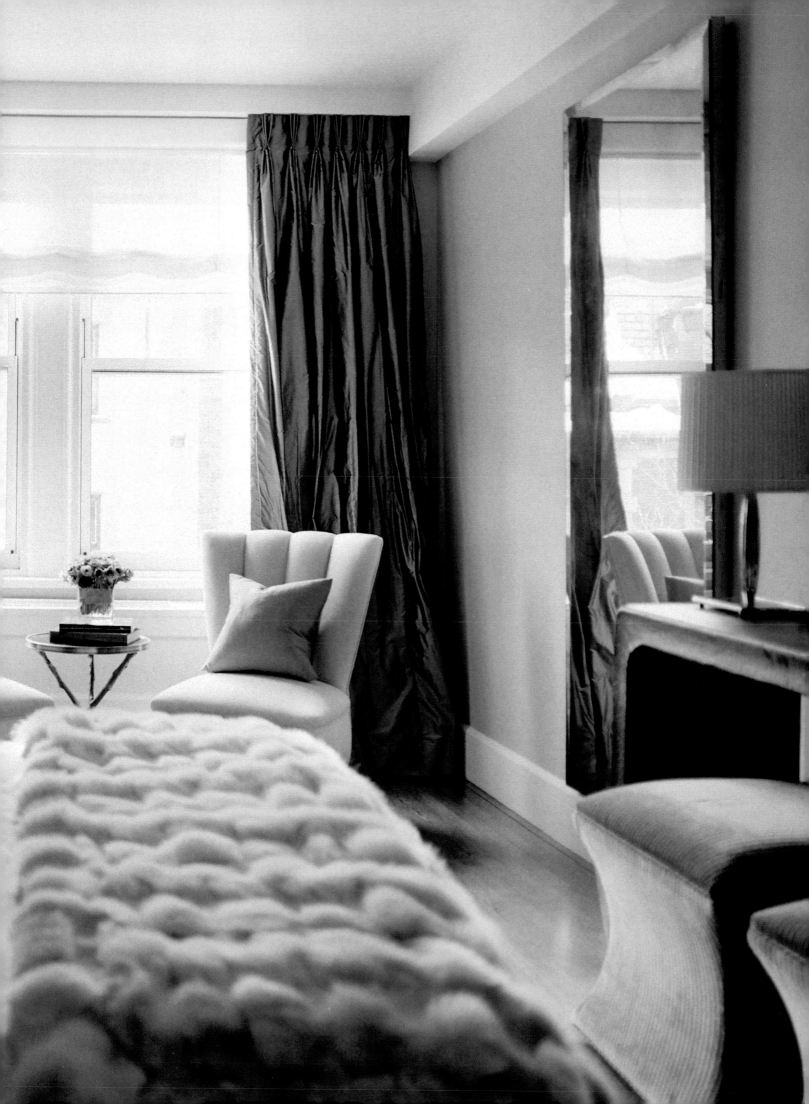

AT THE GEORGE V, THE DESIGN APPROACH IS TO CHOOSE ONE FABRIC FOR A ROOM AND THEN DO EVERYTHING IN IT.

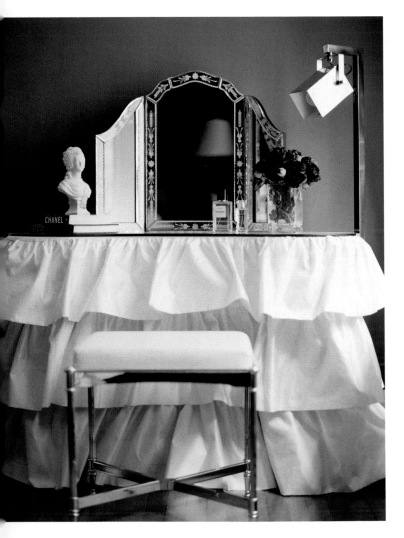

That concept can feel old-fashioned if it's taken to an extreme. But if you're selective about what you're using the fabric for and you don't overdo it, the look is fresh, with just a nod to the past. For the guest room (pages 112–115), I used a beautiful mint-green silk fabric for the bench at the foot of the bed, the lampshades, and the drapes.

My client wanted a vanity with a tiered skirting, and I've always loved the look of a kidney-shaped Louis XV writing table, so I had this piece (left) custom-made for her. I added a 1970s spotlight lamp to balance the girlishness.

A writing desk stands in close proximity to the bed (opposite)—another idea inspired by hotels that makes the most out of a small space.

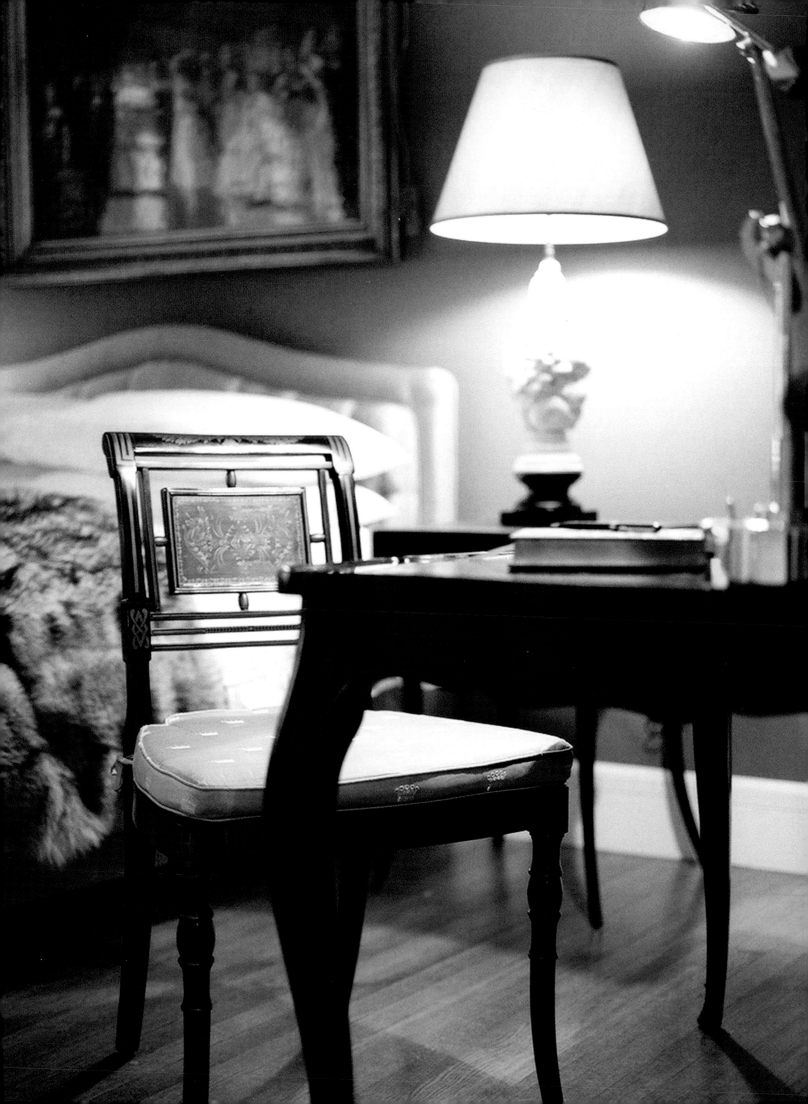

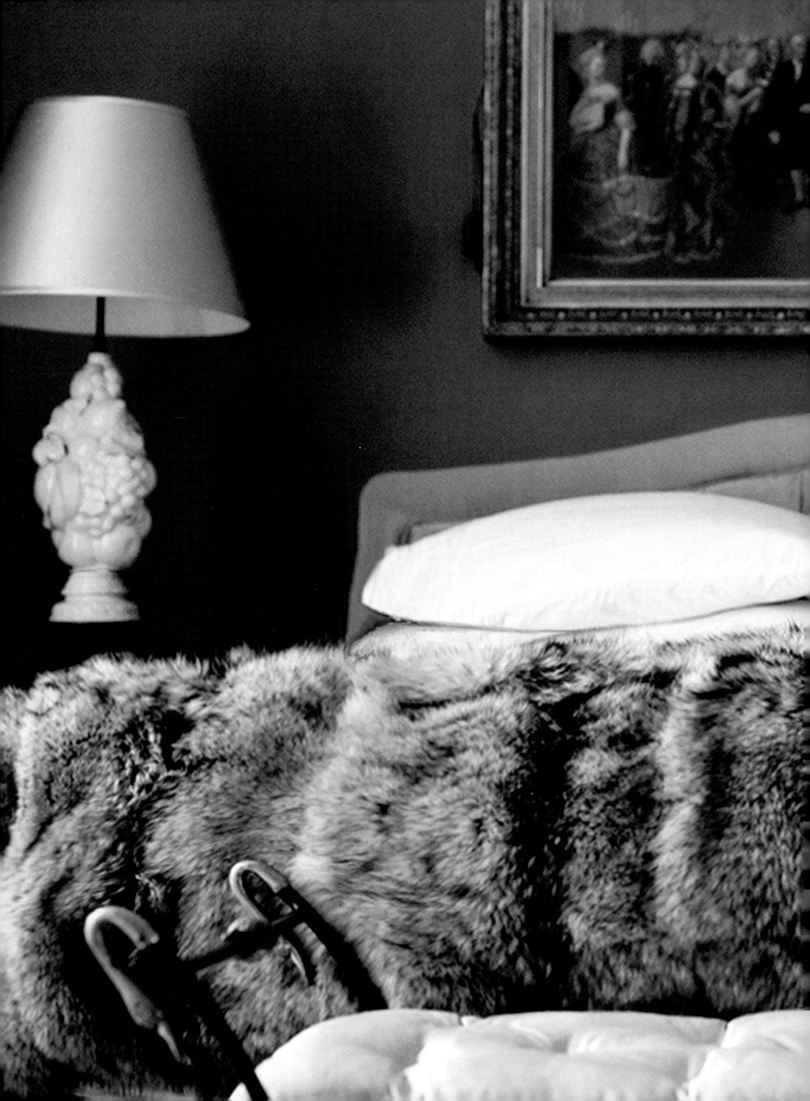

5

THE LITTLE DETAILS

WHEN I MOVE INTO A NEW PLACE, THE MATTRESS GOES ON THE FLOOR, AND MY FIRST AREA OF CONCERN IS THE ACCESSORIES.

I need to have gorgeous lamps, rugs, candles, and art, and then I worry about the other things. It's these objects that give a home character and soul. Beautiful accessories and curios that you've assembled over your life—things that speak to who you are, where you've been, and how you've grown, that tell a story or have strong sentimental value—make living spaces unique, imbuing them with a certain spirituality. It's in mixing these things that something very interesting happens. Take the renowned collection assembled by Yves Saint Laurent and his partner Pierre Bergé. Nobody in the world put art and objects together like they did. In a single area, they'd hang a Matisse on a door that they never closed, with a Warhol silkscreen, a Brancusi sculpture, and an eighteenth-century bronze bust. They shared an uncanny talent for combining seemingly unrelated objects in a way that was perfect, yet felt natural and uncalculated. In bringing these seemingly disparate items together, they gave the pieces new life and made them accessible.

Much like fashion accessories, home accessories—pillows, art, glassware, napkin rings (which I consider to be as important as the rings on your finger)—are an extension of your personality and style. I always think about these details, and once my clients understand that

every accessory they choose is an opportunity to express themselves, they become inspired by the possibilities. They realize that everything in the home can be done with style. "When I finish brushing my teeth, where do I want to put my toothbrush?" A black crystal cup. "How do I want to store all the TV remotes?" A beautiful silver box. Once you start thinking this way, your house does become your home.

Certain accessories immediately add richness and glamour to a room, such as those made from exotic skins (crocodile boxes, horn pencil holders, ostrich table lighters), crystal (chandeliers, ashtrays, candleholders), or metal (chrome lamps, brass bowls, polished nickel vases). You can have a very simple glass coffee table, but put a shagreen tray on top of it along with a pair of silver candlesticks, and suddenly you've elevated the look into something extraordinary.

Decorative moldings are another way to add character to your home. Both picture and chair rails are very French and give a room a sense of history. If you don't have moldings, you might want to give them a try: they can make a big difference, and simple ones are easy to install and take no time to paint. Pay attention to trimmings: installing and painting them can really transform a space. You may have a dumpy apartment, but if you paint the doorframe and baseboards black and add molding, you'll have a look that's really spectacular in no time.

Flooring also makes a big difference in a space; change the floor and it changes the whole feel. I favor a dark floor. It's the perfect canvas to work from. And a black herringbone floor is simply the most elegant. You don't see herringbone that often outside of Europe, because a lot goes into laying it. It's a real craft, and that's why I appreciate it. But I also love the way it draws the eye in different directions. I'm a fan of marble, too. It simply elevates the space into something grand.

But here's what I love the most on a floor: wall-to-wall carpeting. It gets such a bad rap—many people consider it outdated and cheap—but, really, it is wonderful, and not just in the bedroom, but throughout the home. I'm not advocating living with the old wall-to-wall carpet that came with your new house or apartment, but if you move in and have it installed, it is truly luxurious. The sensation of it is like nothing else. It's that feeling you never get anywhere else but in a hotel room—that really clean, comfortable, walking-around-with-your-shoes-off-in-a-bathrobe feeling.

S

THE WHOLE APPROACH TO THIS LIVING ROOM WAS TO CREATE A SEATING PLAN THAT WAS CALMING.

o I did everything in a subtle, silvery gray that looks almost white. Doing so allowed the accessories in the room (pages 121–123) to pop. The coyote throw and black lacquered tray became the stars of the show. I've done interiors where I've layered accessories like crazy, but this room was a study in restraint. I just wanted to showcase a few things—the silver-dipped nautilus shells, the bronze sculpture—to privilege them.

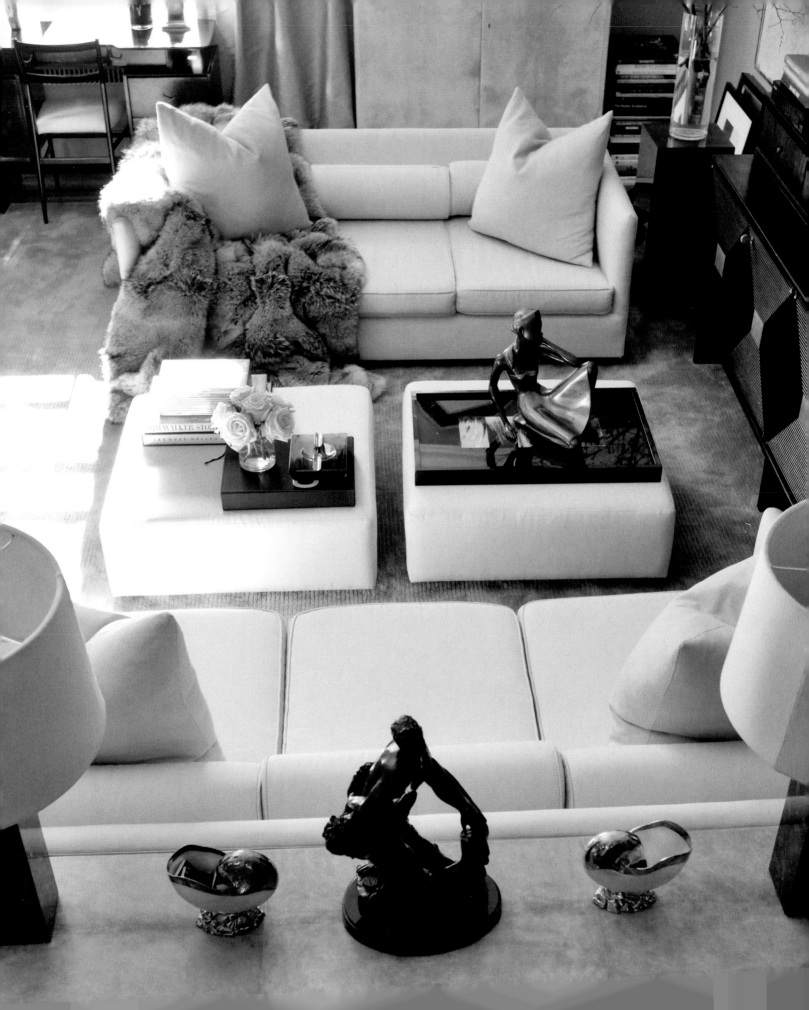

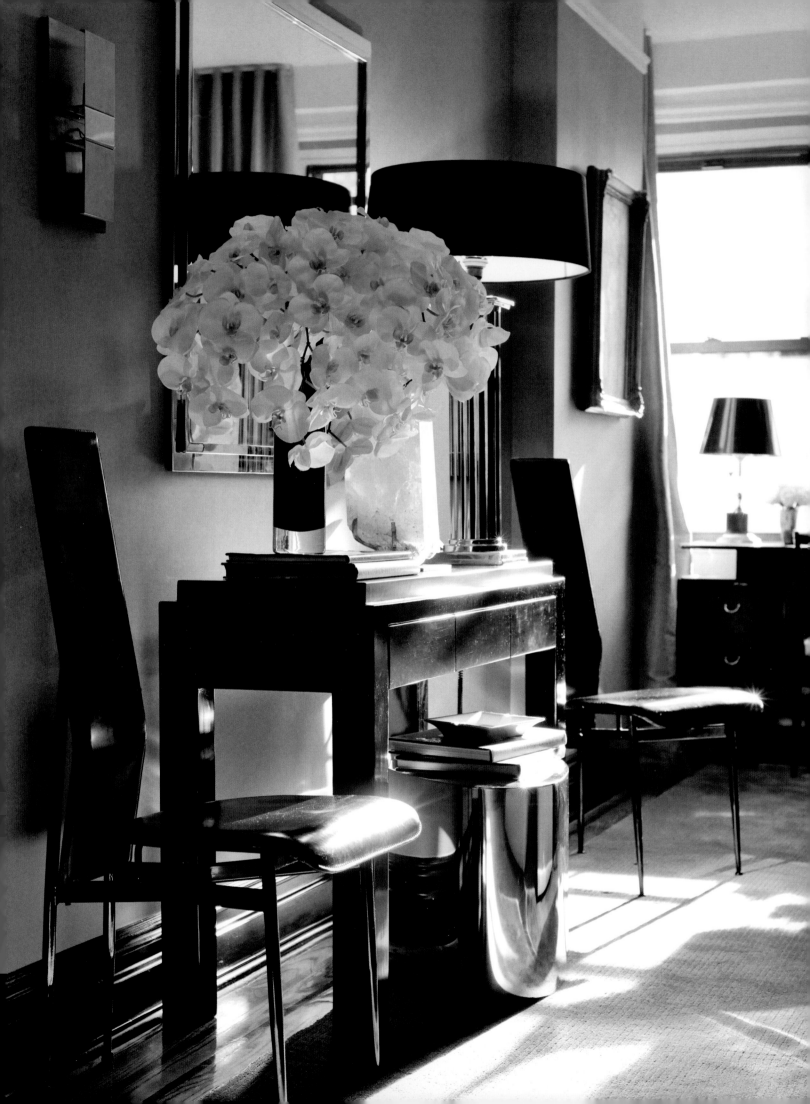

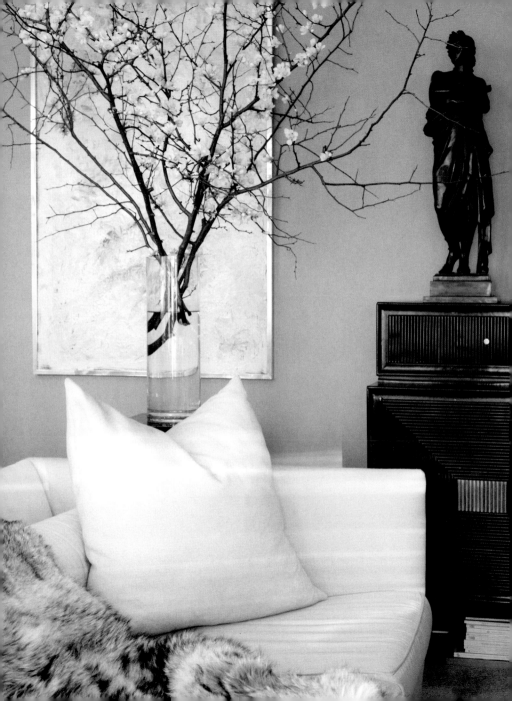

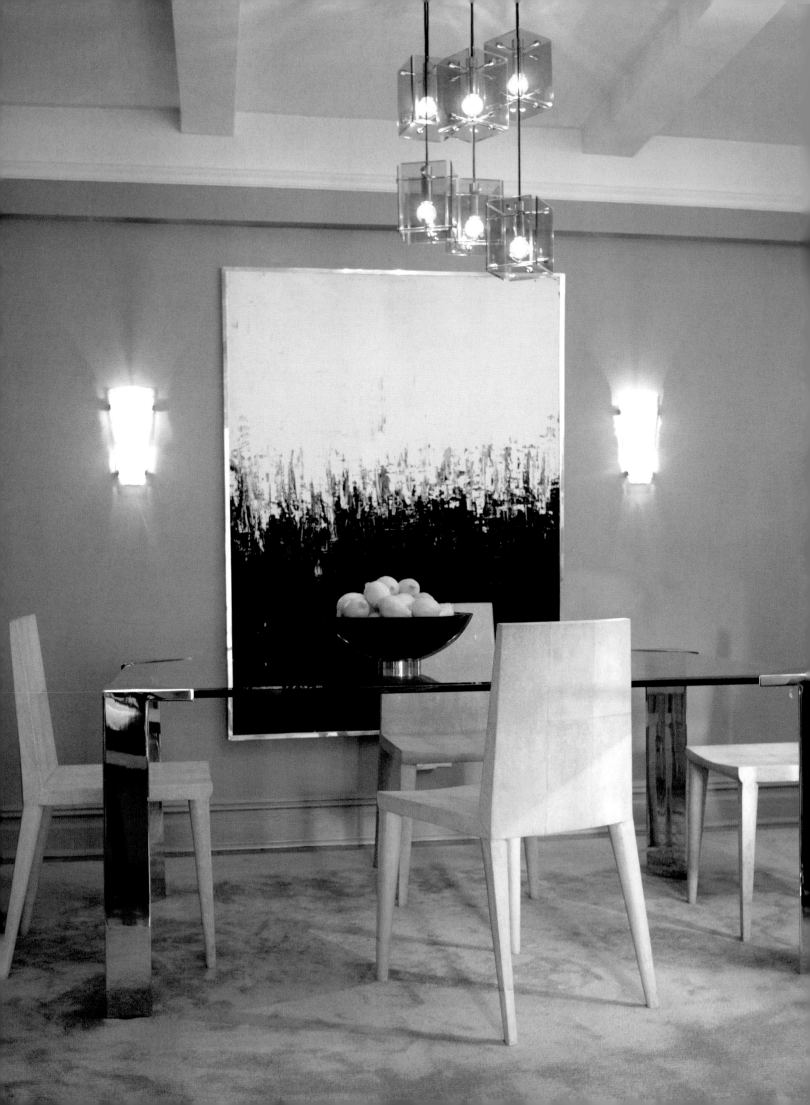

I DIDN'T WANT THIS UPPER EAST SIDE APARTMENT TO FEEL OVERSTUFFED, SO I LIMITED THE TYPES OF OBJECTS ON DISPLAY,

going with bronze sculptures and malachite boxes in the dining room. Here, too, there's a bit of a lacquer story happening: the chest of drawers looked pretty beat-up when I bought it, so I had it custom lacquered. I loved the lamp because it looked as if the paint was dripping down the base onto the table.

This small dining area feels larger because the dining table is glass and thus transparent. The paleness of shagreen chairs makes them seem lighter and much less of a presence. Instead, the focus is on the shine of accessories.

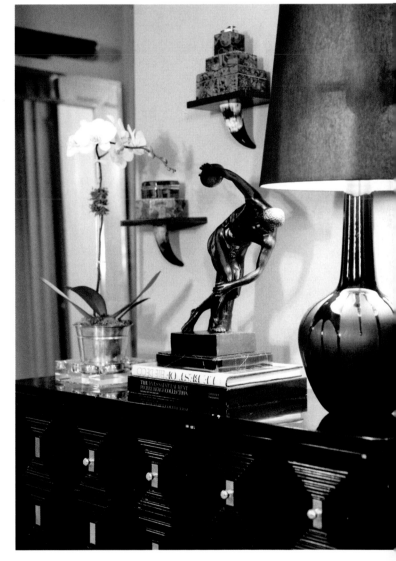

YVES SAINT LAURENT COLLECTED ONLY THE MOST SUBLIME OBJECTS.

Even the telephone stand (opposite) in his rue de Babylone home, with its horn pencil cup and framed logo, was lovely to behold. This layered approach inspired me to do the space below, in which a modern art deco lamp is placed on a ram's-head pedestal, piles of books cover the paintings, and a bronze sculpture is displayed atop a jewelry box, with orchids spilling across it all. It's a more-is-more approach to decorating.

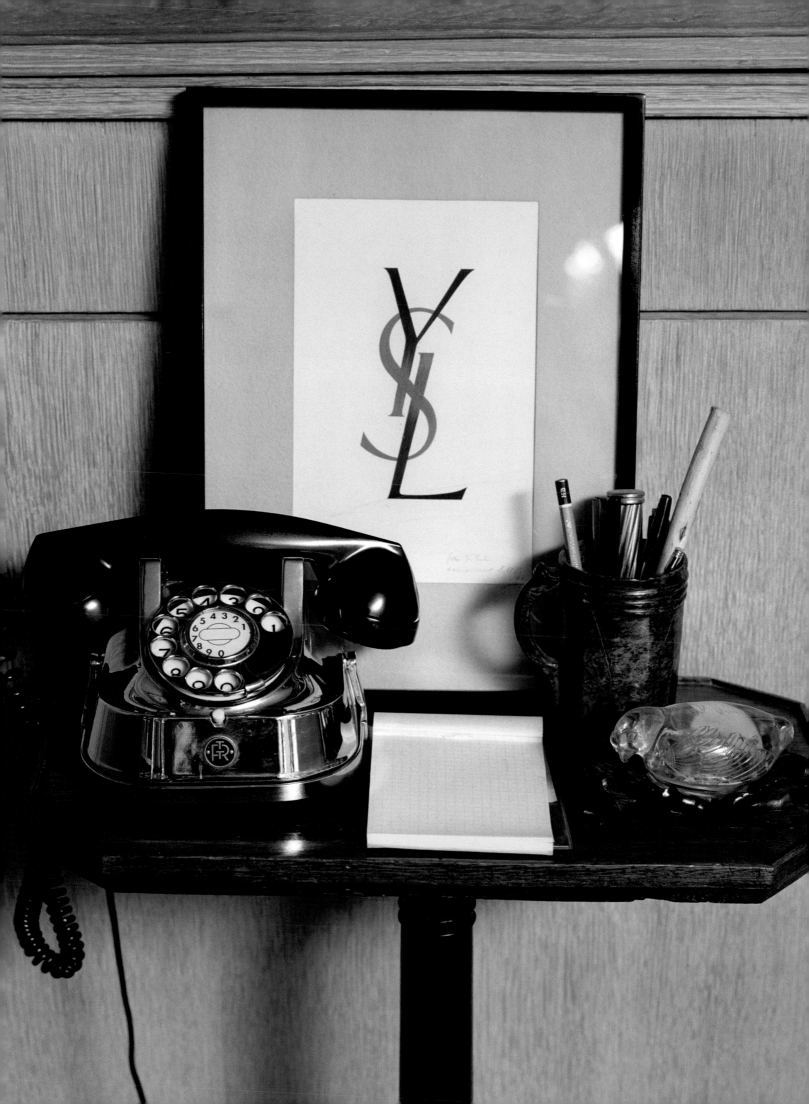

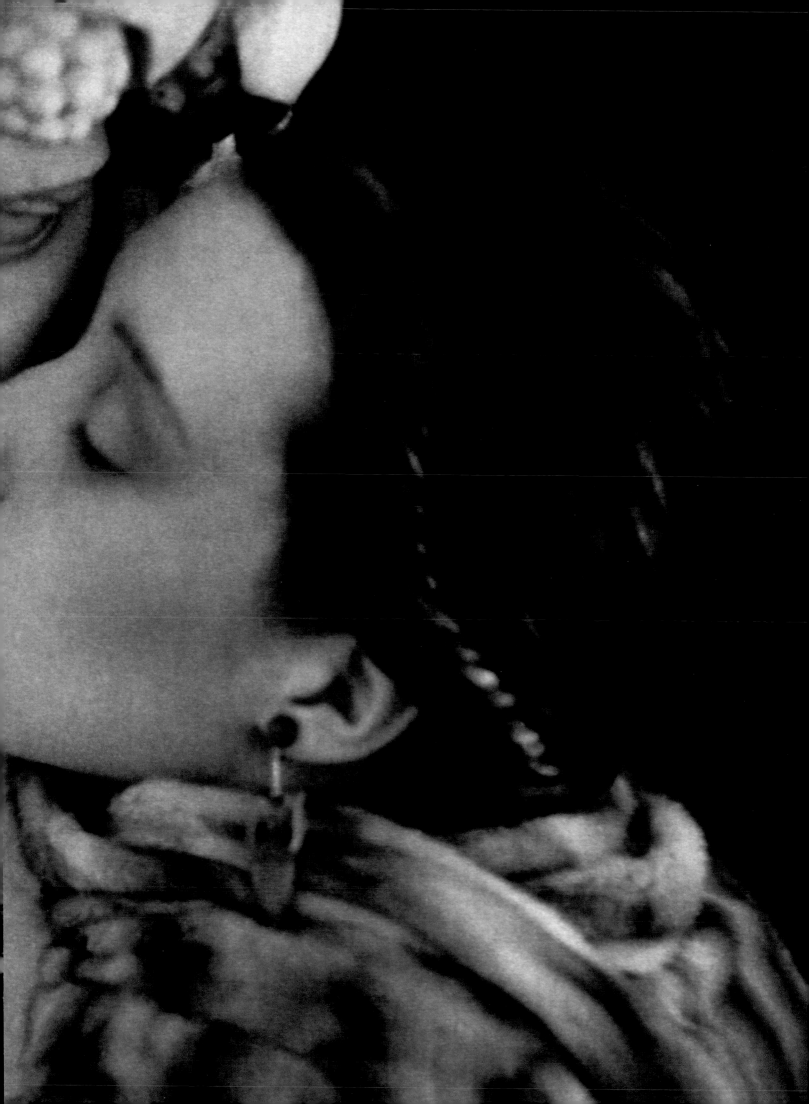

I'M DRAWN TO FIGURATIVE SCULPTURES IN BRONZE AND PLASTER,

particularly when they're weathered, flawed, or damaged in some way. They suggest a sense of history and add a nostalgic, romantic element to a room that might feel too modern otherwise. I love the rich mix of materials in this area of the room—the plaster sculpture with a tortoise-shell mirror and a black Lucite lamp. The brass detailing ties it all together.

PAGES 130–131: Fendi's This Kiss fragrance advertising campaign, photographed by Sheila Metzner, 1986

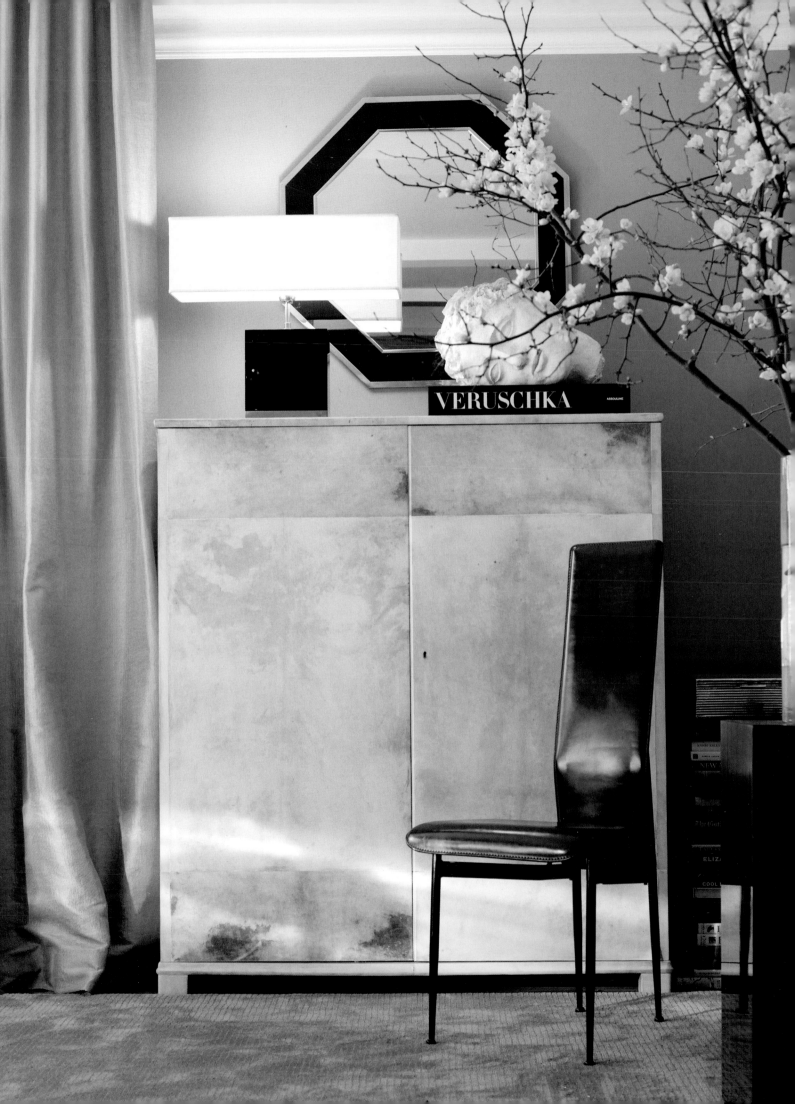

tend to go romantic whenever I decorate
a place where you sit down and do something
personal—a writing area, for instance, or a vanity. In this
case, the desk stands in contrast to the more modern areas of the living room,
but all these vignettes are linked by something, whether through the color
or the finish.

Most of the time, I prefer crisp, white bedding, but for the bedroom
(pages 136–137), I felt that black sheets worked better with the art deco lac-
quered bed. To soften the look, I chose a set that had a subtle pattern and a
bit of sheen, and I piled on the pillows. The result is very plush and inviting;
it shows that black bedding doesn't have to be harsh.

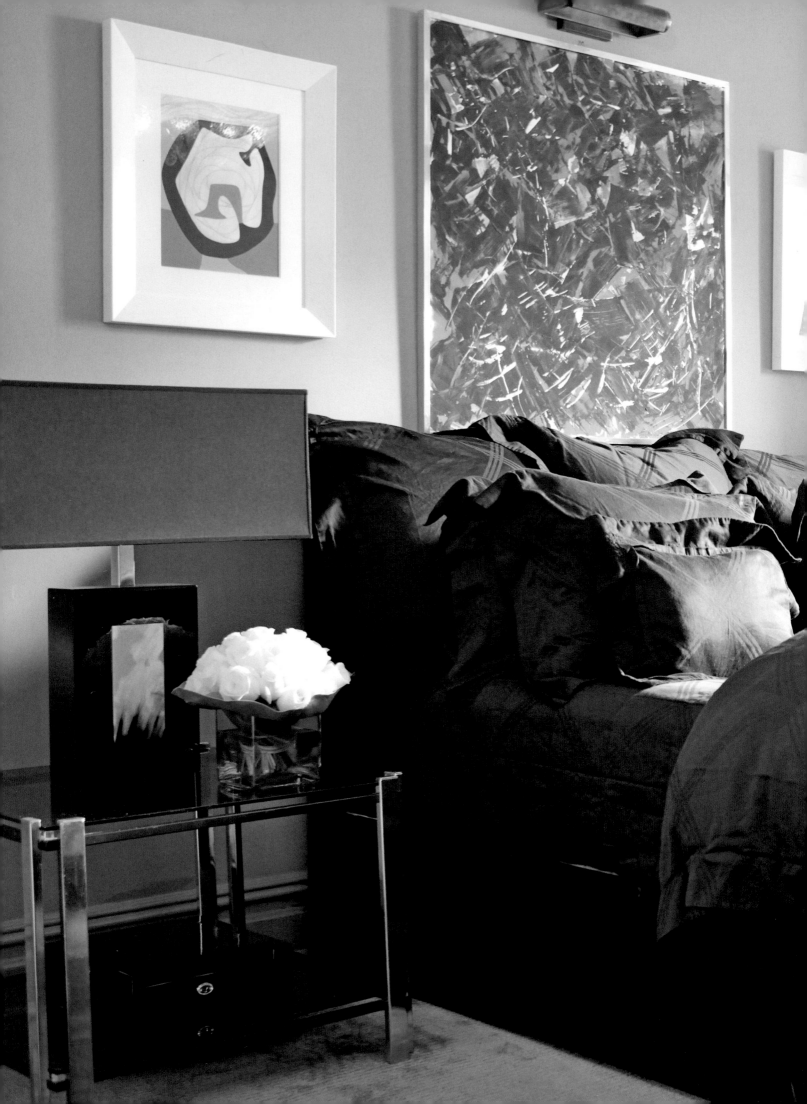

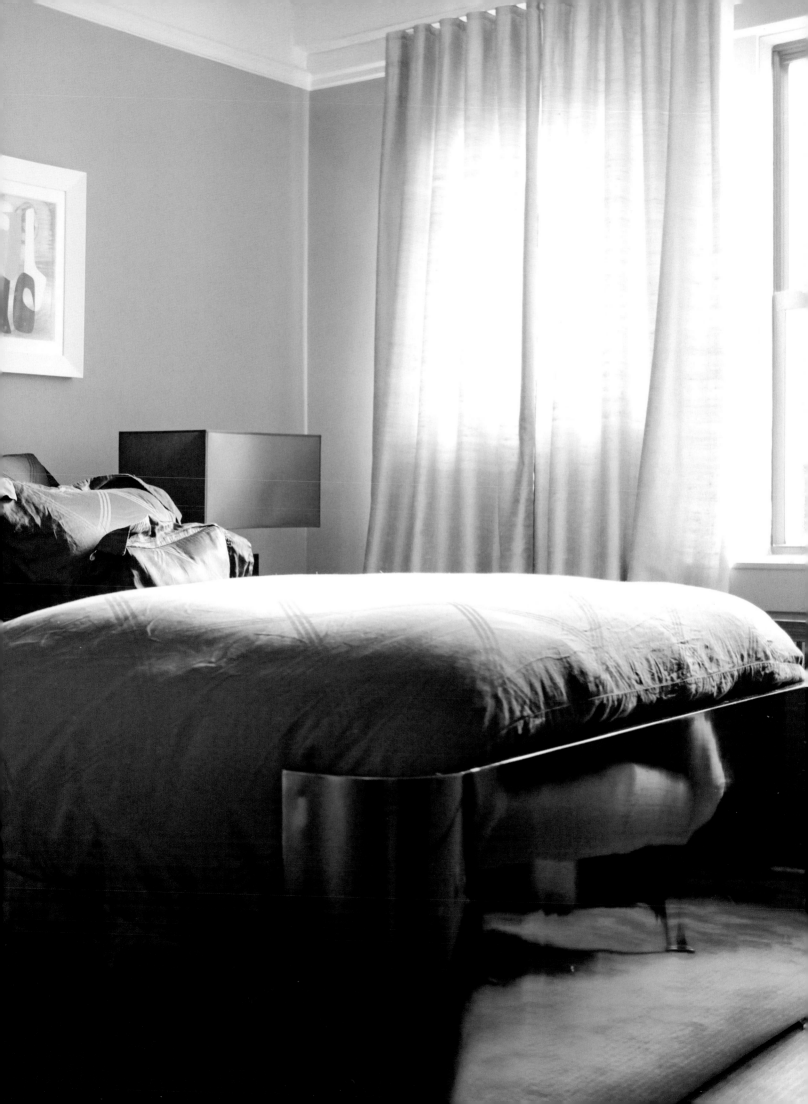

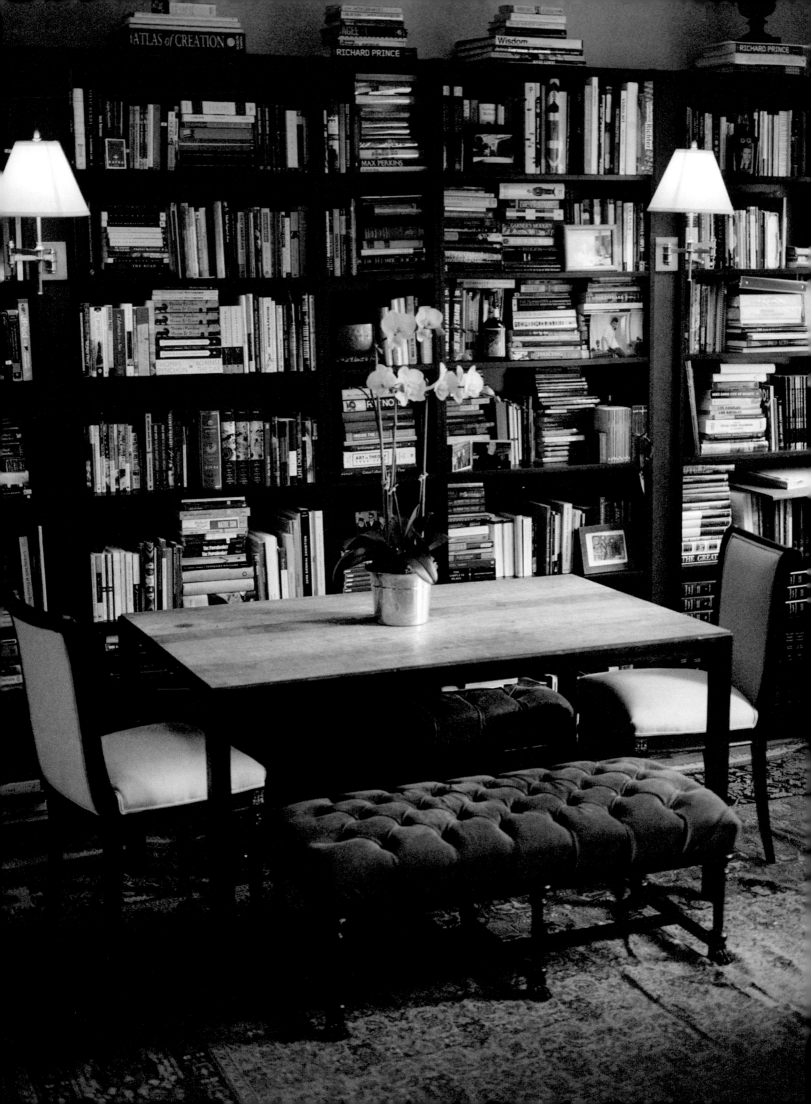

6

THE GENTLEMAN'S CLUB

NOTWITHSTANDING ALL THE ROMANCE AND FANTASY THAT MY AESTHETIC ENCOMPASSES,

I'm also inclined toward prototypical gentleman's décor, particularly the academic English study and the straight-up sexy bachelor pad. But then, I find there's a lot of romance in the former and a certain fantasy in the latter. There's definitely sex in both.

My interest in the English study has a lot to do with its inherent sense of history. There's a feeling in these gentlemen's spaces that all the elements have personal importance and have been carefully chosen: the Chesterfield couch, passed down from one's grandfather; the hardcover books by favorite authors and on meaningful subjects, pored over. With that sense of significance comes an air of privilege that is by its very nature alluring. People are drawn to things that are exclusive—whether it's a club, a party, or a room in the house. They want to be privy to it. On the flip side, there's the sophisticated bachelor pad—a sleek funhouse full of shine and modernity. It is the ultimate

fantasy apartment, one that telegraphs sex and easy money and—much like the English study—power.

In decorating both of these spaces, I take a lot of inspiration from men's fashion, particularly English men's fashion. I've always been drawn to the way men dress in London; it's the one city where the men catch my eye, style-wise, more than the women do. They exude an air of elegance and refinement, right down to their signet rings and suede loafers. In this way, these gentlemen's spaces are very personal; they speak to my own style preferences. I decorate them in the way I want to dress. The gray cashmere sweater, pinstripe jacket, vintage watch—they all translate into these interiors.

Another source of inspiration is luxury cars. A luxury car brand conveys a sense of power, sexual appeal, and seductive affluence. When I refer to past decades for inspiration, I look at fashion, homes, and the interiors and exteriors of luxury cars. For instance, if I want to do a room in a rich brown, one way I might build a color palette for the space is by looking at a vintage Mercedes, Jaguar, or Rolls-Royce—one in which the leather upholstery is cognac, the steering wheel is chocolate, and the baseboards are tortoiseshell. All of a sudden I have a visual language that I can translate to a cognac leather sofa, chocolate-brown tweed chairs, and a tortoiseshell console—and it's a gorgeous mix.

Car interiors are a great source for researching fabric and leather treatments, too, whether a subtle pinstripe or a perforated leather. There's even something to be learned from the stitching on a steering wheel. If you look at a company like Poltrona Frau, you can see a clear relationship between their furniture—its piping, stitching, and finish—and the interiors they make for Ferrari. When I'm designing custom pieces for these more masculine spaces, the cross-pollination of such details is foremost in my mind.

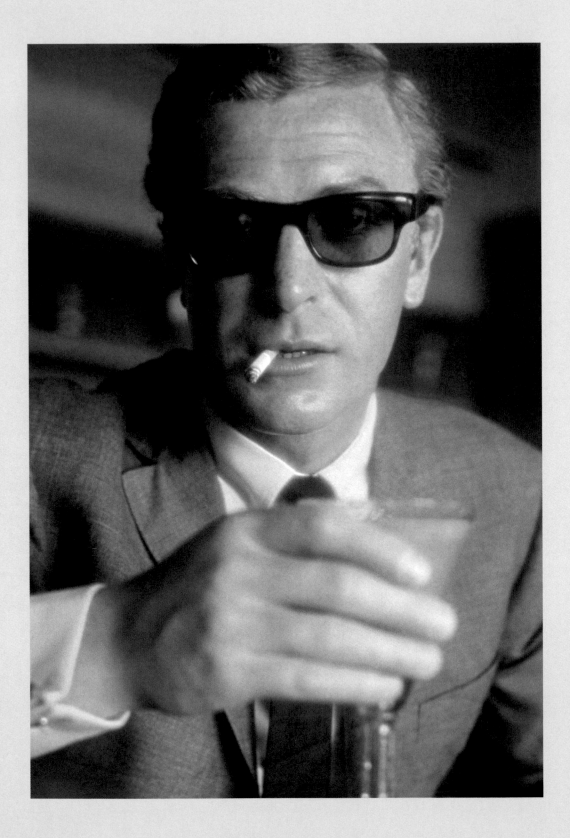

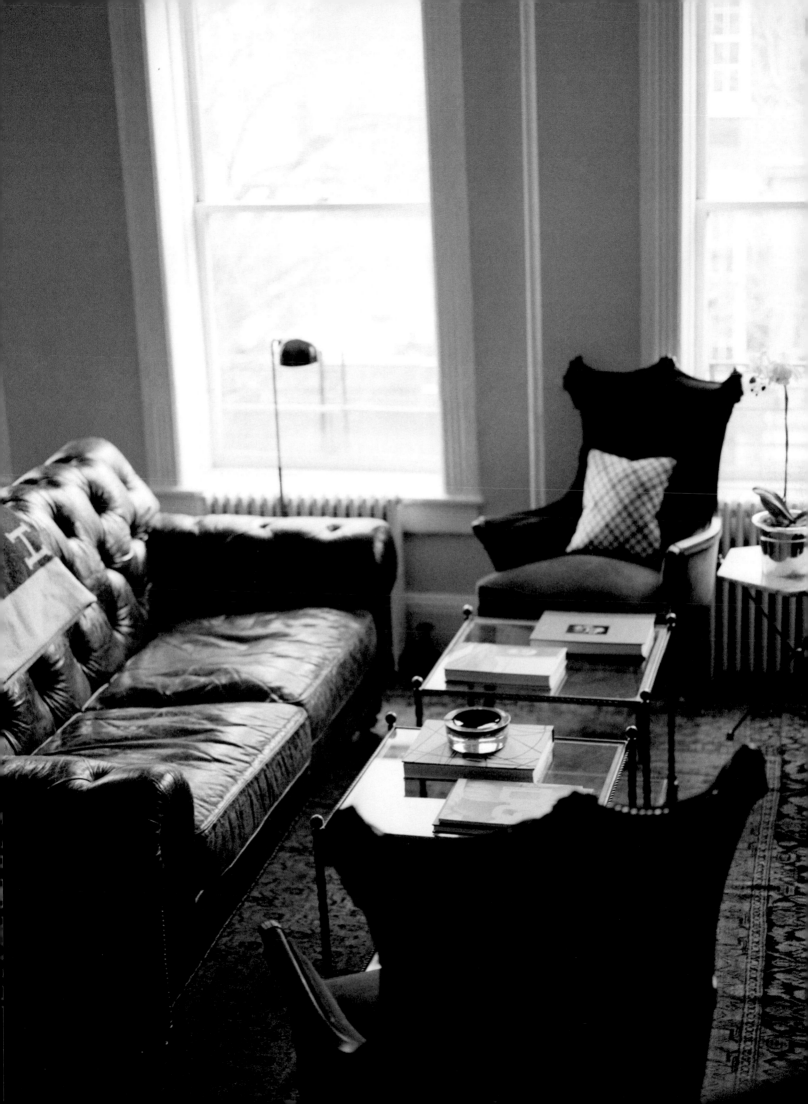

this particular client lived in a prewar brownstone that had a nostalgic feel to it. The idea was to emphasize its age and make the apartment on pages 138–145 feel like a traditional study, but a bit more chic—a place Michael Caine, circa his Alfie days, might have found himself. I chose a navy-and-brown color scheme that was at once clubby and warm, then furnished the space with a vintage Chesterfield couch, big reading chairs, and Persian rugs. Everything in this apartment had an old English air to it—including the paint color, London Fog.

To give the dining room (page 138) a library-like feel, I installed built-in bookshelves and sconces. Then I found an old wooden dining table, and instead of surrounding it with chairs I added gorgeous tufted benches with cast-iron bases by Lars Bolander.

This client had a fantastic art collection, including Richard Prince photographs and Warhol sketches. He also had a huge collection of first-edition books. The art and books enhanced the authenticity of the design scheme. Opposite, a work by the artist Carter echoes the shape of the staircase beside it.

PAGE 142:
Terry O'Neill
Michael Caine, London
1968

PAGE 149:
Vanina Sorrenti
Make It Sparkle,
Make It Shine,
Make the Magic All Mine,
i-D Magazine
December 2009
featuring Shalom Harlow

A BACHELOR PAD DOESN'T HAVE TO BE OVERLY MASCULINE.

In this space, I added topiaries and chairs covered in Mongolian lamb to
soften the look a bit and to give the room a more European sensibility.

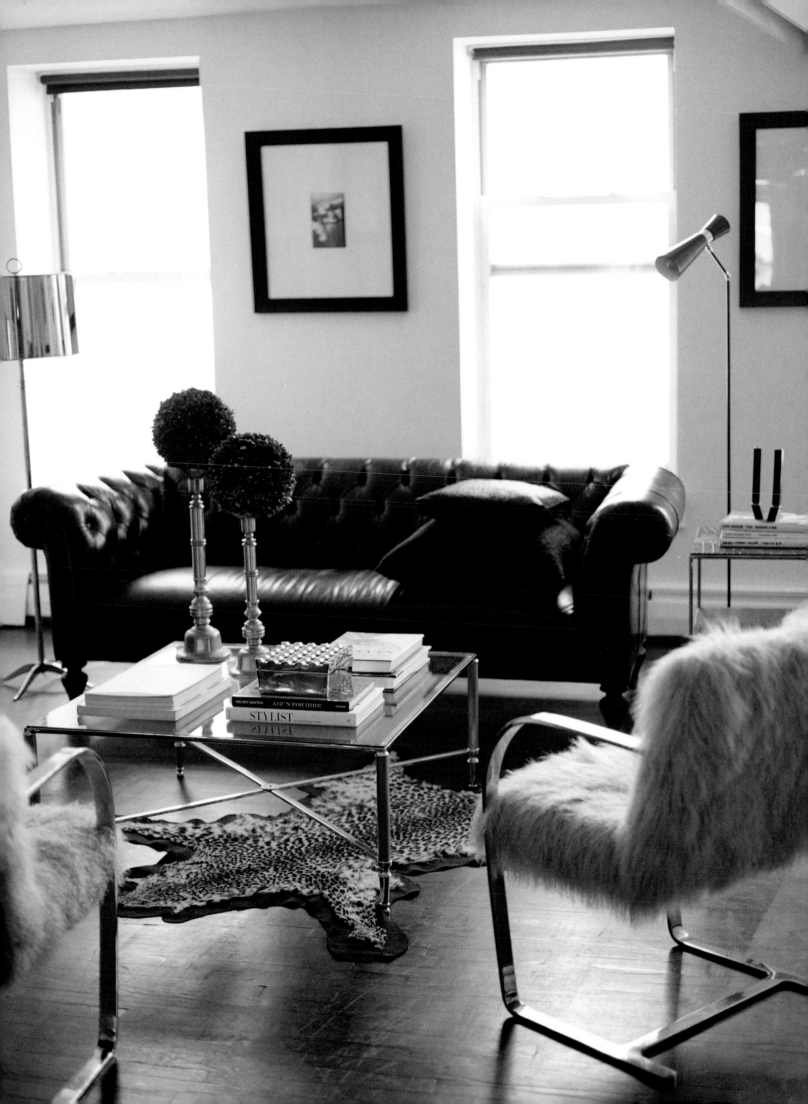

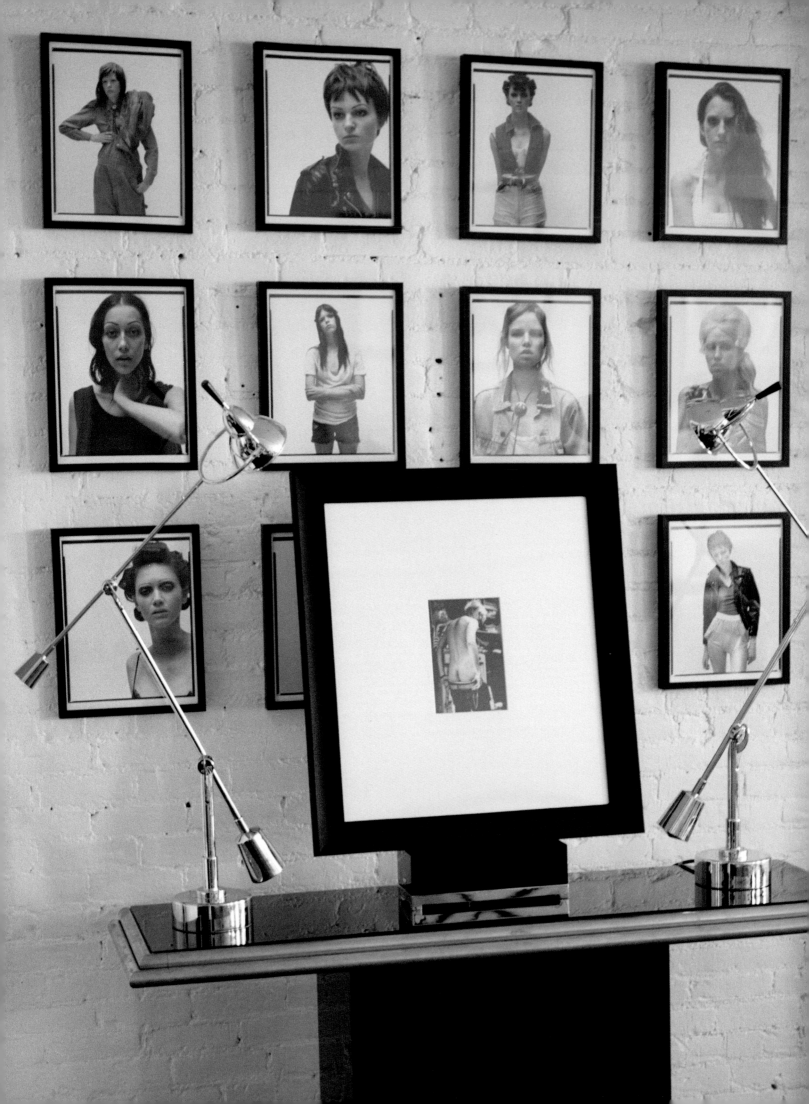

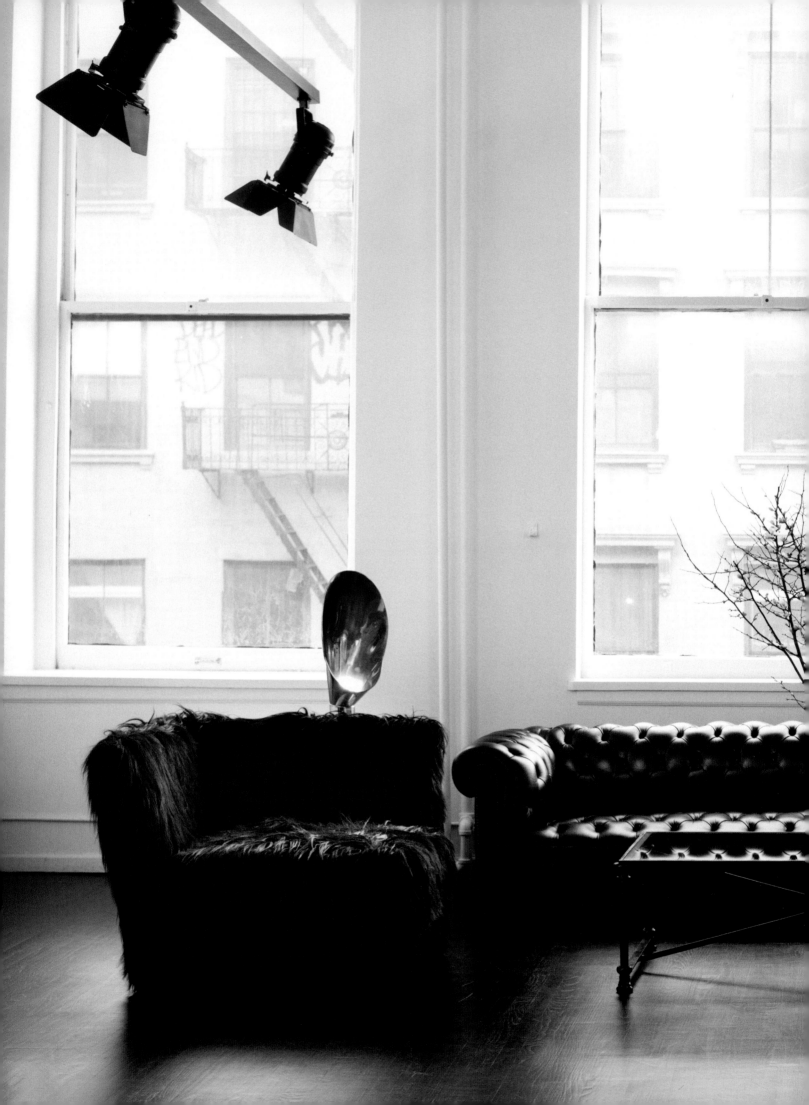

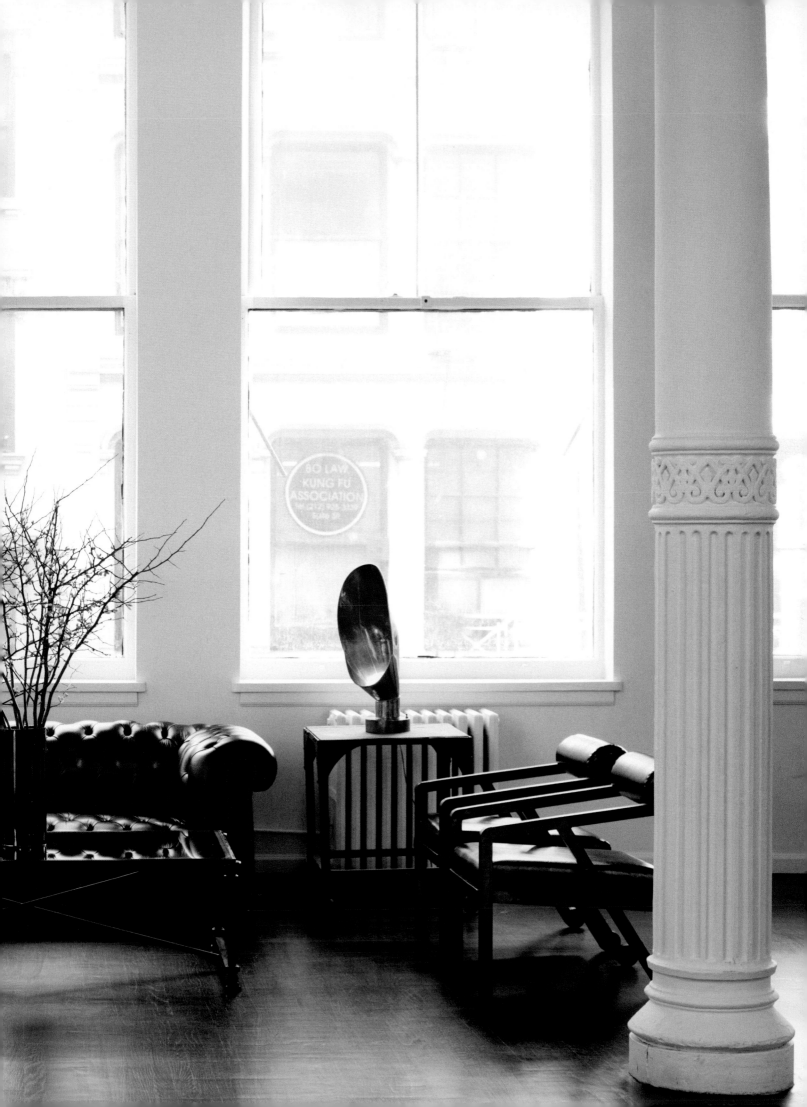

THIS NEW YORK APARTMENT IS THE ULTIMATE BACHELOR PAD.

But because it's a loft and not the Playboy mansion, I wanted to make the space feel a bit more refined—something along the lines of the photograph by Hugh Lippe on page 156. Both its mood and color palette were influential: the apartment's gray floor echoes the concrete; the navy chairs are akin to the pool tiles; the coyote fur mimics the color of the model's skin.

The space was very raw, open, and edgy. The owner is an artist and had some of his oversize graffiti-style works hanging on the walls. It was a strong, super-downtown environment that I worked around, adding sleek elements like lots of chrome, low-slung couches, and club chairs done in pinstripe mixed with leather. I also added a lot of animal skins: a fox-fur rug, python pillows, a zebra skin, a shagreen coffee table—things that essentially ooze sexiness.

Strong and clean, the Audi poster on page 162 represents a sleek, somewhat retro interpretation of luxury that's very alluring. I tried to channel that same feeling into this apartment, down to the caramel leather seating.

PAGE 156:
Hugh Lippe for
Exit Magazine,
November 2009

PAGE 162:
Audi promotional
poster designed by
Karl Gerstner, 1965

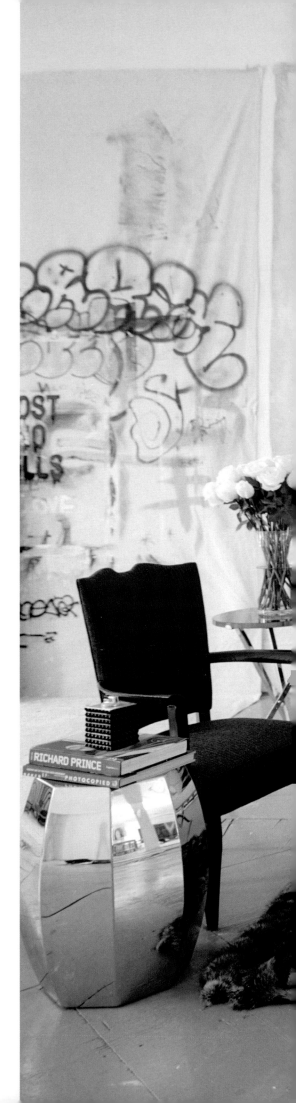

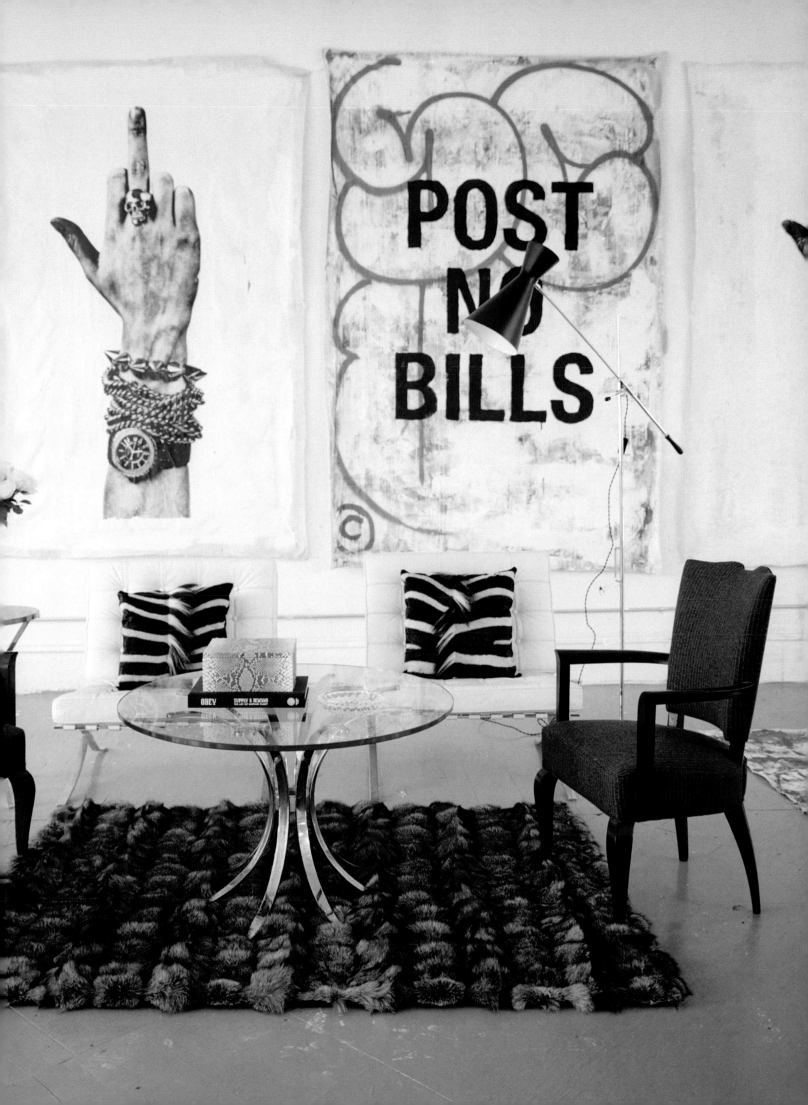

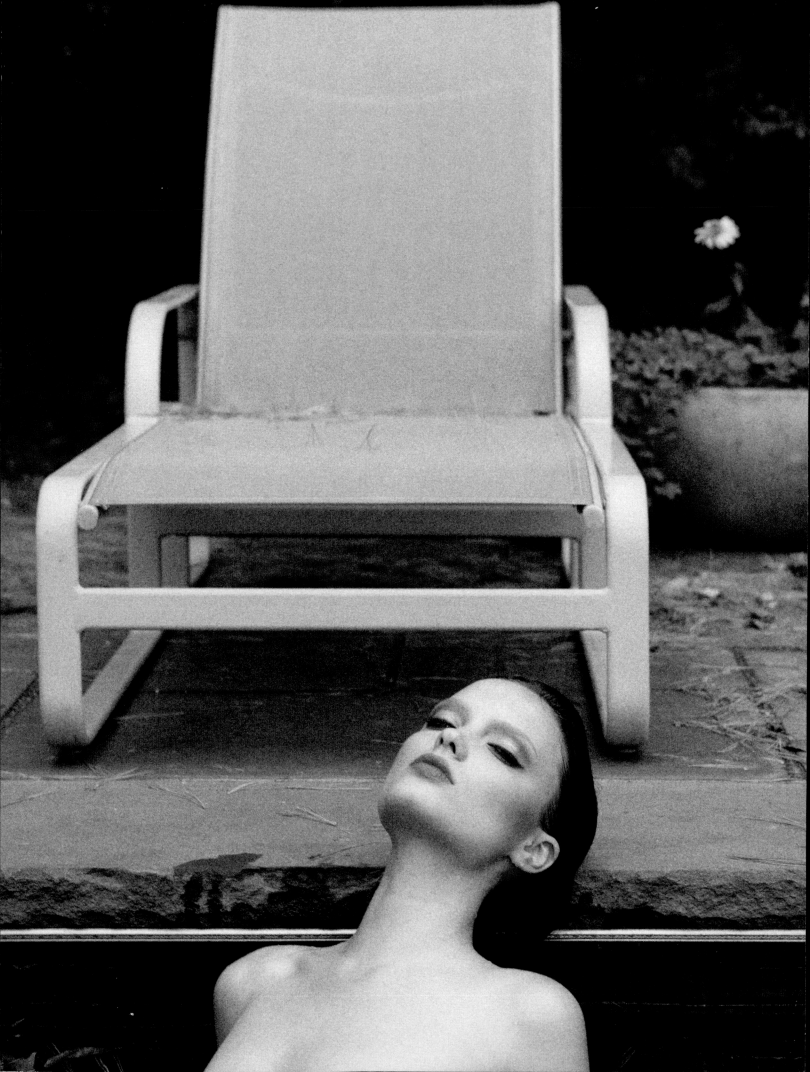

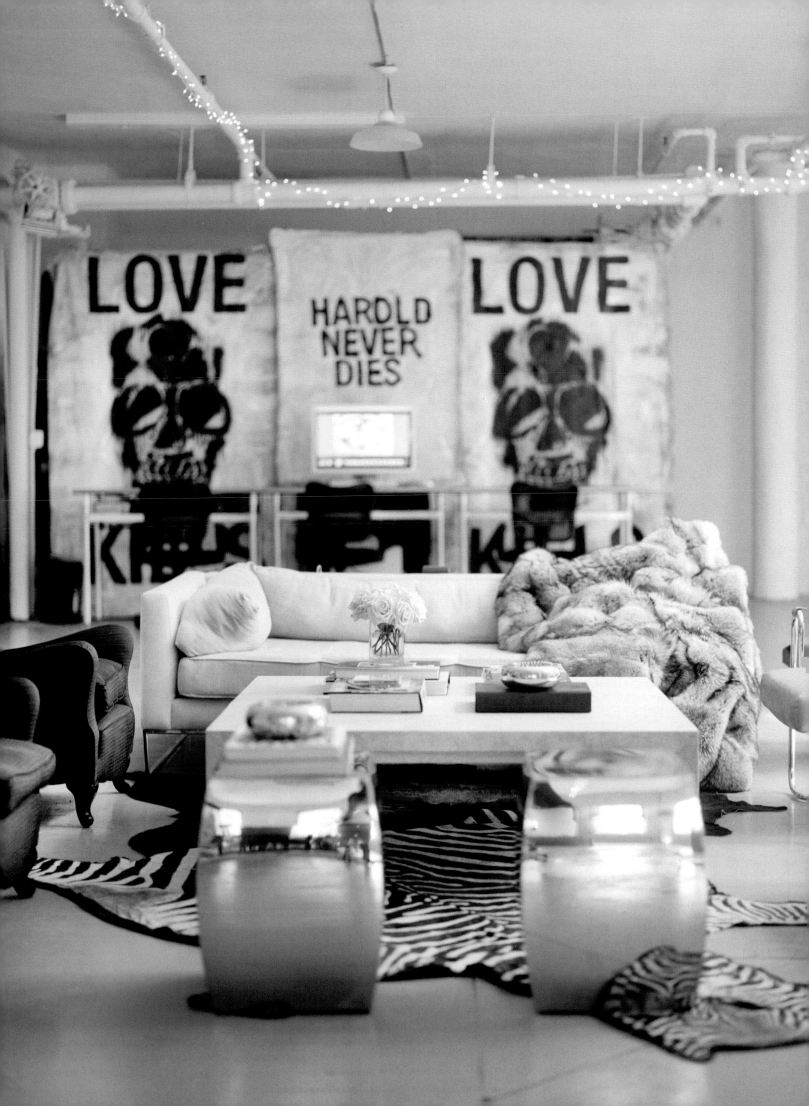

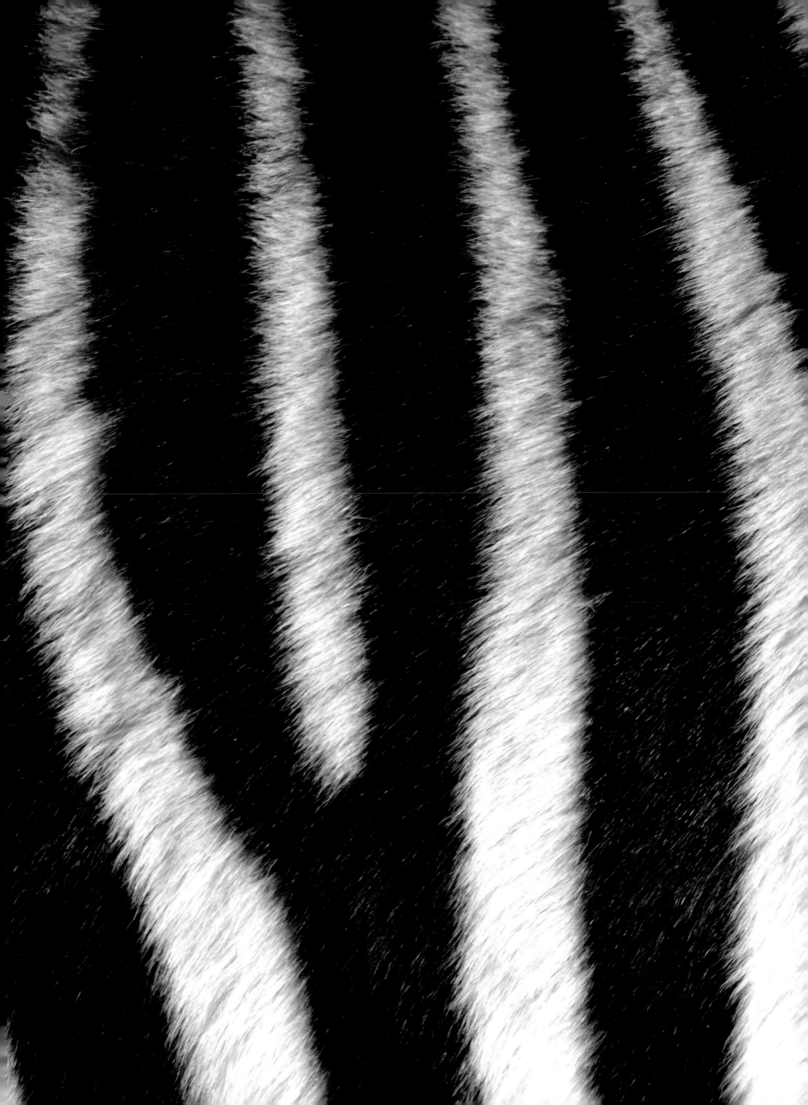

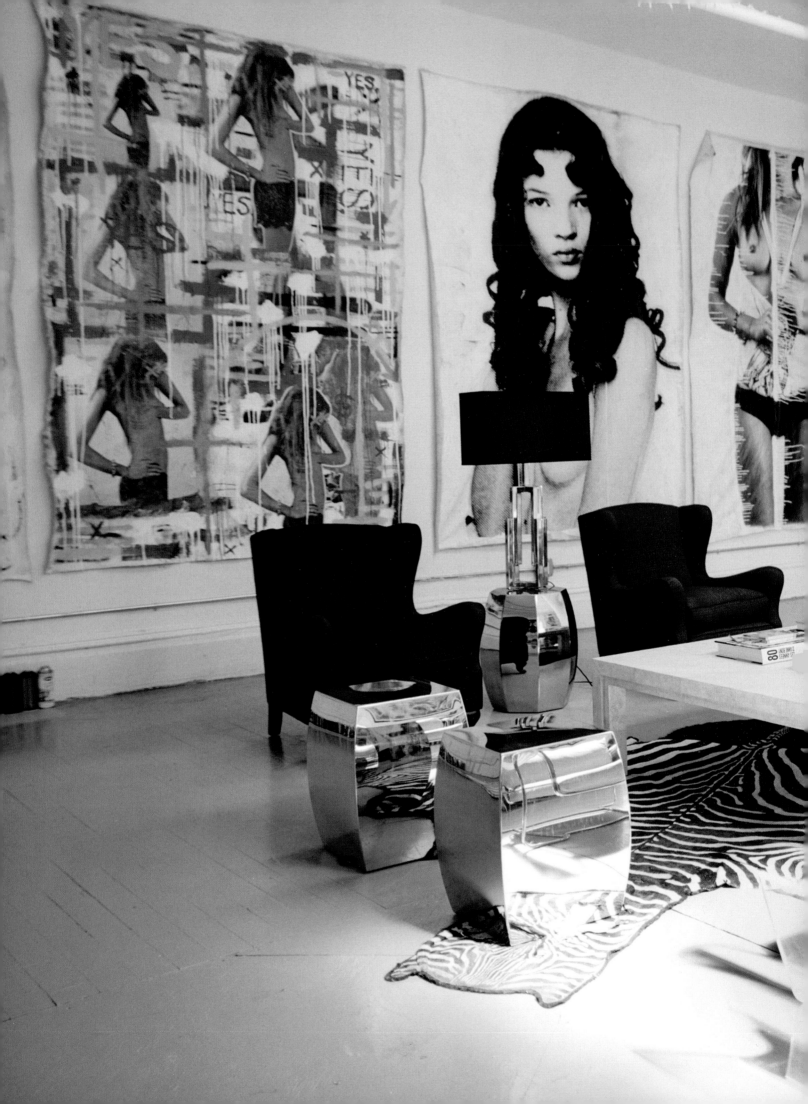

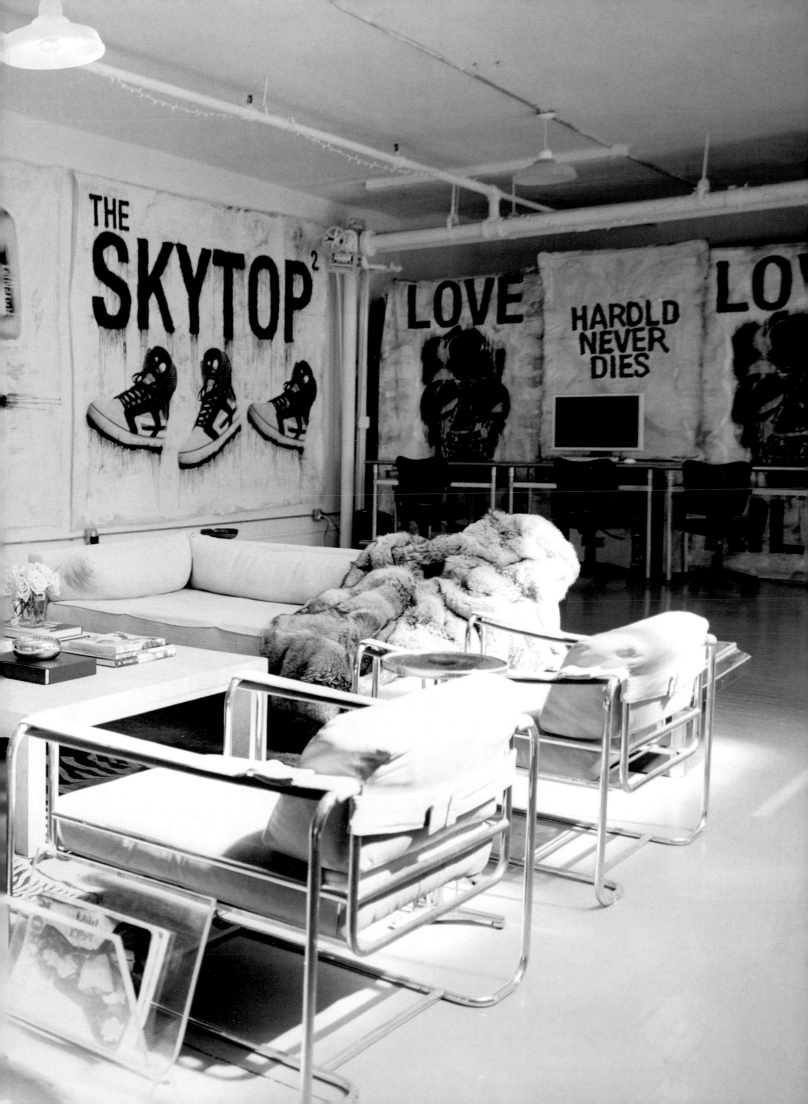

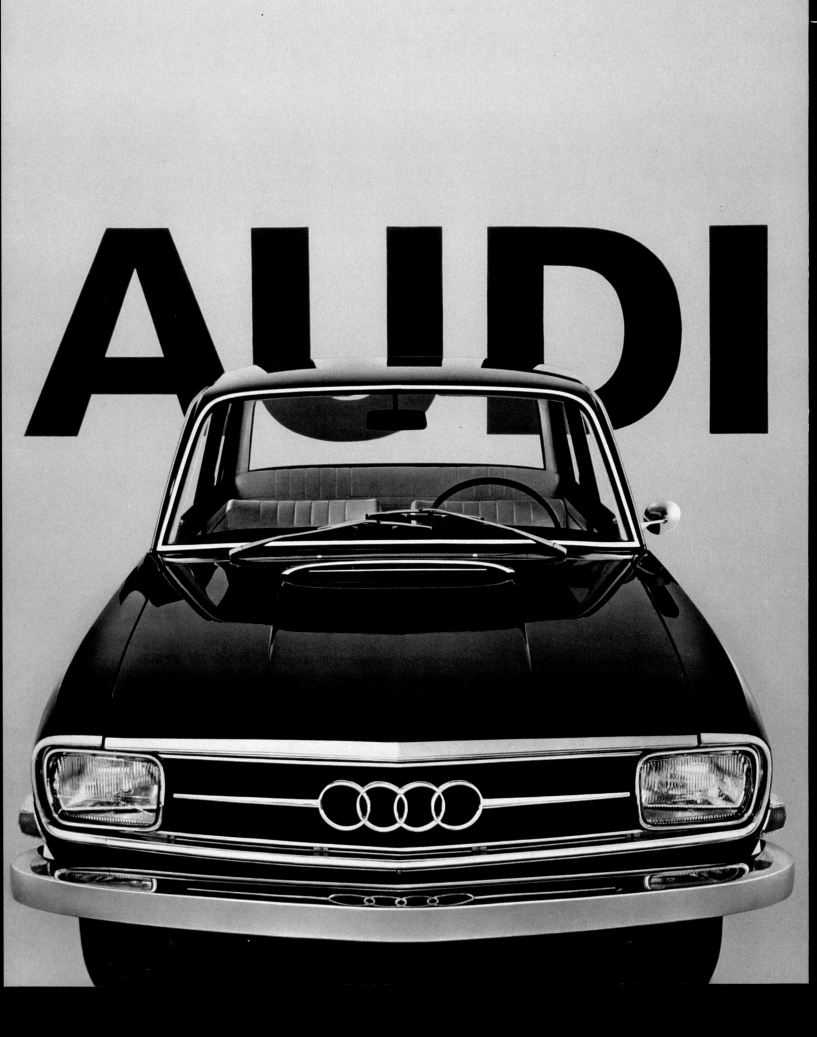

7

THE ROYAL TREATMENT

I'VE ALWAYS BEEN INSPIRED BY ENGLISH STYLE, AND THE MAIN REASON IS THE MONARCHY.

Buckingham Palace, in particular, has always intrigued me because it exemplifies living on a grand scale within the context of contemporary society. The three-hundred-year-old palace operates today in much the same way it did in 1837, when the first royal family took up official residence. The palace has an enormous staff of some 1,200 workers, including a clock changer on yearly salary, furniture and art restorers, florists, pastry chefs, sommeliers, drivers, secretaries—all these people to keep its 775 rooms in top form.

I rarely have the opportunity to design spaces that push a single look to the limit. In Buckingham Palace, the White Drawing Room, for example, which is the most imposing of all the state rooms, is fully gilded. The walls are adorned with gold cornices and covered in gilt-framed mirrors; the furniture is upholstered in gold silk and carved with burnished gold

lions. The Throne Room, used for ceremonial receptions, is scarlet from top to bottom: scarlet silk walls and a scarlet rug; scarlet thrones situated atop a scarlet dais. I try to translate some of that over-the-top grandeur into the rooms that I decorate, to take whatever I can extract from that high level of extravagance and infuse it into even the smallest of spaces.

That doesn't mean I advocate living like the queen! By employing extravagant touches sparingly, and in the right places, you can really elevate a space in a tasteful manner. Doing that can be as easy as bringing in jewel tones like emerald green, sapphire blue, and ruby red—or using richer fabrics like silk velvet and taffeta. Even if you have a clean, unfussy aesthetic, adding small regal elements like tassels or contrast piping on a pair of pillows can really dress up otherwise simple furnishings. Using decorative blue-and-white china pieces or creating a gallery of hanging portraits (old photographs and paintings can be bought fairly inexpensively at flea markets) can also add a sense of formality. Small touches of gold—in a picture frame, a lamp base, or the legs of a table—also go a long way in creating an imperial atmosphere. At Buckingham Palace, every wall has some sort of ornamentation, whether it's gilded molding, wallpaper, fabric, or some combination. You can take a cue from that and give the wall behind your bed an ornate look. Or you might want to focus instead on window treatments and add balloon curtains or an upholstered valance.

On a larger scale, you can play with a more formal floor plan. Most people decorate their homes by putting all the furniture against the walls, leaving a lot of dead square footage in the center, which is not necessarily the best use of space. At Buckingham Palace, the furniture is arranged in a way that's conducive to entertaining and conversation. All the pieces are brought into the middle of the room to create vignettes. There might be two chairs arranged with a settee, or a pair of sofas facing each other or positioned back-to-back. Smaller pieces of furniture are included as well, such as delicate-sized chairs, footstools, and ottomans. Common to royal interiors, these more incidental elements can add a charming bit of pomp to any room.

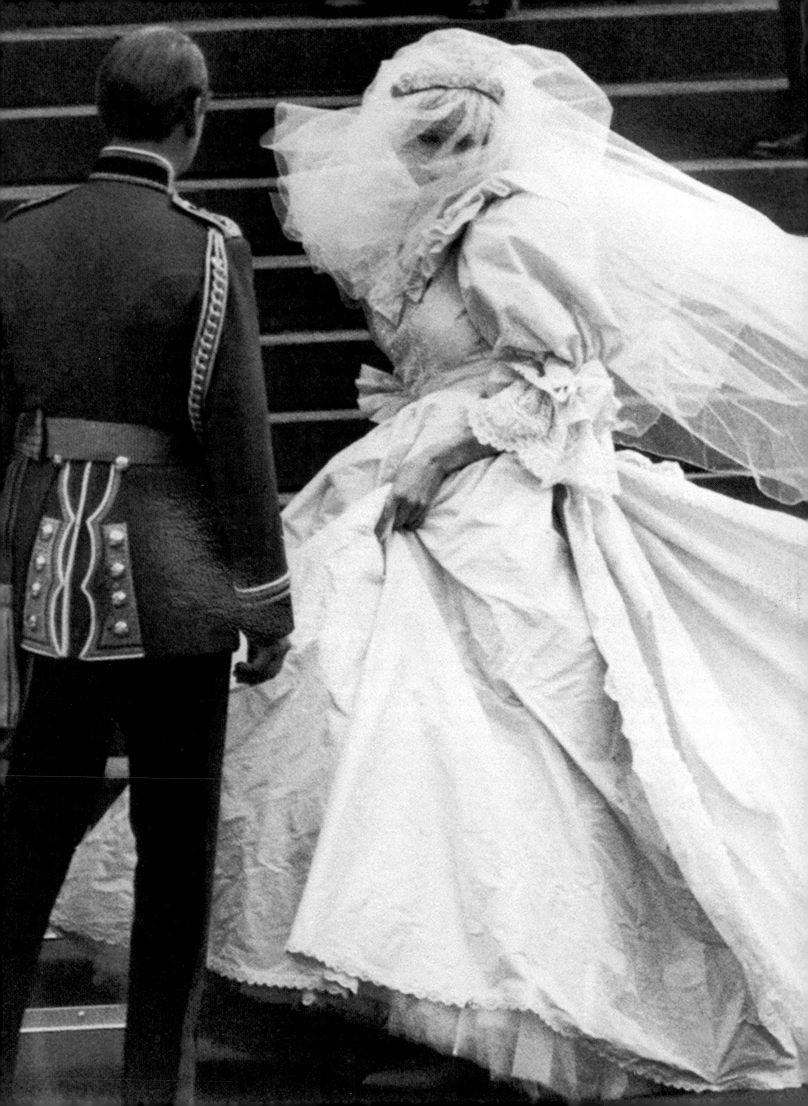

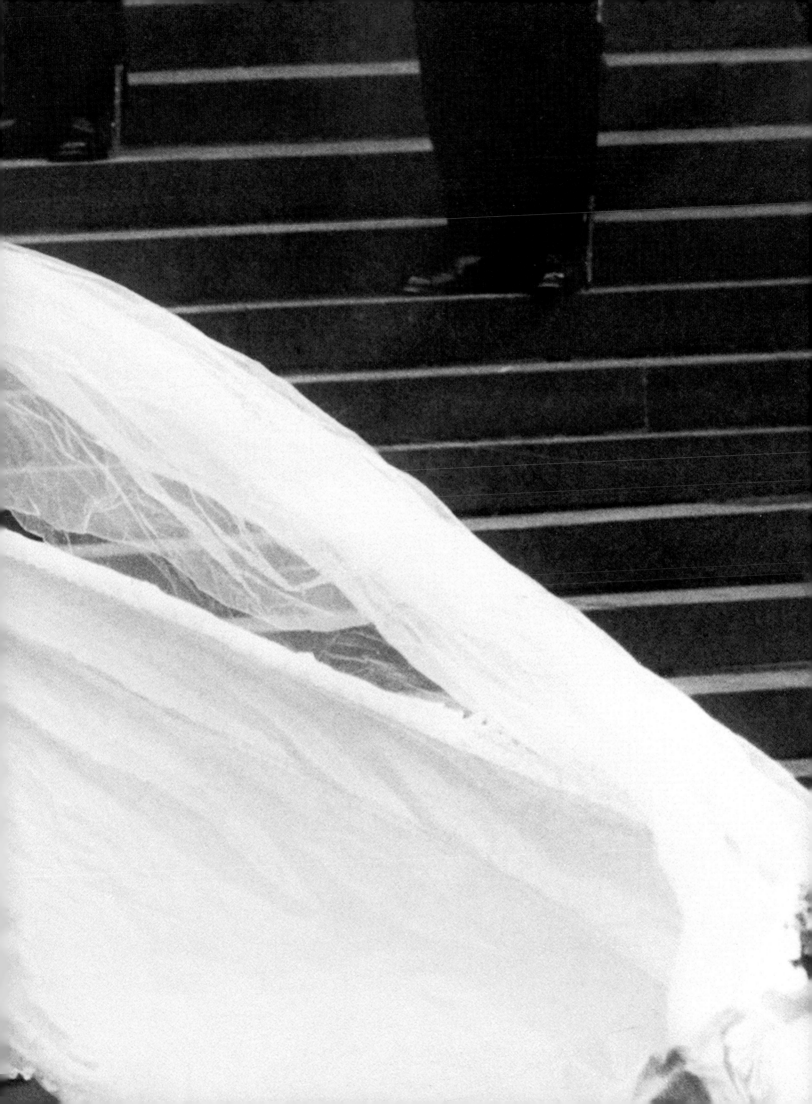

UNTIL 1981, WHEN

PAGES 168-169:
Lady Diana,
Princess of Wales,
on her wedding day,
1981

PAGE 176:
Emerald and
diamond ear clips,
sold by Sotheby's
Geneva, 2011

Lady Diana Spencer wed Prince Charles, the longest bridal train in the Royal Archives measured twenty fee in length. David and Elizabeth Emanuel, the designers of Diana's gown, took the train further, to twenty-five feet. At that length, it barely fit in the glass carriage that brought her to St. Paul's Cathedral. No matter what anyone says about the dress or the fact that the marriage didn't have a fairy-tale ending, the wedding exemplified romance and pageantry to the utmost.

When I was hired to decorate Fivestory, a two-floor women's boutique pictured in this chapter, I thought immediately of Buckingham Palace and its elaborate wrought-iron gates. I chose a regal green-and-gold color scheme and brought in lots of marble. Even though there's a definite youthfulness and coolness about the products on display, the space is located within a traditional town house, so it seemed natural to preserve an old-world feeling in the design.

Jewelry has always been a huge inspiration for me. I'm fascinated by the different cuts, the placement of precious stones, the mix of metals, and the use of color. The shimmering green of an emerald, for instance, is something I continually try to replicate in a room. I did so with silk velvet walls and subtle brass sconces (pages 172–173) that to me resembled a gorgeous pair of earrings.

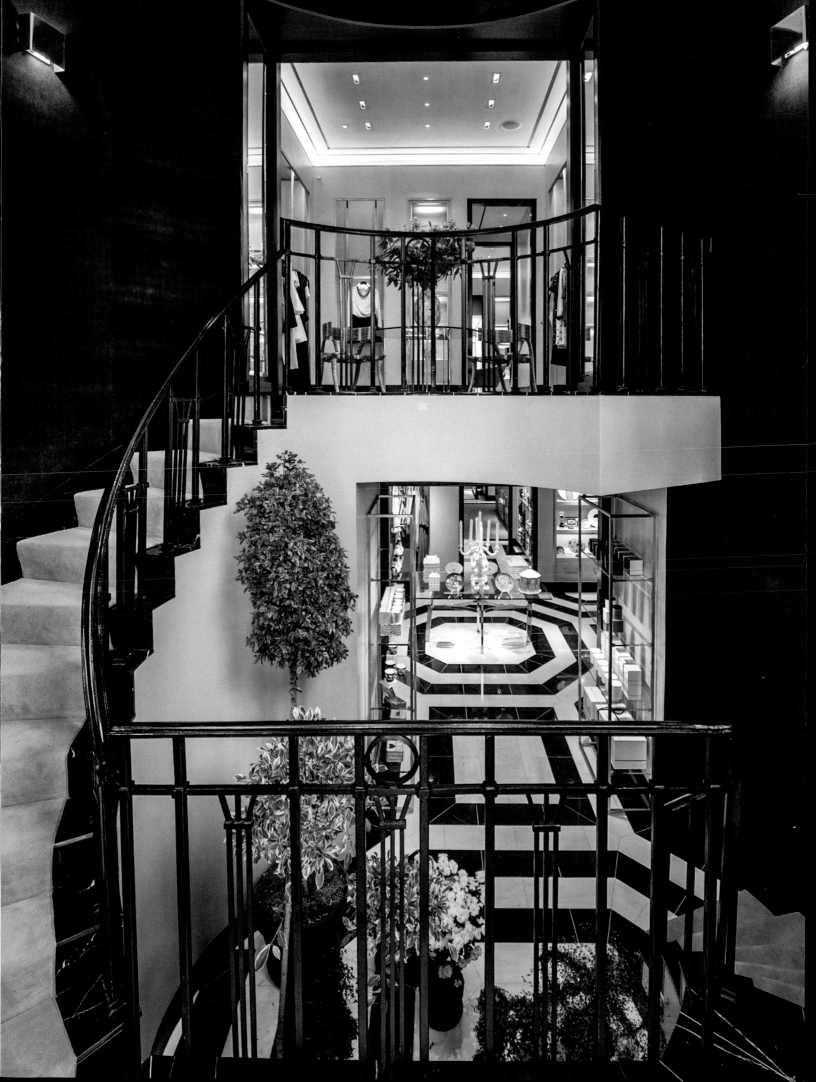

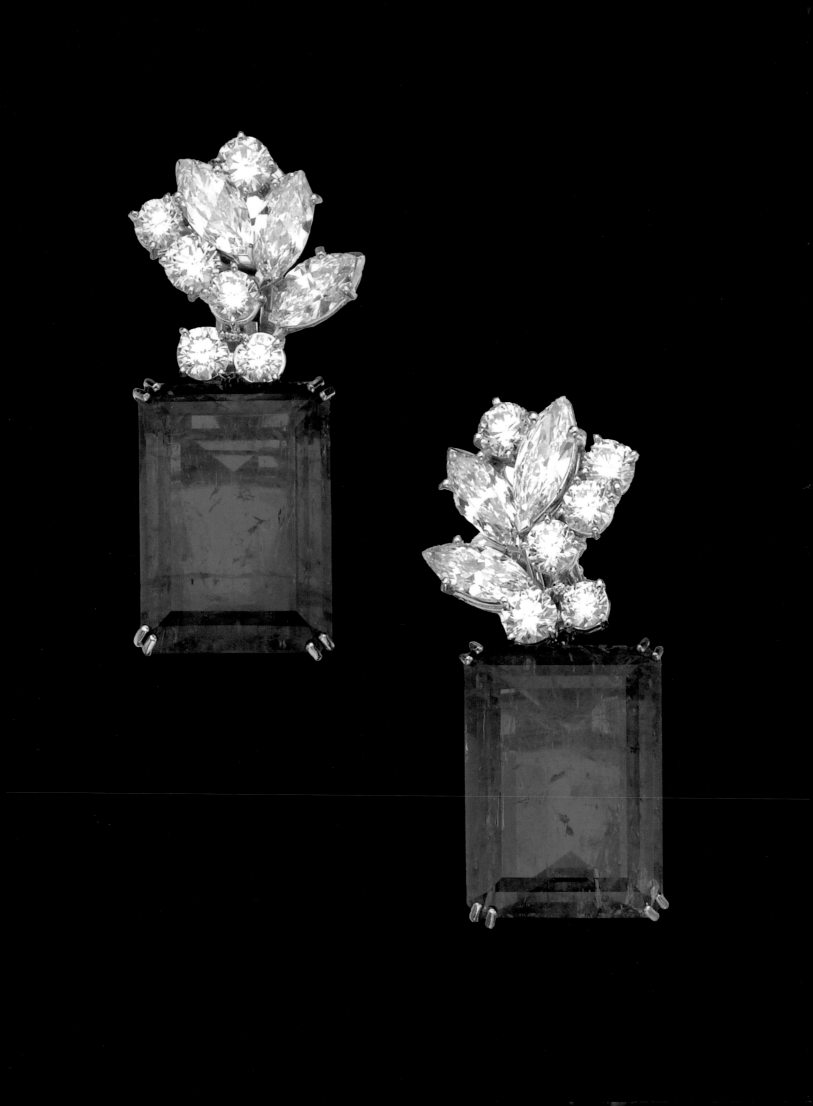

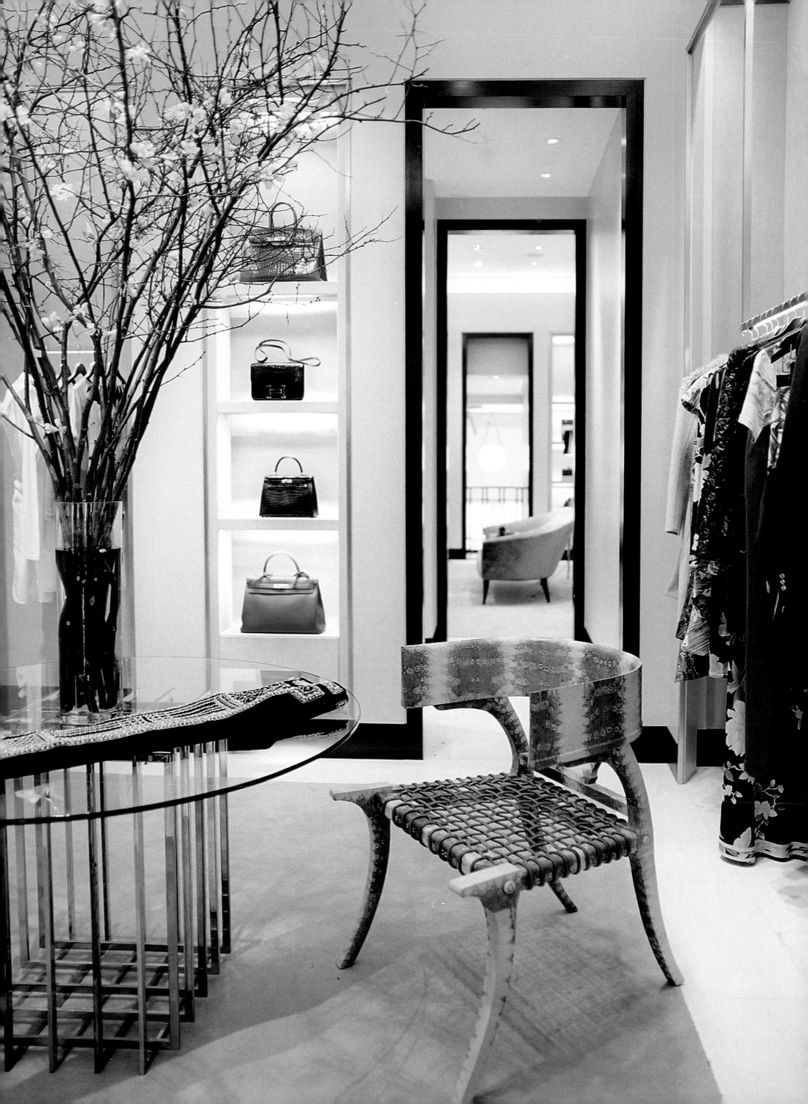

I CARPETED THE WOMEN'S SALON AND UPHOLSTERED THE WALLS IN SUEDE TO GIVE THE SPACE A SOFT, PLUSH, FEMININE FEEL, LIKE THAT OF A BOUDOIR,

and then added klismos chairs that are fully wrapped in lizard to impart a sense of decadent luxury (opposite). The velvet and brass in the accessories room (pages 180–183) lend a regal air. But the subtle, cool color palette offsets all the tradition and makes it feel modern.

We referred to the conservatory (pages 184–185) at the back of the shop's ground floor as the "shoe garden." The concept here was about bringing the outdoors in and decorating the space as one would a courtyard. The pendants hanging from the ceiling are ordinarily used for outdoor lighting. I affixed an antique basin I found in London to the wall to suggest that the room was a place to wash your hands and feet.

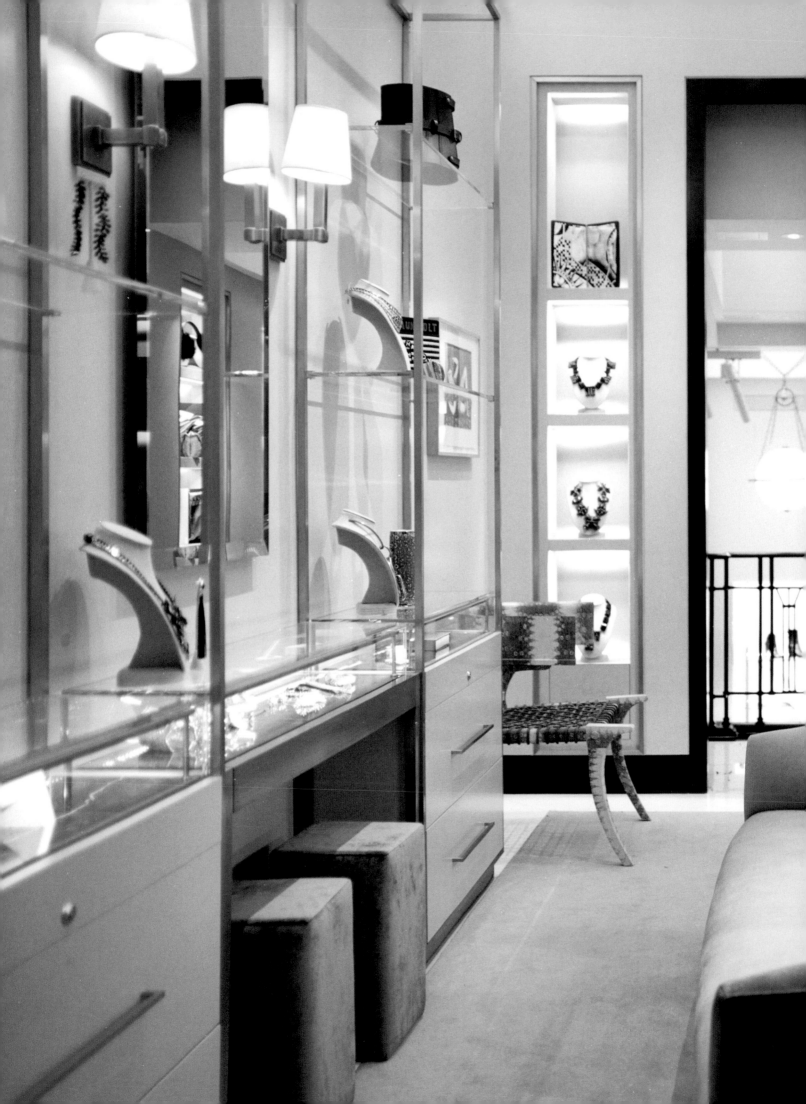

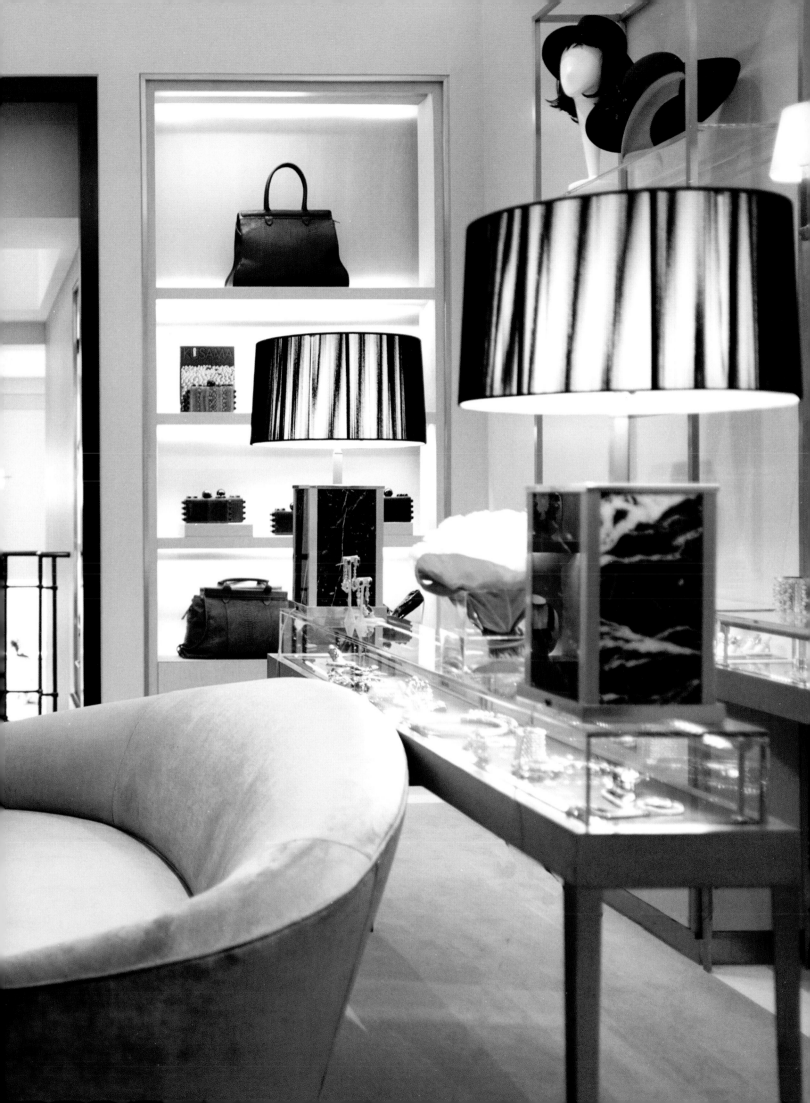

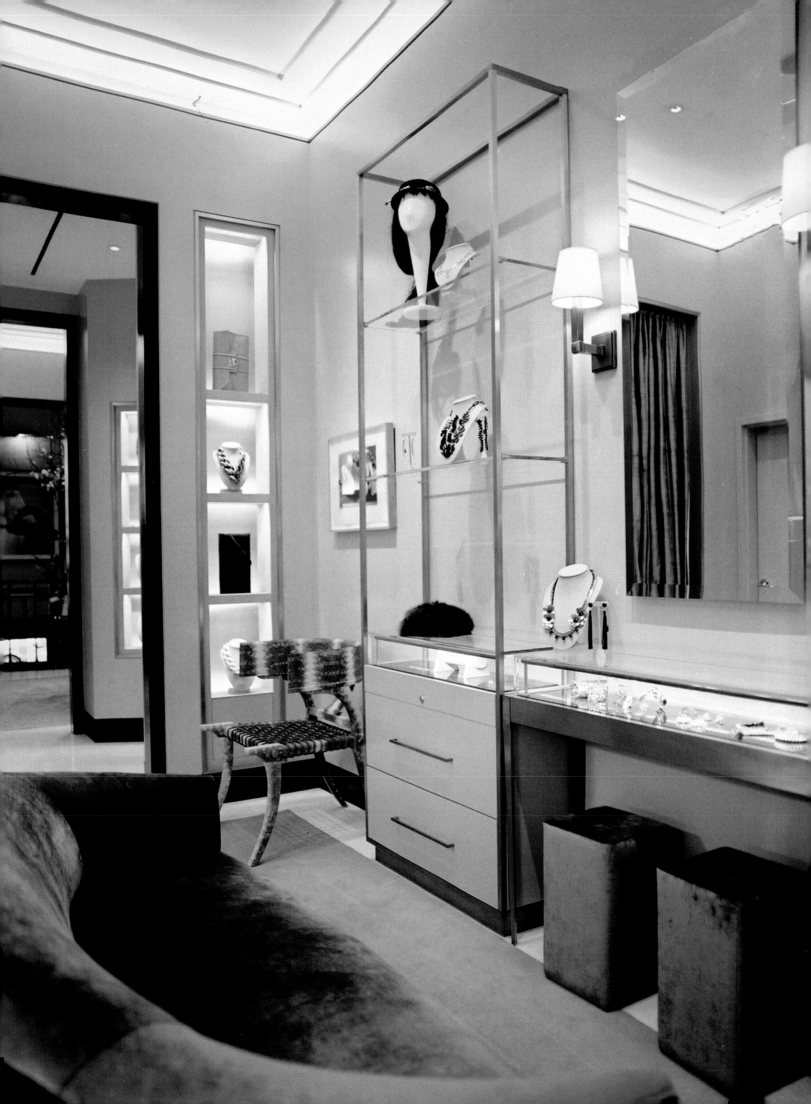

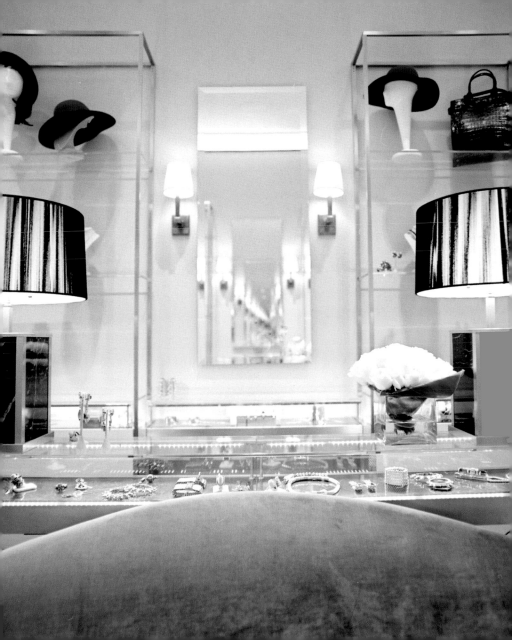

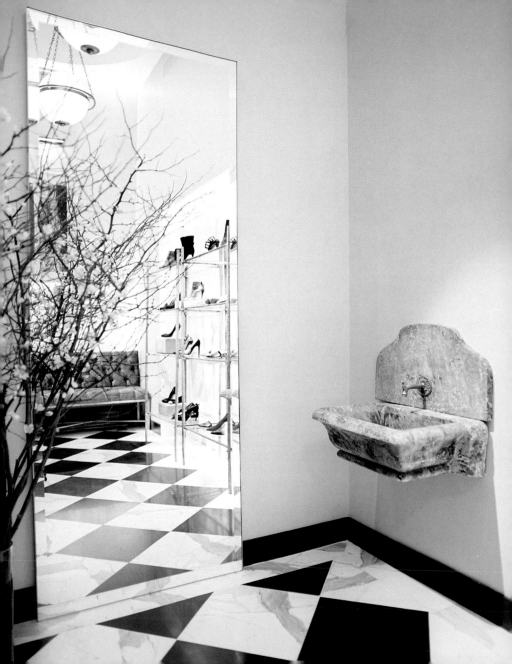

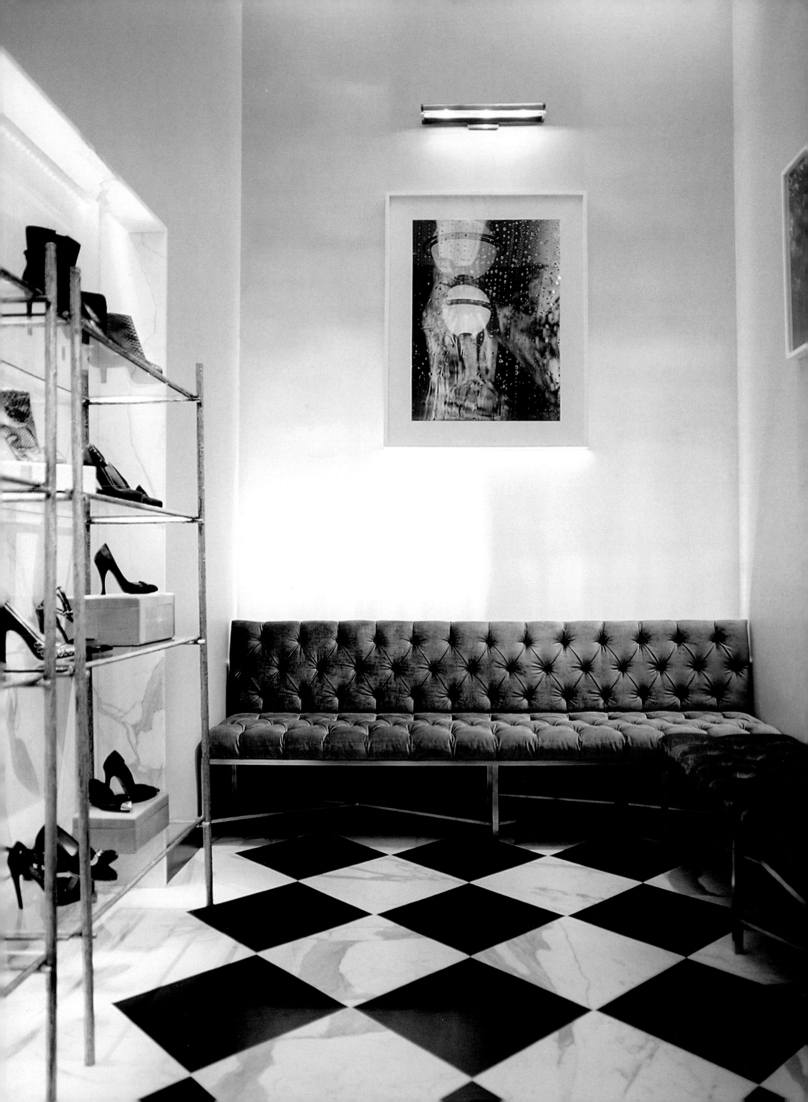

RESOURCES

Accessories

ASPREY
853 Madison Avenue
New York, NY 10021
(212) 688-1811
www.asprey.com

Replete with witty, whimsical items like leopard-print espresso cups and tumblers etched with octopi, this is my favorite shop for home accessory gifts.

CREEL & GOW
131 East 70th Street
New York, NY 10021
(212) 327-4281
www.creelandgow.com

A cabinet of curiosities—turtle shells, ostrich eggs, silver-dipped coral—sourced from all over the world.

KATHARINE POOLEY
160 Walton Street
London SW3 2JL
+44 20 7584 3223
www.katharinepooley.com

A well-curated place for classic, cool items like ice buckets, croc table lighters, and photography by Terry O'Neill.

R&Y AUGOUSTI
103 rue du Bac
75007 Paris
+33 01 42 22 22 21
www.augousti.com

Not many companies wrap furniture in animal skins like this one does. I've worked with R&Y Augousti on many pieces, including shagreen dining chairs and an ostrich dresser. They have made my wildest dreams come true.

THE RUG COMPANY
88 Wooster Street
New York, NY 10012
(212) 274-0444
www.therugcompany.com

Rugs are expensive, and this company makes them worth the price. Not only are the rugs of extremely high quality, they are also stunning in a very subtle way.

Candles

AEDES DE VENUSTAS
9 Christopher Street
New York, NY 10014
(212) 206-8674
www.aedes.com

Decorated with fresh flowers, a taxidermy peacock, and an array of incredible fragrances and candles, this is the most romantic store in New York. It's nearly impossible to leave empty-handed.

BY KILIAN
804 Washington Street
New York, NY 10014
www.bykilian.com

From the complex scents to the black lacquer packaging, Kilian's fragrances telegraph sex like none other.

CIRE TRUDON
78 rue de Seine
75006 Paris
+33 1 43 26 46 50
www.ciretrudon.com

The place to go for stronger, more complex scents.

DIPTYQUE
971 Madison Avenue
New York, NY 10021
(212) 879-3330
www.diptyqueparis.com

Diptyque's Roses scent has been my favorite candle for as long as I can remember. Plus, they offer jumbo-sized candles, perfect for a serial candle-burner like myself.

FRÉDÉRIC MALLE
898 Madison Avenue
New York, NY 10021
(212) 249-7941
www.fredericmalle.com

It's hard to find good floral-scented candles. At Frédéric Malle, they're fresh and clean without being over-powering.

Fabrics & Upholstered Pieces

ARMANI CASA
979 Third Avenue
New York, NY 10022
(212) 334-1271
www.armanicasa.com

I'm fond of unconventional upholstery. I often use fabrics from fashion houses, and Armani is one of the best. Choosing fabric at Armani Casa feels as if you're picking out fabric for an Armani Privé suit.

CHRISTOPHER HYLAND

979 Third Avenue
New York, NY 10022
(212) 688-6121
www.christopherhyland.com

Christopher Hyland is home to the most decadent fabrics. They offer 100 percent silk velvets that shine like the Chrysler building.

J. ROBERT SCOTT

979 Third Avenue
New York, NY 10022
(212) 755-4910
www.jrobertscott.com

Nearly every fabric in my home is from here. The shop offers beautiful raw silks in the neutral grays I adore.

WOLF HOME

936 Broadway
New York, NY 10010
(800) 220-1893
www.wolfhome-ny.com

Headboards, pillows, dining chairs, Roman shades—if you want upholstered anything, this is the place to go.

Flowers

ANGELICA FLOWERS AND EVENTS

436 Hudson Street
New York, NY 10014
(212) 229-0272
www.angelicaflowersandevents.com

Angelica has a great eye. She is the only florist in New York City I trust to do mixed arrangements.

MIHO KOSUDA

310 East 44th Street
New York, NY 10017
(212) 922-9122

Miho is all about the simple beauty of the flower. I love her no-fuss bouquets of cabbage roses.

LACHAUME

103 rue du Faubourg Saint-Honoré
75008 Paris
+33 1 42 60 59 74
www.lachaume-fleurs.com

The most exquisite flower shop, filled with the most exquisite flowers, including roses the size of your fist!

L'OLIVIER FLORAL ATELIER

213 West 14th Street
New York, NY 10011
(212) 255-2828
www.lolivier.com

When I need a formal arrangement for an event, I go here. L'Olivier does stunning tied bouquets arranged artistically in glass vases.

BARBRA SCOTT

150 West 28th Street
New York, NY 10001
(212) 366-9011
www.barbrascott.com

Using a nontoxic chemical process, Barbra creates beautiful dried flower arrangements—from pink peonies to quince branches.

Furniture

CHRISTIAN LIAIGRE

34 East 61st Street
New York, NY 10065
(212) 201-2338
www.christian-liaigre.us

Christian Liaigre is probably the only furniture designer whose work I would consider using to decorate a house entirely. His furniture is so simple and chic.

FLAIR

88 Grand Street
New York, NY 10013
(212) 274-1750
www.flairhomecollection.com

Filled with low-slung 1970s-era furniture and accessories with tons of shine.

FLAIR

Piazza Goldoni, 6/R
50123 Florence
+39 055 267 0154
www.flair.it

The same super-Italian feel as the New York location, but with a more feminine spin.

GASPARE ASARO MILLENOVECENTO

251 East 60th Street
New York, NY 10022
(917) 386-8380
www.ga1900.1stdibs.com

There is gorgeous lighting to be found at this shop—in particular, pieces from the 1940s and 1950s, which are fairly uncommon.

GUINEVERE ANTIQUES

574-580 Kings Road
London SW6 2DY
+44 20 7736 2917
www.guinevere.co.uk

Beautiful English furniture—and outrageously expensive. This is where you go to drool.

HIGH STYLE DECO

27 West 20th Street
New York, NY 10011
(212) 647-0035
www.highstyledeco.com

A well-edited shop for everything art deco.

LEREBOURS ANTIQUES

220 East 60th Street
New York, NY 10022
(212) 308-2275
www.lereboursantiques.com

A small store with a large array of items—from shagreen waterfall tables to Louis XVI armchairs—and a great place to go for ideas.

LES PUCES DE PARIS

Porte de Clignancourt
93400 Saint-Ouen
+33 6 09 48 84 53
www.marcheauxpuces
-saintouen.com

Not only is there a wealth of stuff at this flea market outside Paris, there are also great treasures to be found. It's no wonder all the antique dealers go here.

VENFIELD

227 East 60th Street
New York, NY 10022
(646) 205-3034
www.venfieldnyc.com

This boutique carries decadent mid-century pieces like zebra-skin ottomans and Murano chandeliers. If you want glamour, go here.

Taxidermy and Fur

AREA ID

262 Elizabeth Street
New York, NY 10012
(212) 219-9903
www.areaid.com

My go-to for fur accessories—from coyote fur throws and pillows to zebra-skin rugs.

FRANÇOIS DANECK

45 avenue Georges V
75008 Paris
+33 1 47 23 02 35
www.francoisdaneck.com

This boutique has the most interesting array of exotic taxidermy and objects. You might find, for example, a taxidermied snow leopard standing beside an ancient headdress.

THE EVOLUTION STORE

120 Spring Street
New York, NY 10012
(212) 343-1114
www.theevolutionstore.com

A great shop for all things natural, from mounted and framed butterfly specimens to huge hunks of colorful crystals.

FRANK ZITZ

479 Schultz Hill Road
Rhinebeck, NY 12572
(845) 876-4896
www.taxidermymuseum.com

The best taxidermist in the United States, Frank will work with clients on custom pieces.

BIBLIOGRAPHY

Drake, Alicia. *The Beautiful Fall: Fashion, Genius, and Glorious Excess in 1970s Paris*. New York: Little, Brown, 2006.

Hennessy, Kilian. E-mail interview. September 3, 2012.

Metzner, Sheila. E-mail interview. March 7, 2013.

O'Neill, Terry. E-mail interview. August 22, 2012.

PHOTOGRAPHY CREDITS

ACKNOWLEDGMENTS

First and foremost, I'd like to thank all the artists, fashion designers, photographers, and subjects whose incredible work is included in this book. You have inspired and defined my aesthetic and guided me from the start of my career.

I am grateful to Kate Lee and Kari Stuart at ICM, who believed in this project from the beginning; Heather Hughes, who facilitated it; and Elizabeth Viscott Sullivan and Lynne Yeamans at HarperCollins, who beautifully brought it to fruition.

Thank you to Karin Nelson for accompanying me on this journey; Victoria Traina, Hamish Bowles, Alexander Wang, and Joseph Altuzarra, for your kind words; and both Robyn Berkley and Leslie Rubisch, for all your help and support.

I must extend my gratitude to the following individuals, who were instrumental in acquiring the images for this book: Robin Morgan, James Danziger, Arnaud A. Adida, Rob Magnotta, Nadja Conklin, Liesel Vink, Billy Vong, Joanna Hunt, Lauren Hechel, Heather Strange, Jennifer Ramey, Katherine Marshall, Pauline Vidal, Stephanie Breslin, Michael Diver, and Alessia Contin.

And lastly, thank you to Patrick Cline, Billy Farrell, Ditte Isager, and Matt Ramirez, whose photographs portray my work in its best light.

HarperCollins books may be purchased for educational, business,
or sales promotional use. For information please e-mail the Special
Markets Department at SPsales@harpercollins.com.

First published in 2014 by
Harper Design
An Imprint of HarperCollins *Publishers*
10 East 53rd Street
New York, NY 10022
Tel: (212) 207-7000
Fax: (212) 207-7654
www.harpercollinspublishers.com
harperdesign@harpercollins.com

Distributed throughout the world by
HarperCollins *Publishers*
10 East 53rd Street
New York, NY 10022

ISBN 978-0-06-223573-2

Library of Congress Control Number: 2012941895

Book design by Lynne Yeamans
Printed in China
First Printing, 2014